PROVENCE
500 PHOTOS

GÉRARD SIOEN

PROVENCE
500 PHOTOS

FOREWORD BY TERENCE CONRAN

Flammarion

My Provence
by Terence Conran

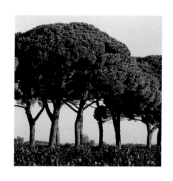

Landscapes

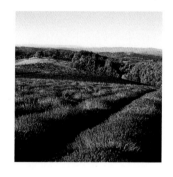

Towns and Villages

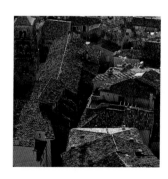

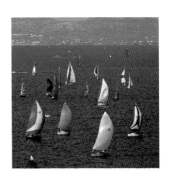
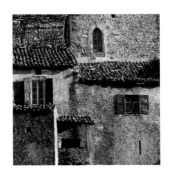
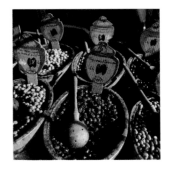

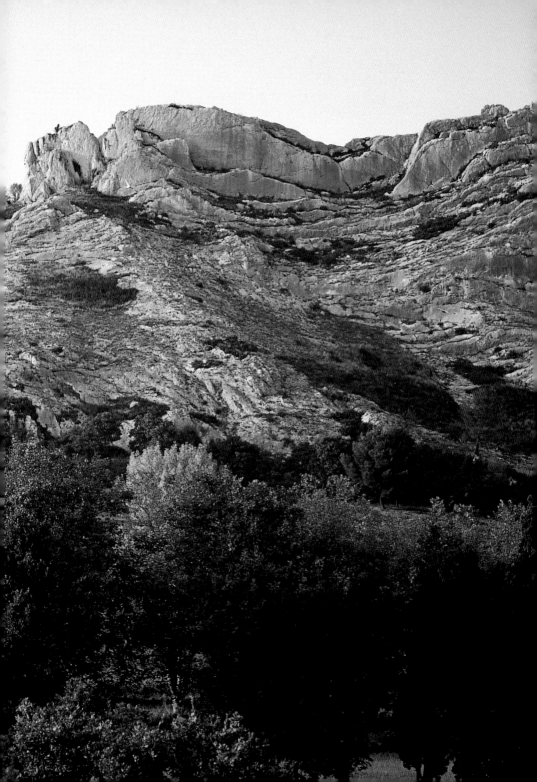

My Provence

by Terence Conran

Although somewhat overexposed by a certain British author, Provence is a truly huge and beautiful place. I have lived in an old-fashioned farmhouse between Paradou and Fontvielle on and off for the last twenty years or so. It is in a very green valley with fields of grass, wild flowers, and olive trees, well irrigated by little streams fed by the Canal de Provence. In the distance is that extraordinary range of tiny mountains called Les Alpilles that look as if they have been carved by Henry Moore and on one side are hills covered with the herbs of Provence—wild thyme and rosemary—and on the other are rocky slopes covered by giant pine trees and scrub oak. I am told it is one of the last remaining true Mediterranean forests and it is always guarded by fire engines on hot Mistral days in the summer.

My favourite moment is eating supper outside in the evening, just as the sun goes down. The quietness and the quality of the subfusc light makes the countryside look, sound, feel, and smell magical. Is heaven like this? I have only seen a tiny part of Provence, as these brilliant photographs have admirably demonstrated

The Servannes golf course
in Mouriès, Les Alpilles.

to me. Do I want to see more—yes, of course I do and so will you.

Sadly the photographs don't (yet) smell or taste but they are sufficiently evocative for one to be able to almost feel the heat, smell the lavender and rosemary, and taste the salt of the sea, and the olive oil and garlic.

As I have mentioned, my abiding memory of Provence is the quality of light which has proved a magical attraction for hundreds of thousands of artists and photographers from Cézanne and Van Gogh to Matisse and Picasso to Lartigue and Cartier-Bresson and now to Gérard Sioen.

My gastronomic juices are also stirred by the food markets, particularly those where the local farmers display their own produce and those which have not been bespoiled by touristic geegaws. Huge piles of asparagus and melons, white and yellow peaches, mountains of cherries, purple figs and apricots, enormous ugly ripe tomatoes, and a hillside of garlic. The profusion and generosity could easily lead you to gluttony. Then there are the avenues of plane trees with the enchanting dappled light which is so welcome on a hot summer's day. Please France, don't dream of cutting them down as they are a vital ingredient of Provencal life.

A lane of plane trees
near Arles.

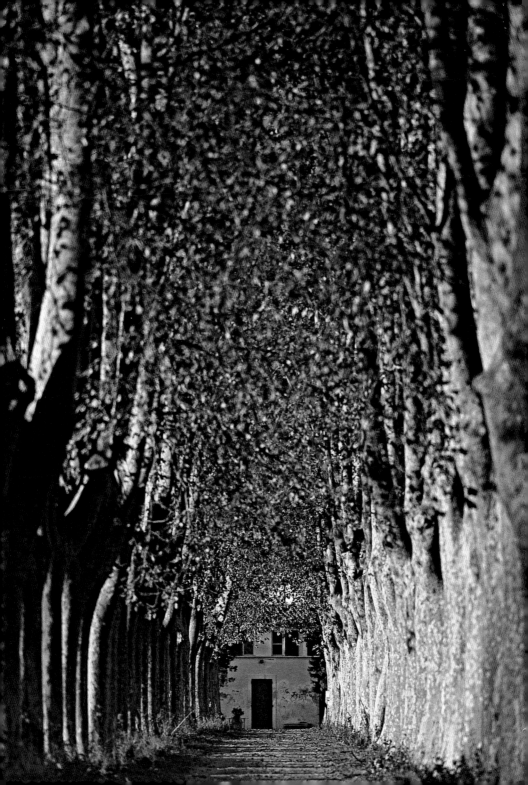

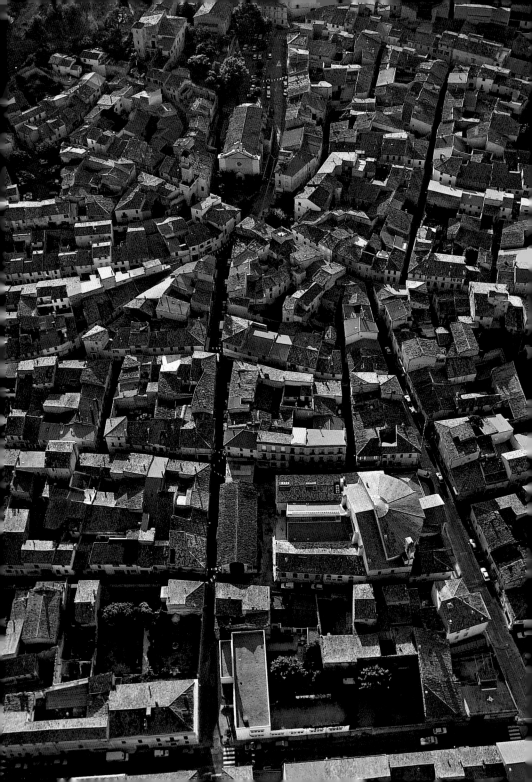

Water is another part of the magic and mystery of Provence. The sun glinting off the Mediterranean as it comes up or goes down, the sparkle of fountains in small village squares, the violent thunderous storms of rain that suddenly refresh the sunbaked countryside and the wonderful smell that comes with it. The salt flats and pink flamingoes with their long legs in the shallow water of the Camargue, then the Canal de Provence, which has allowed the earth to be so productive and to become the vegetable and fruit basket of France.

However, my favourite places in Provence are the tiny little villages hidden away amongst the hills and mountains. They seem to preserve a peaceful and contained style of life that has been little altered by our busy, grasping, techno world.

Go to Provence and enjoy the touristic glamour of St-Tropez, the urban diversity of Marseille, and do not miss Le Corbusier's *unités de habitation* while you are there, but, finally, retire to a quiet and peaceful hill town and sigh a deep sigh of contentment.

Terence Conran
November 2004

Terence Conran

The village of Vauvert
in the Petite Camargue.

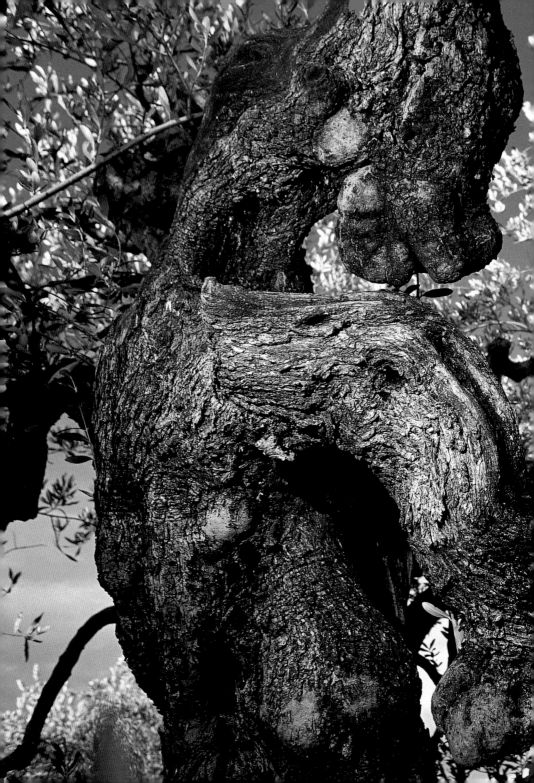

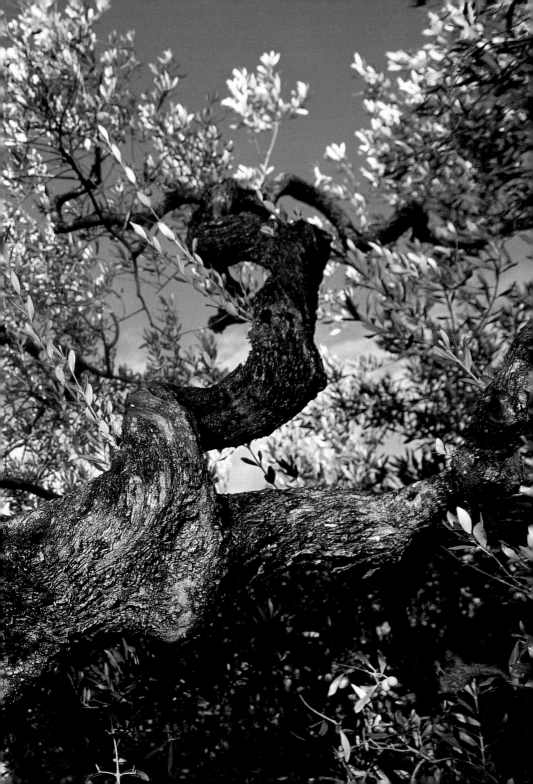

Landscapes

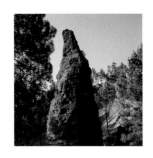 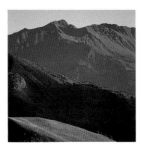 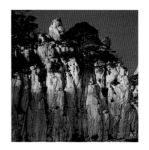

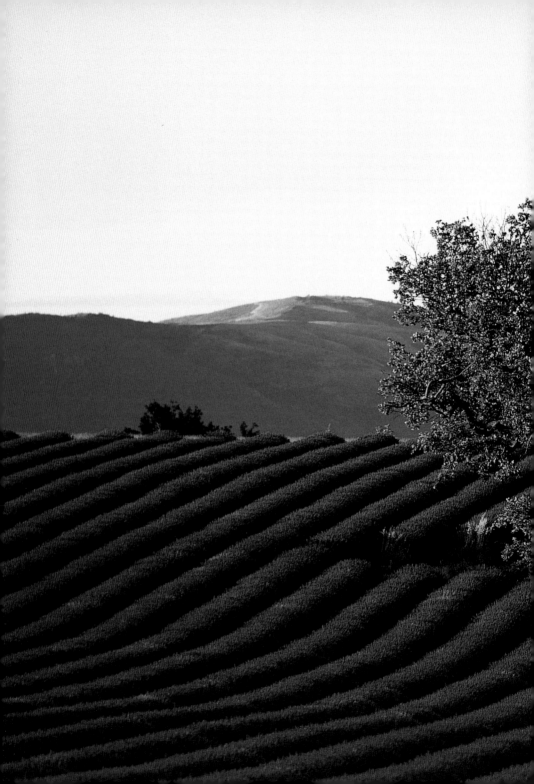

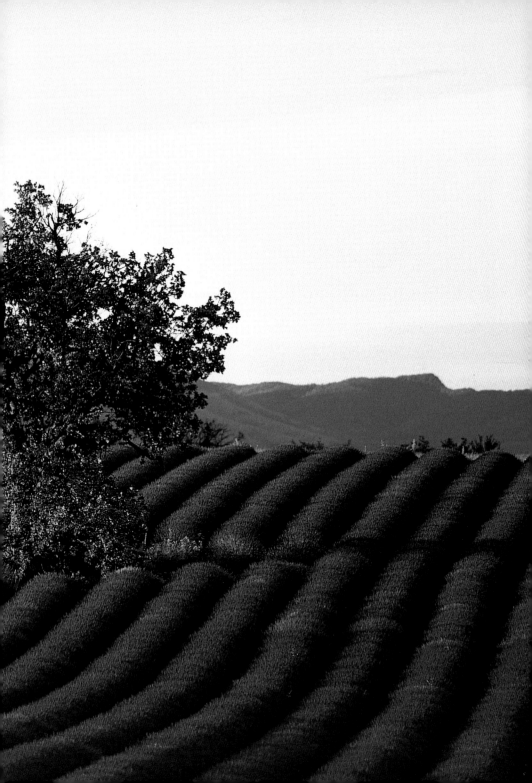

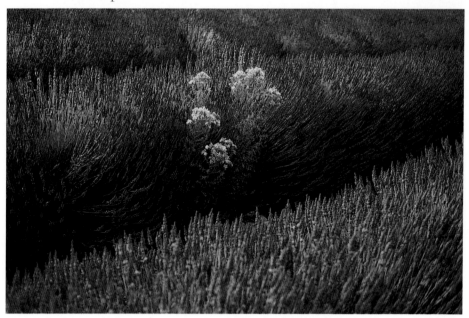

Saint John's wort and hybrid lavender, a variety bred from
two lavender species —*Lavandula officinalis* and *Lavandula latifolia*—
in the fields of Poët-Laval in the Provençal Drôme.

preceding double page
The limestone soil of Haute Provence
is perfect for lavender crops—
here on the Valensole plateau.

The lavender blooms and is ready
for harvest at the height of summer.

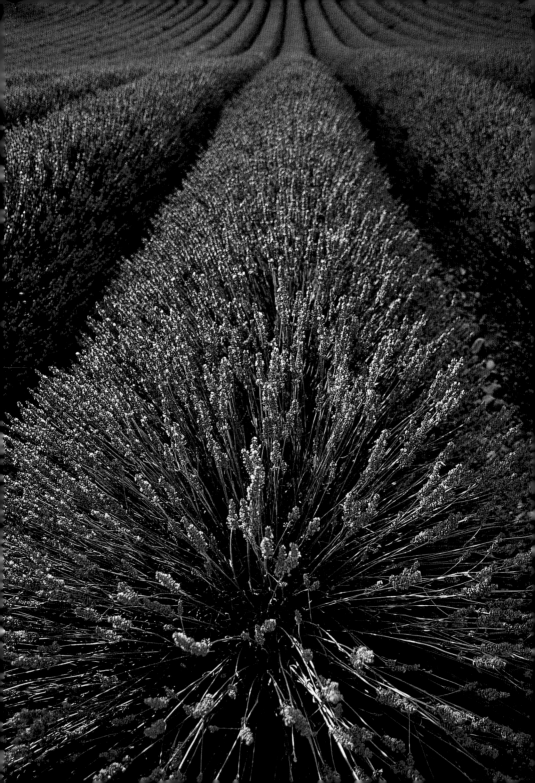

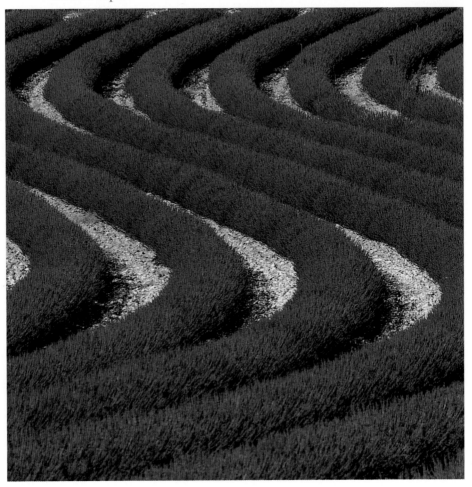

Wild lavender grows in abundance in Provence,
but it is also cultivated, as here in Dieulefit, in the Drôme.

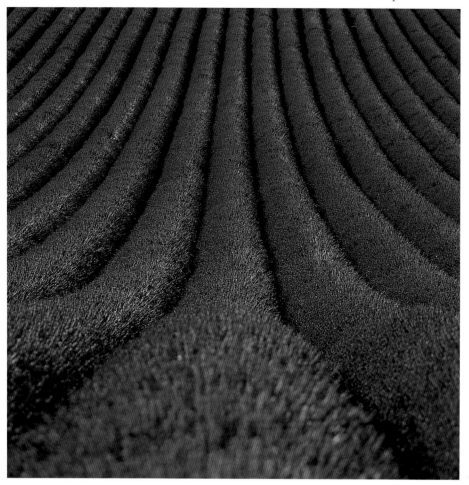

Twenty or so species of lavender exist and their colors vary from light blue to deep purple. Here we see the violet-blue of hybrid lavender.

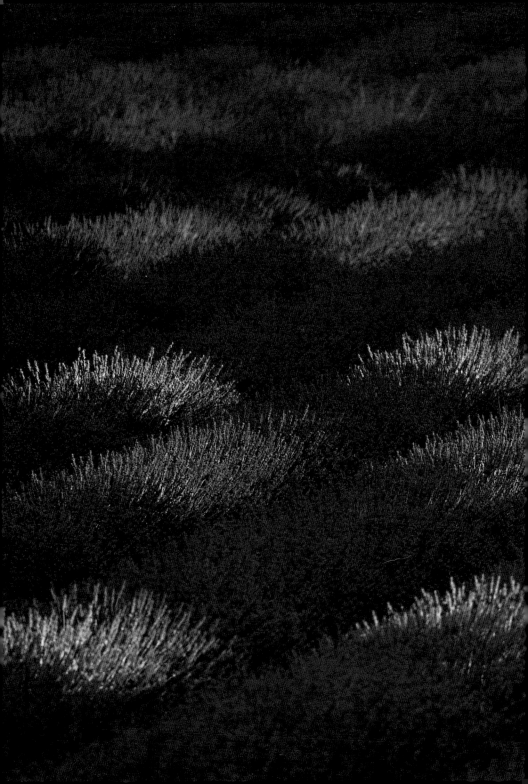

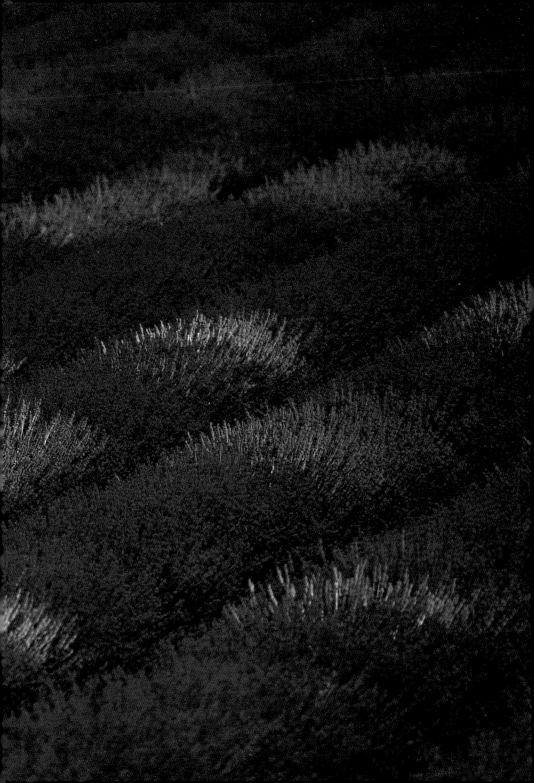

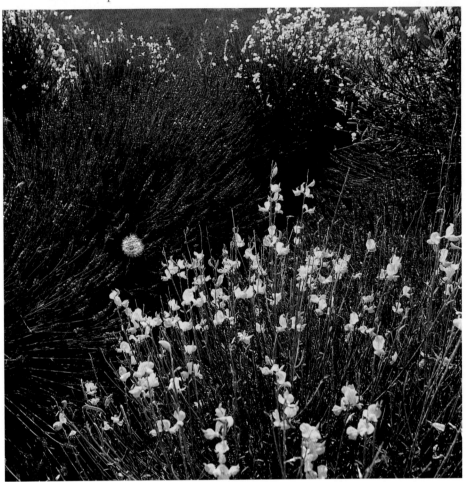

Hybrid lavender and broom around Vachères near Manosque.

preceding double page
At the end of the day, the sun caresses the ocean of lavender.

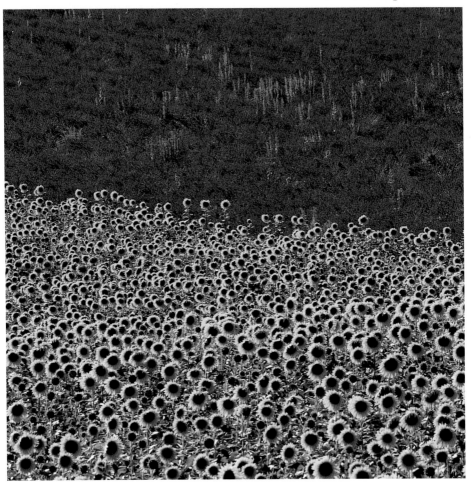

The gold of sunflowers and the violet of lavender outside Forcalquier.

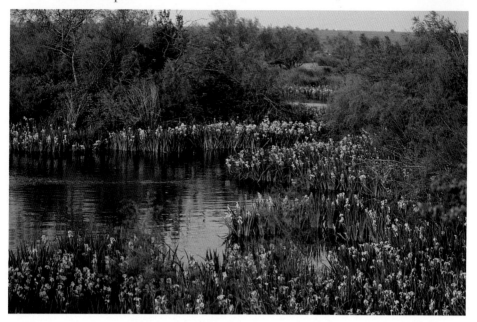

In the Camargue in springtime, the banks of the marshes
are dappled with tufts of bright yellow irises.

Irises, both cultivated and wild, light up the gardens
and landscapes of Provence in April.

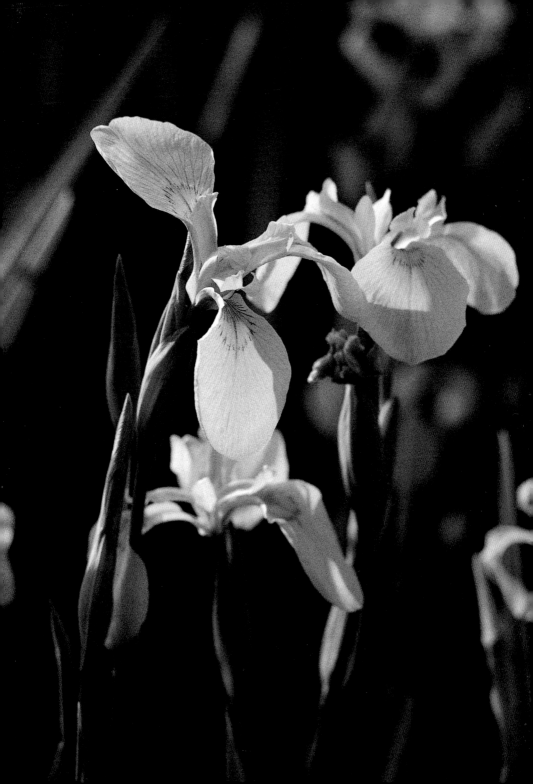

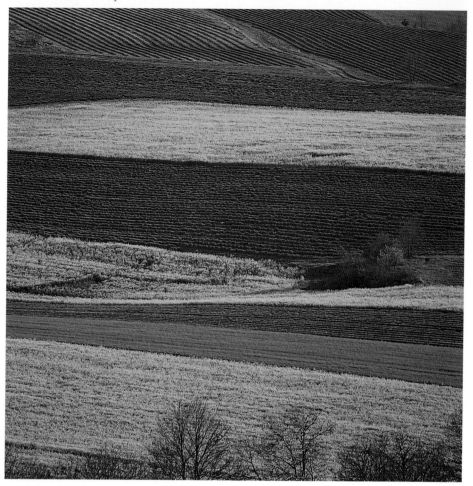

On the Sault plateau, golden colza flowers and the violet
of hybrid lavender dapple the patchwork fields.

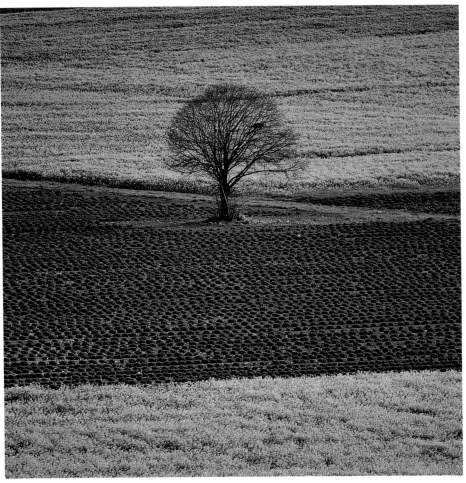

The furrowed landscape at the end of winter. The Sault plateau has lost its vibrant colors.

following double page
Gold and blue, wheat and fine
lavender — summer comes to Provence.

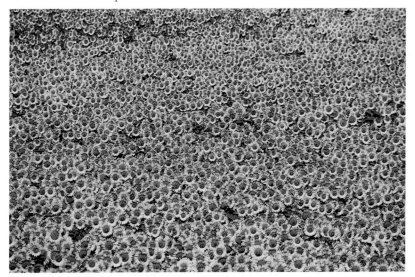

Sunflower field outside Mouriès in Les Alpilles.

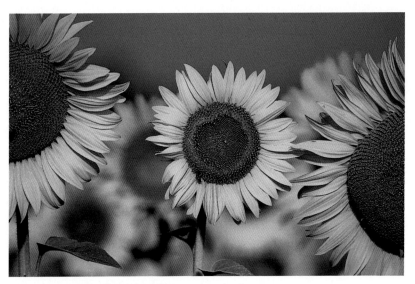

The shapes and colors of sunflowers inspired
Van Gogh's most famous paintings.

Sunflowers and olive trees
outside Manosque.

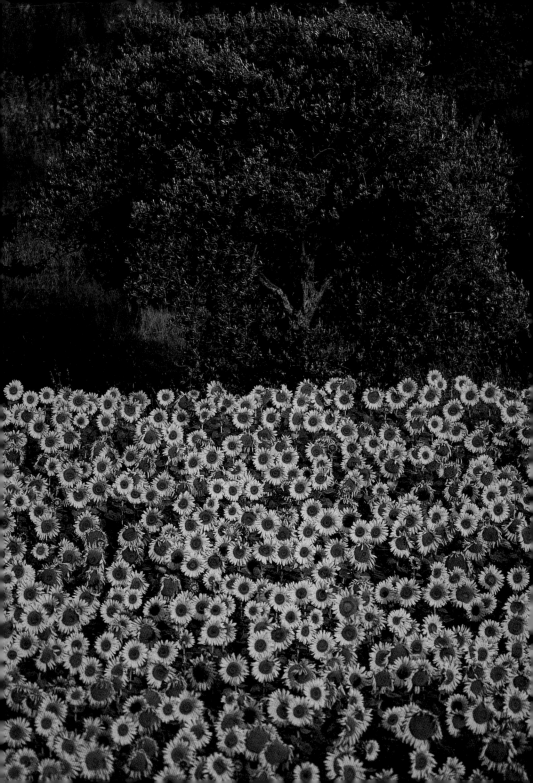

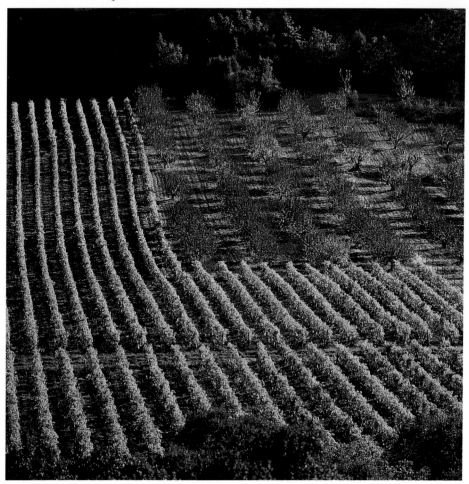

In early November, the vines and cherry trees
take on fall shades.

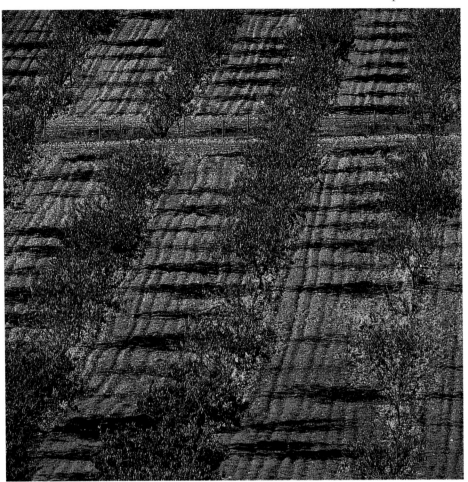

Cherry trees figure prominently in the orchard
landscape near Apt in the Vaucluse.

following double page
Poppy field near Lacoste in the Lubéron.

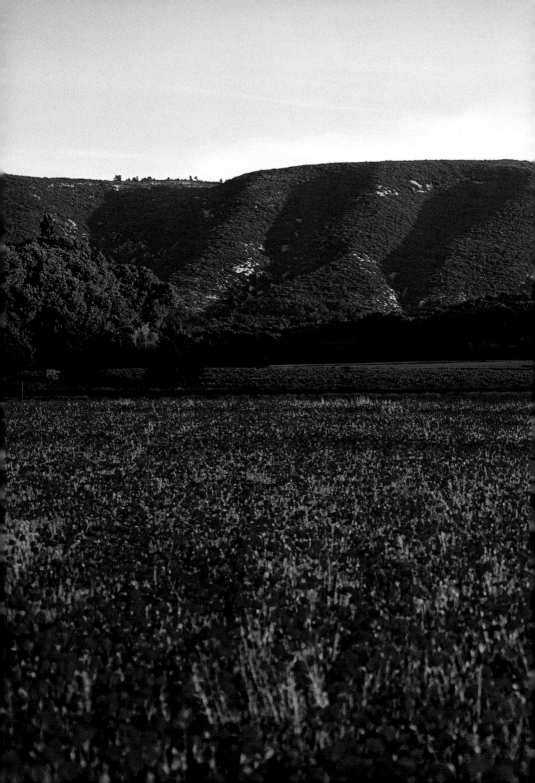

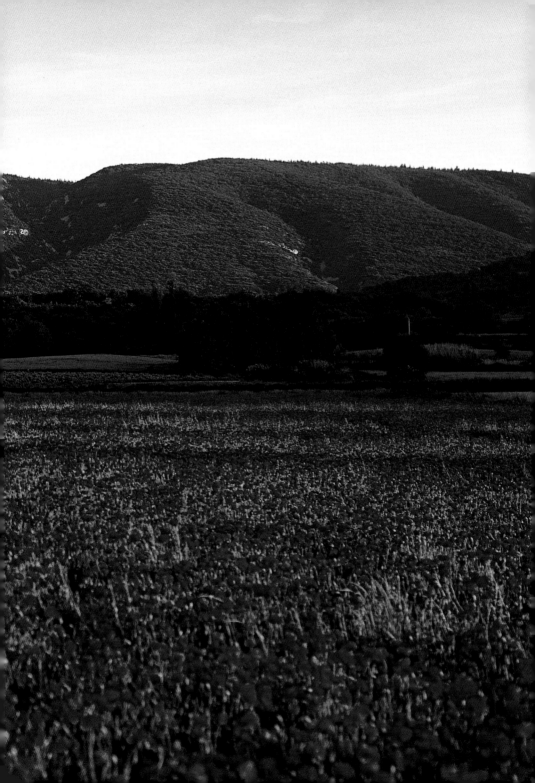

Landscapes

A bed of wild flowers—poppies in the Haut Lubéron.

Morning on the Crau plateau,
outside Marseille.

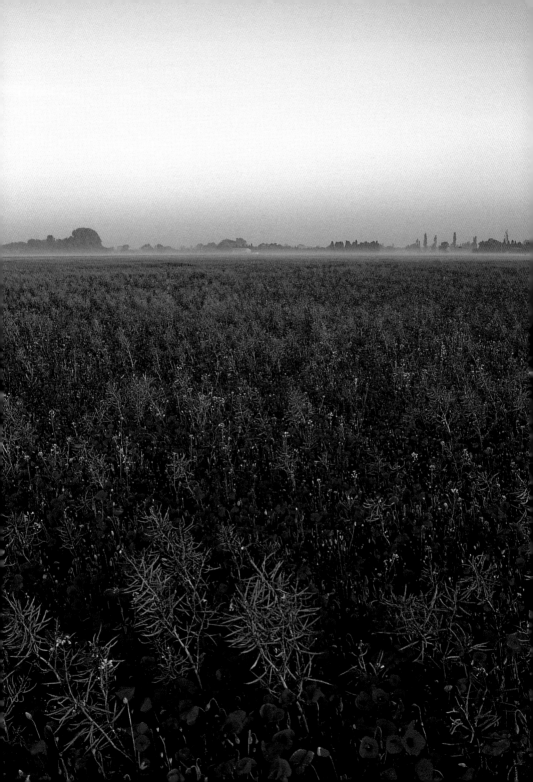

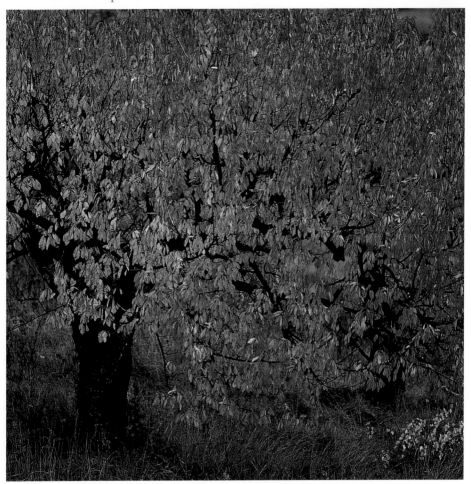

Apt, the world capital of crystallized fruit, owes its production
to the wonders of Provençal orchards—here, a cherry tree in autumn.

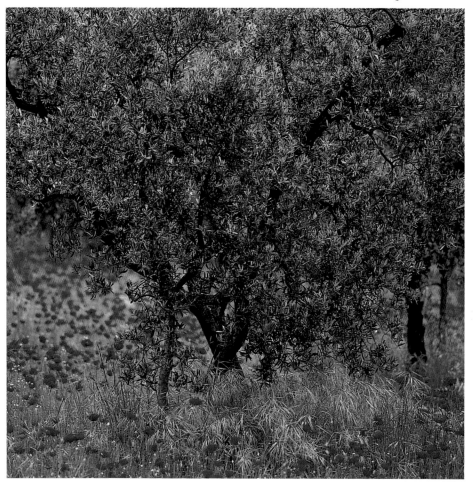

Olive trees and poppies in the scrubland of Les Alpilles.

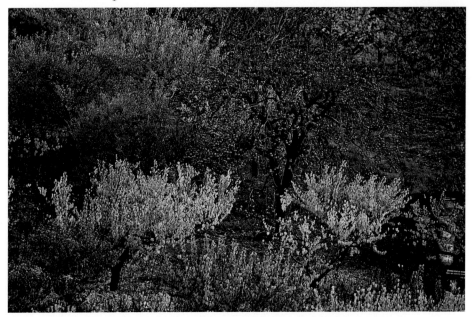

Persimmon and apricots are fruits extensively cultivated in Provence.
Here, in the Ouvèze valley, their branches mingle with those of the olive trees.

following double page
The lavender fields burst into color for only
one month of the year. Their pure symmetry is
eye-catching throughout the rest of the year.

An orchard of apricot
trees, in fall, in the Drôme.

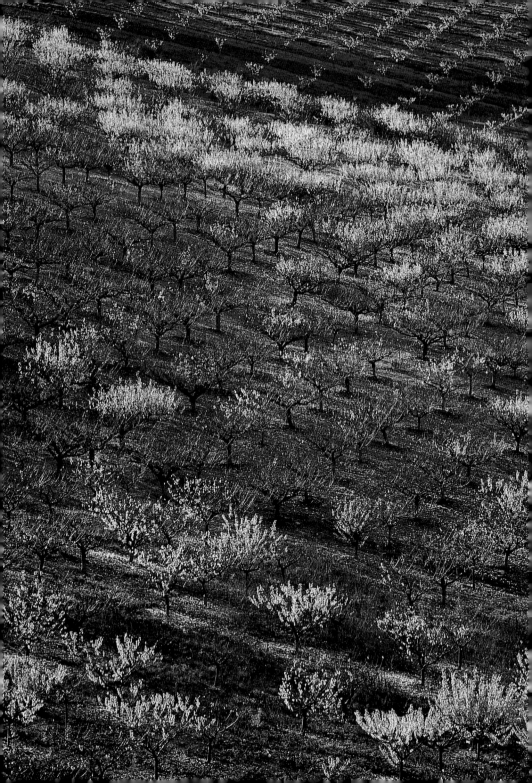

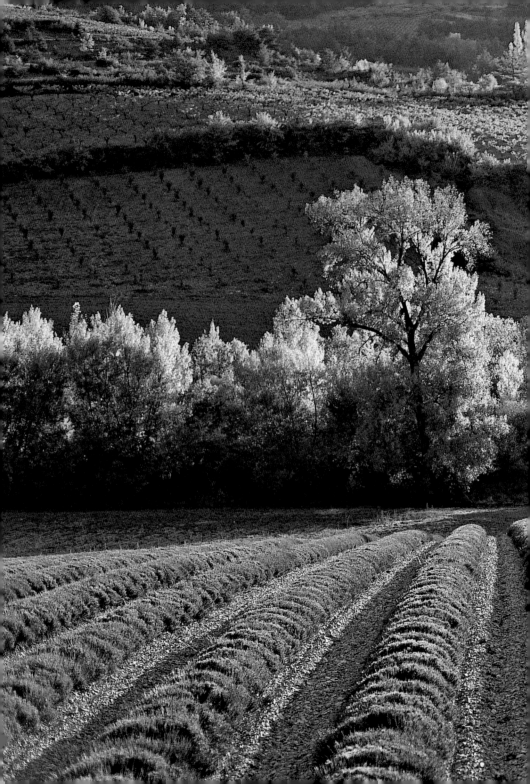

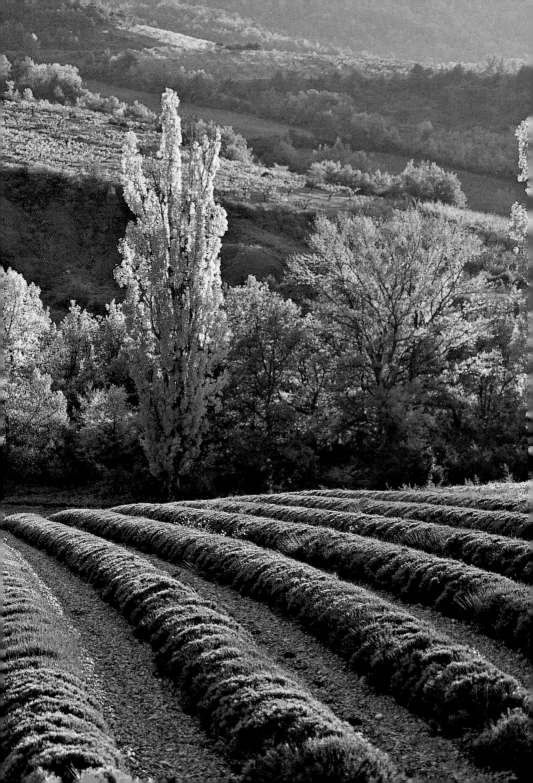

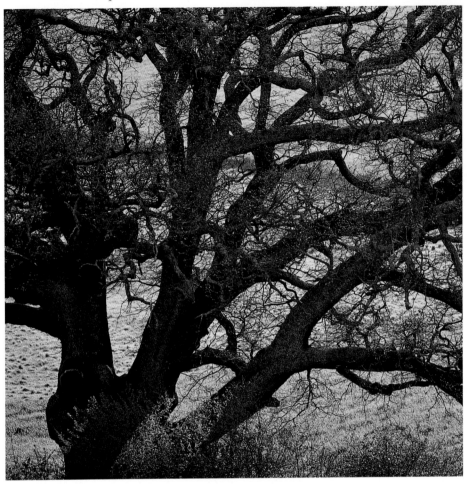

An oak tree in spring on the Vaucluse plateau near Murs.

Lavender and fruit trees
pack the landscape.

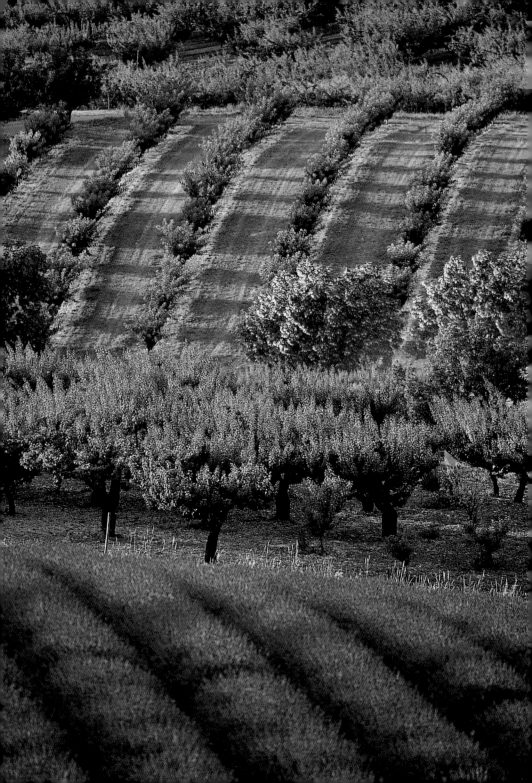

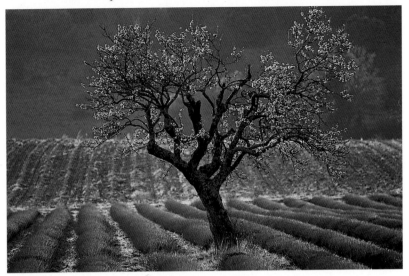

The almond tree is the first to blossom in spring.

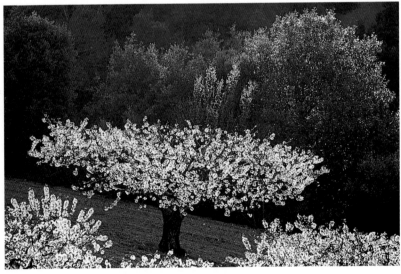

toward mid-April, the cherry trees blossom.

The gossamer blooms of cherry
trees powder the spring landscape.

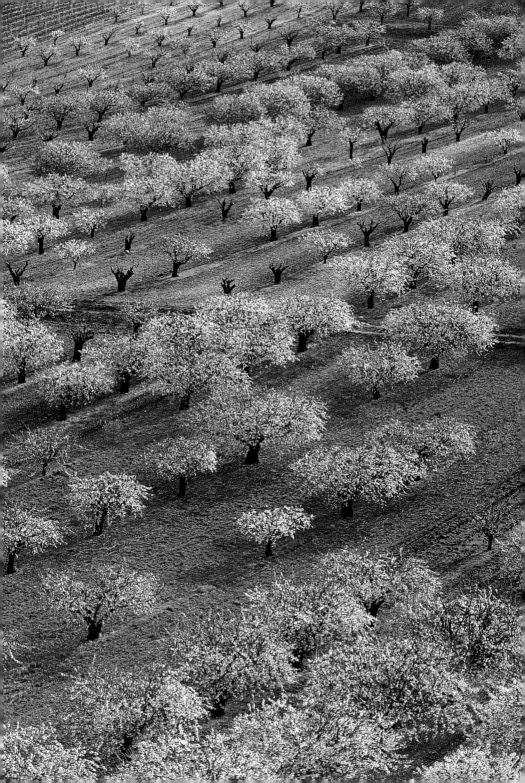

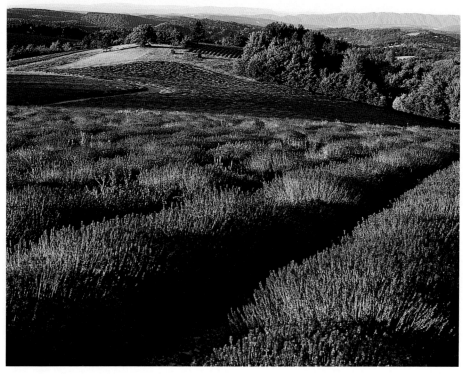

View of the Lure mountain on the Contadour plateau near Manosque.

following double page
A marvelous field of clary sage outside
the village of Banon, near Manosque,
former home to the late Provençal
writer Jean Giono.

The Cistercian monastery of Sénanque,
near Gordes, on the Vaucluse plateau.

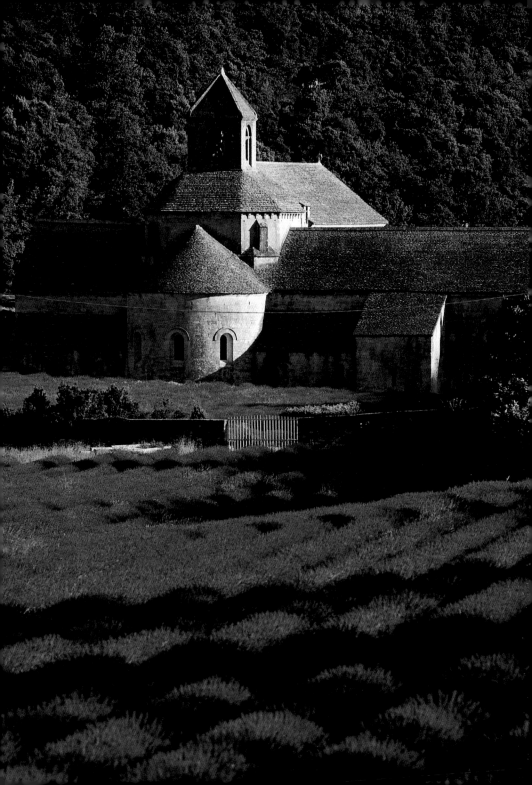

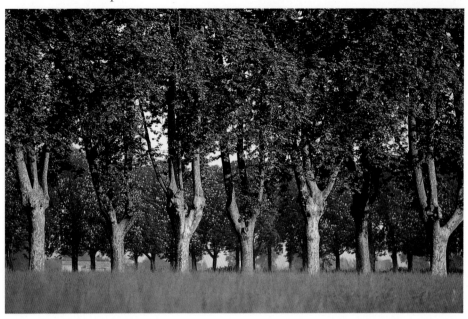

A row of plane trees near Arles.

following double page
A lane of plane trees on
a Côtes du Rhône estate.

Poplar trees at the foot of
Les Alpilles near Maussane.

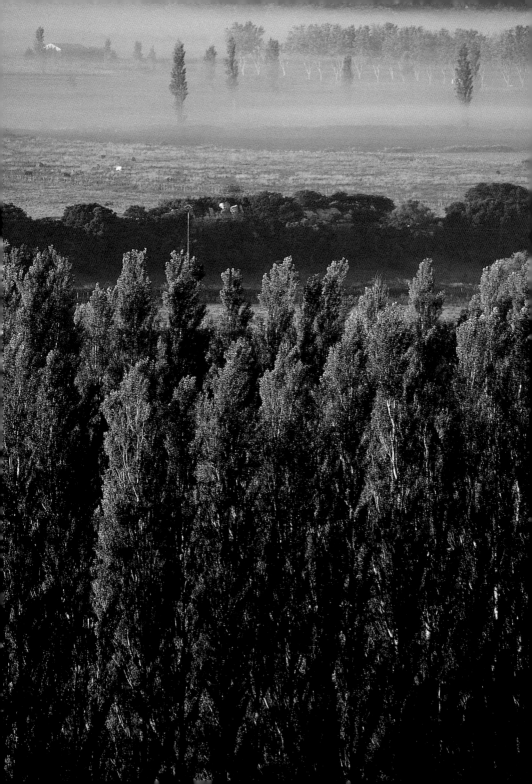

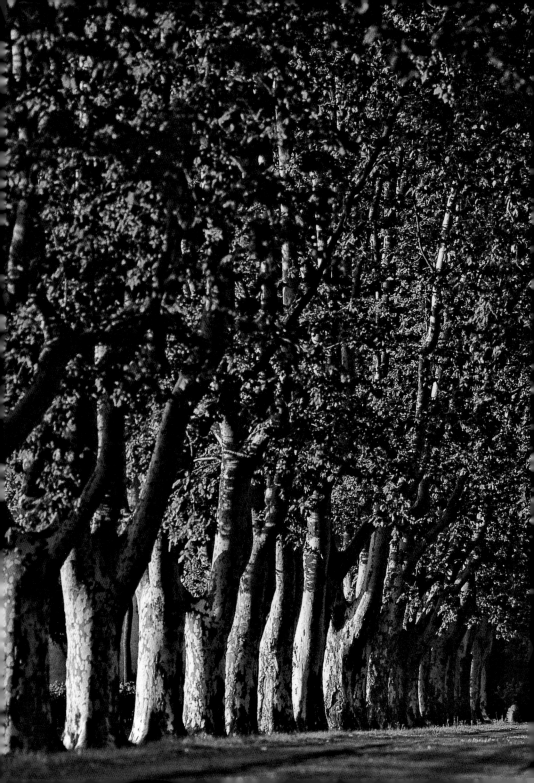

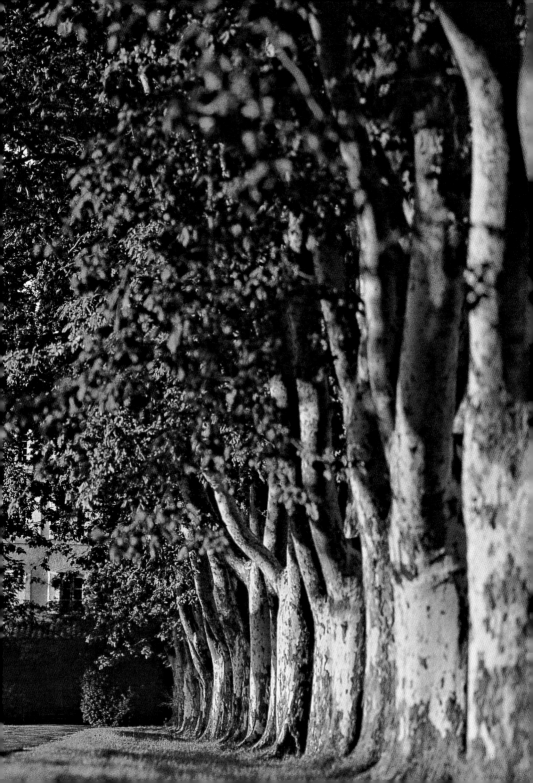

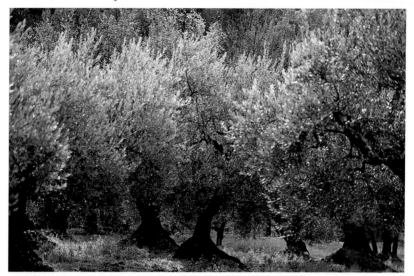

Olive trees in Nyons, Drôme.

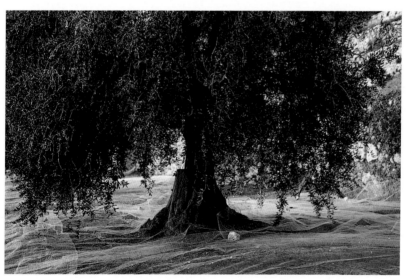

On the ground, nets gather the olive harvest in the hills above Vence.

Hundred-year-old olive trees growing
wild in the scrubland of Provence.

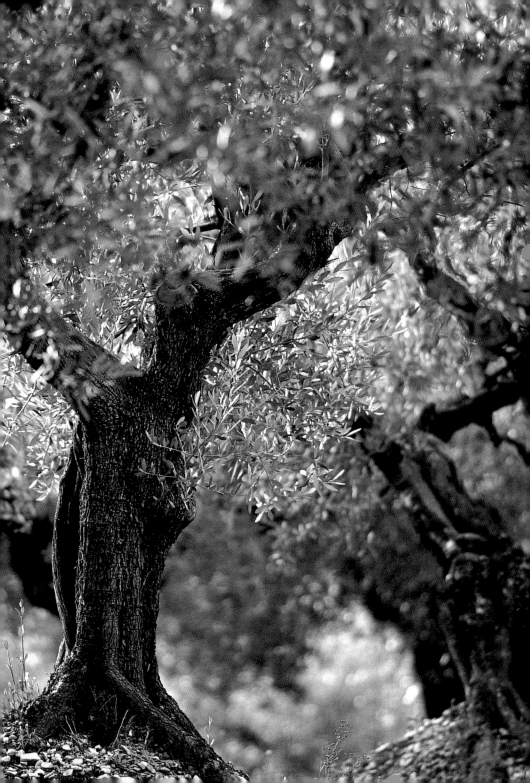

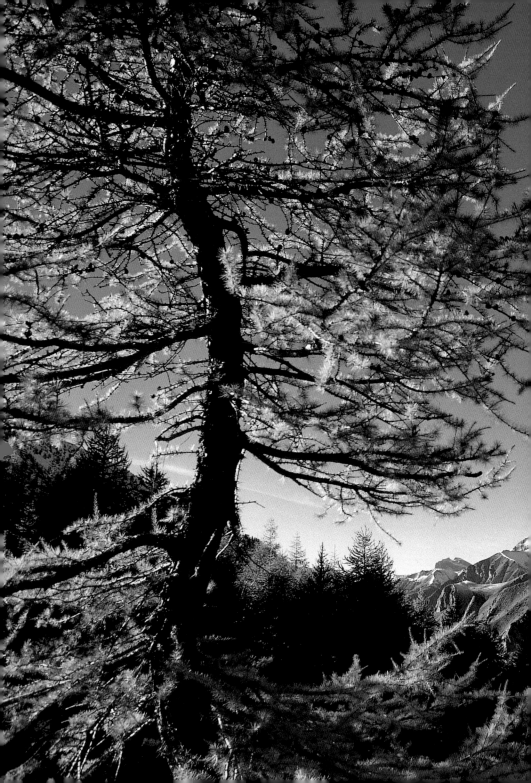

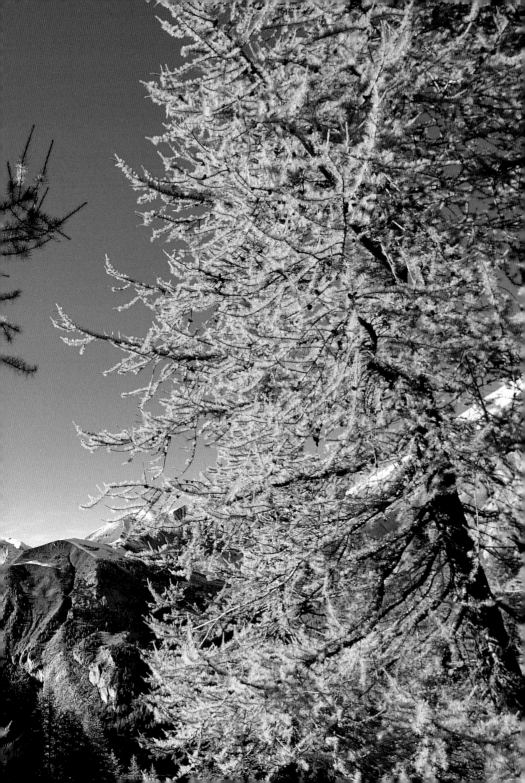

Landscapes

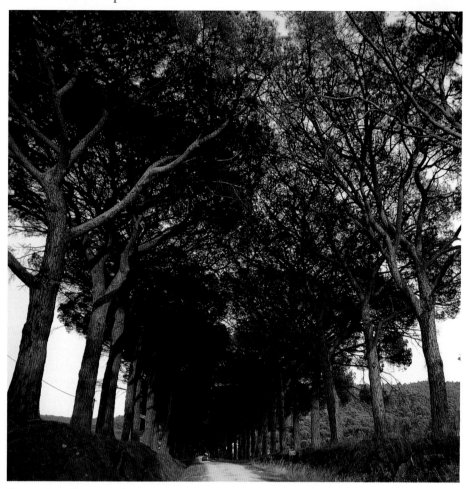

Stone pines line a road on a vineyard near Hyères in the Var.

preceding double page
Near the Val d'Allos, in the valley of Verdon,
the larch forests turn to gold beneath the autumn sun.

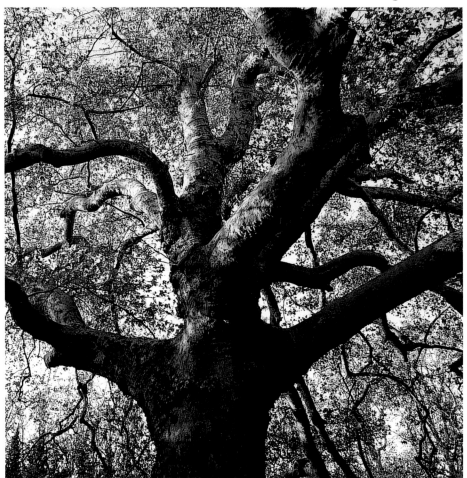

Europe's largest plane tree in Lamanon in Les Alpilles.

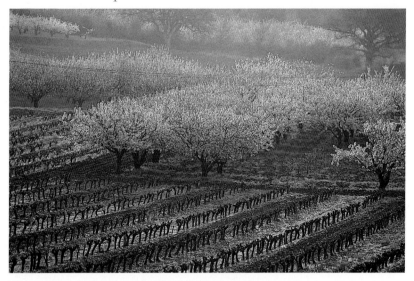

Vineyards and cherry trees, valuable local assets,
back to back in the Lubéron.

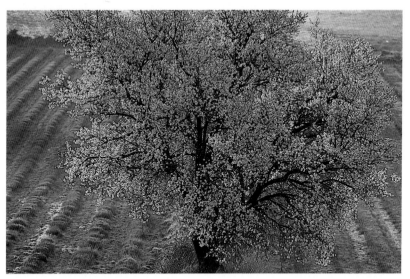

An almond tree in bloom on the Sault plateau.

The countryside around Apt
abounds with cherry trees.

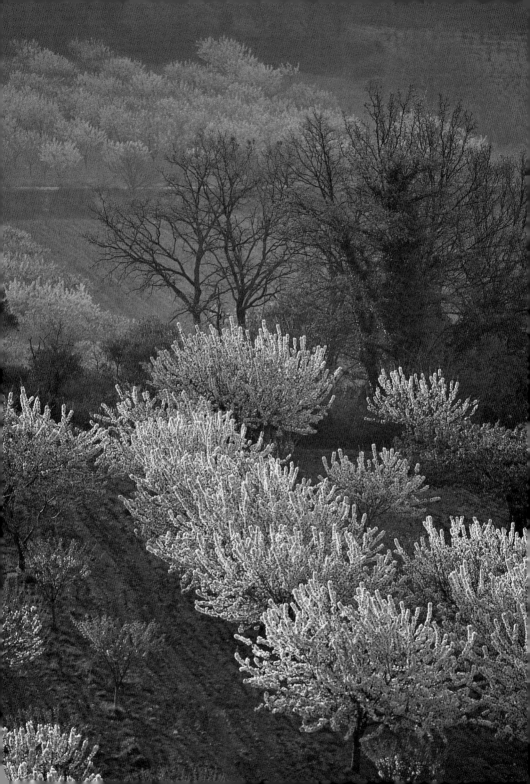

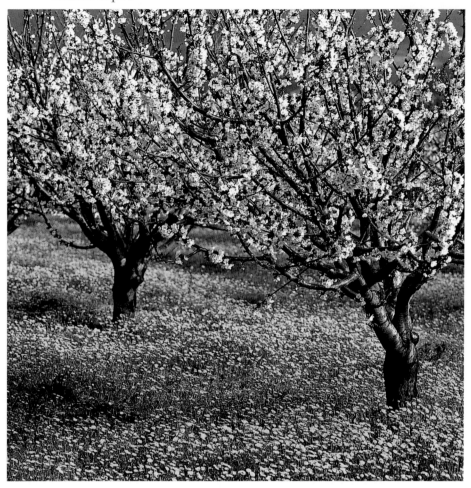

Spring in the Lubéron and the delicate beauty of cherry trees in blossom.

following double page
The Lubéron's own "Giant's Causeway" in Roussillon.

A field of sunflowers at the foot of the Montagne Sainte-Victoire.

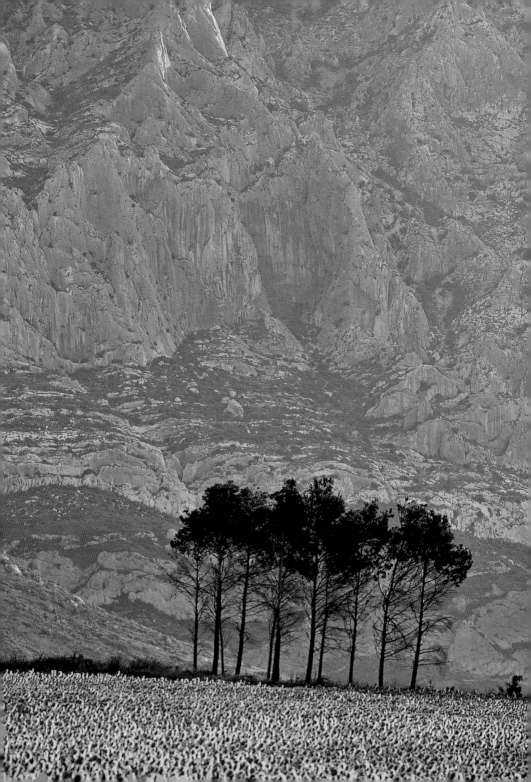

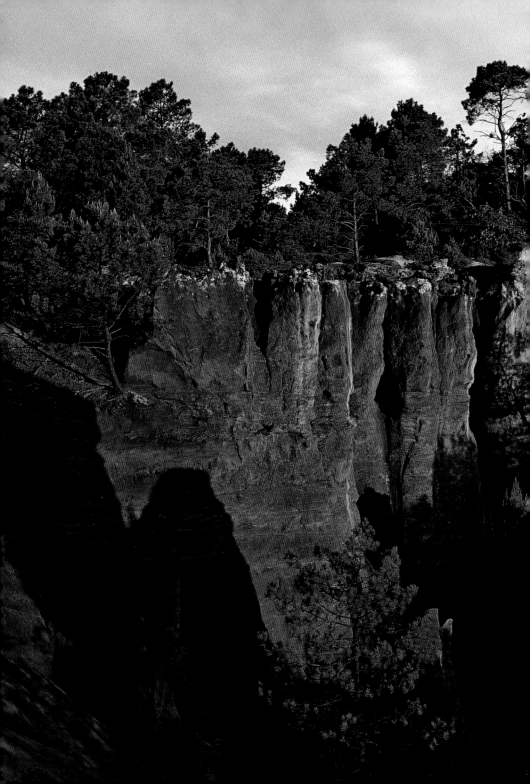

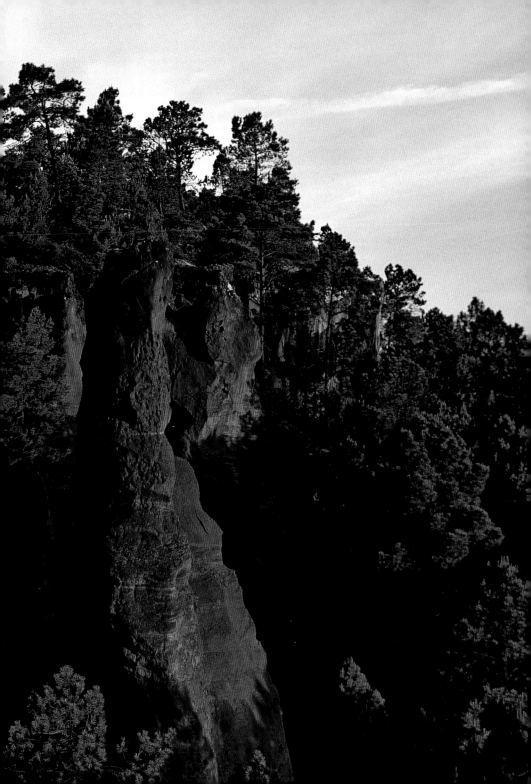

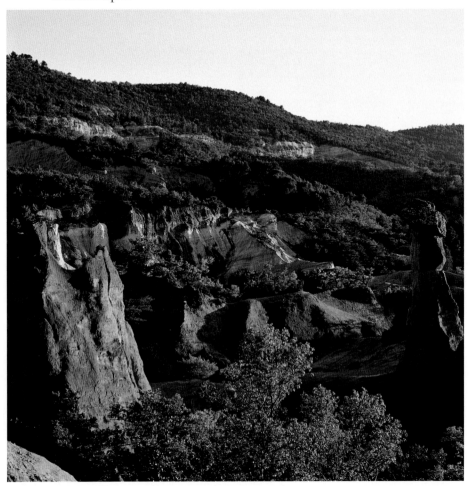

The peculiar formations and amazing ocher shades
of the Colorado de Rustrel in the Lubéron.

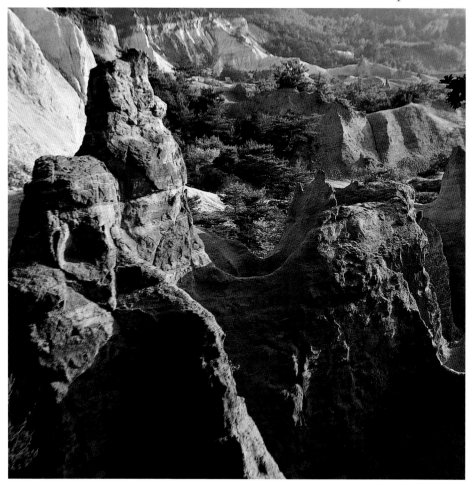

The natural palette of the ocher sands in the countryside around Apt is infinite.

following double page
The Colorado de Rustrel in the Lubéron,
fashioned by time and erosion.

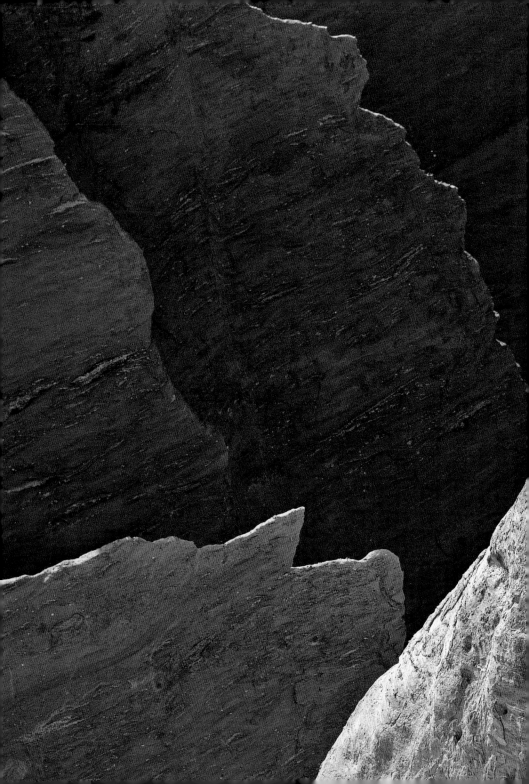

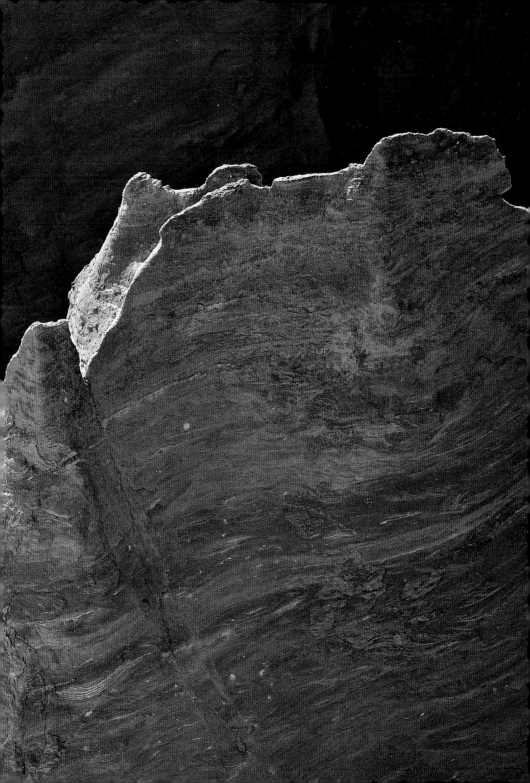

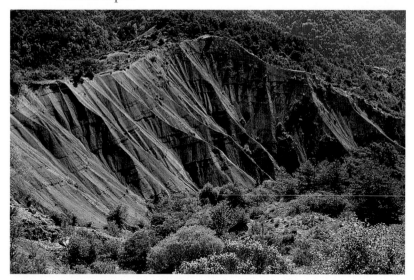

Erosion near Rémuzat in the Provençal Drôme.

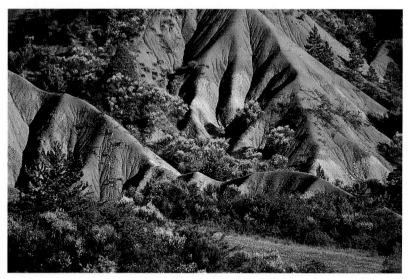

Broom in flower around Nyons.

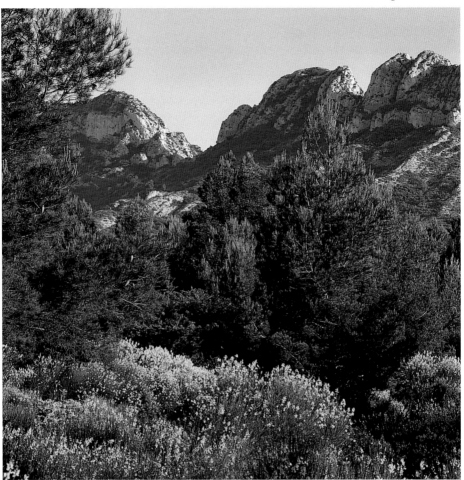

Les Alpilles in the spring—the countryside around Eygalières.

Landscapes

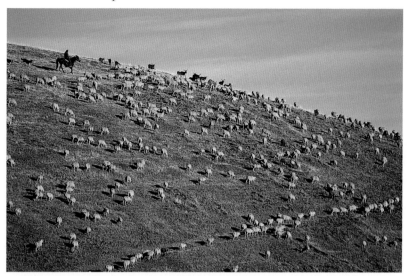

A long crest of pastureland on the Col d'Allos.

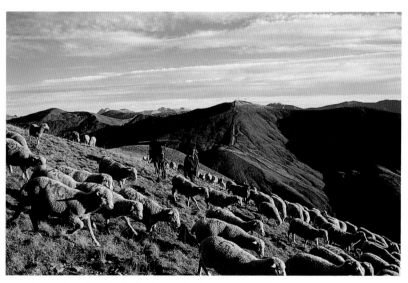

Shepherds leading their flocks to the high mountain pasture
of the Alpes de Haute-Provence for the summer.

To the south of Barcelonnette,
the Col d'Allos is 7,400 feet (2,240 m) high.

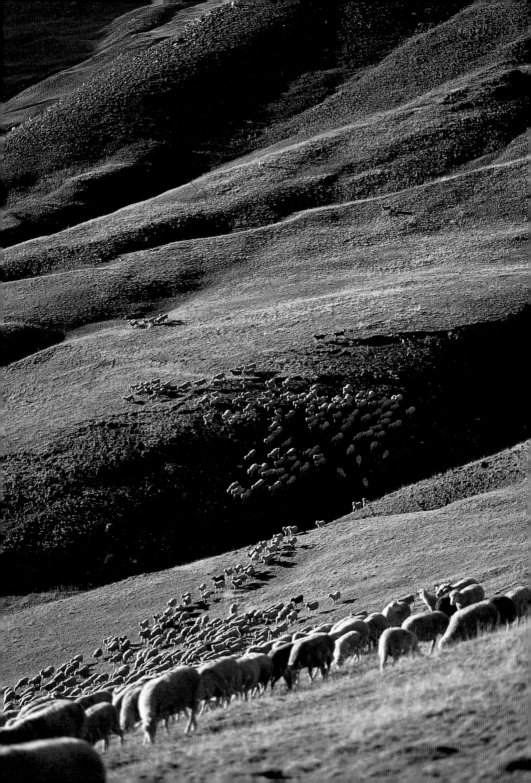

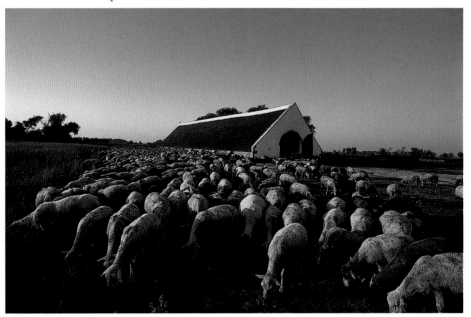

Sheep and sheepfold in the Camargue.

The shingle steppe of the Crau plateau which
stretches from the Camargue to the Berre lake.

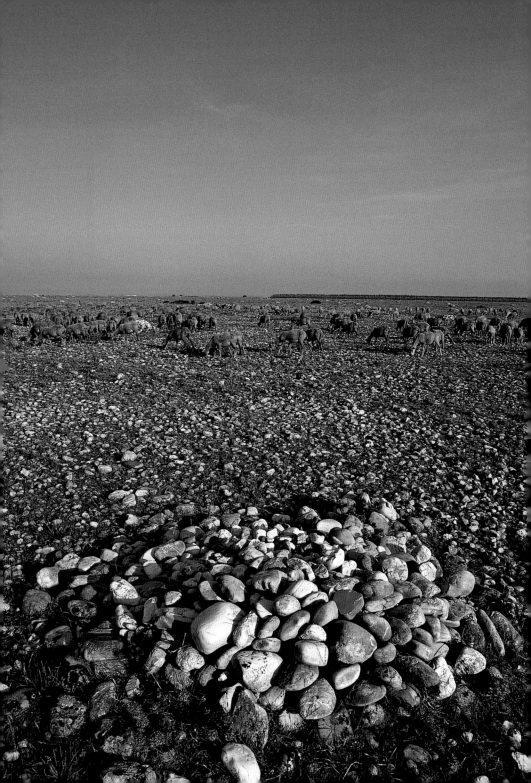

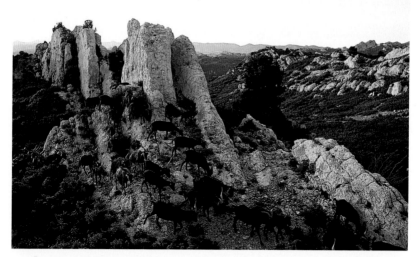

A herd of goats in Les Alpilles.

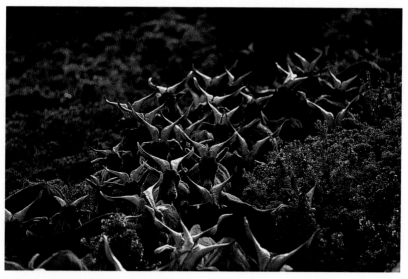

Rove goats and their unusual horns.

Erosion near the village of
Saint-Benoît in the Var valley.

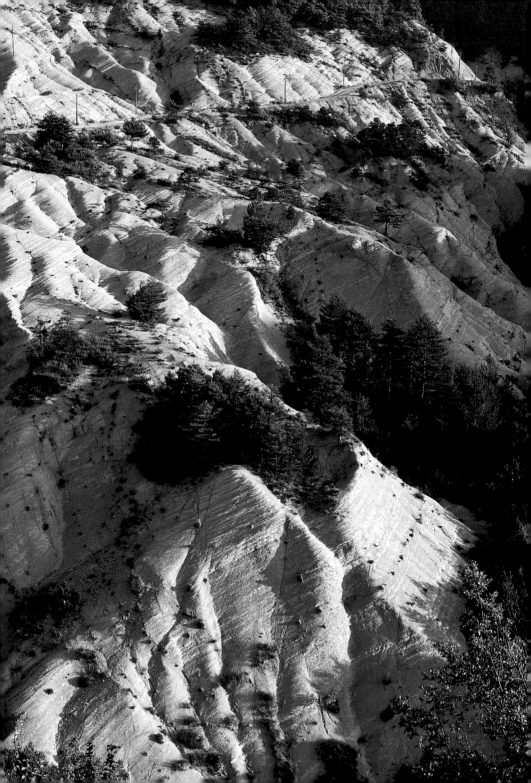

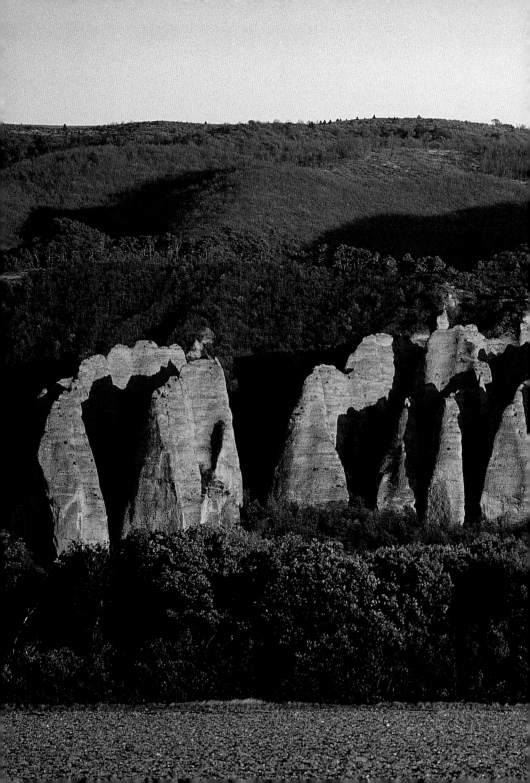

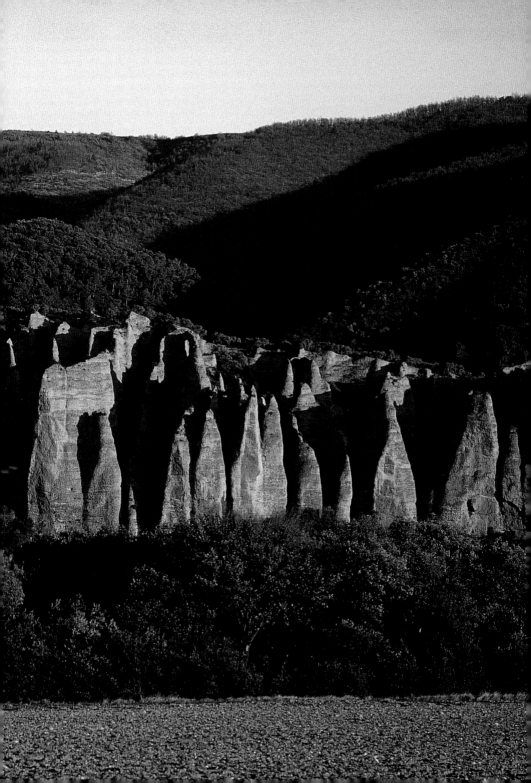

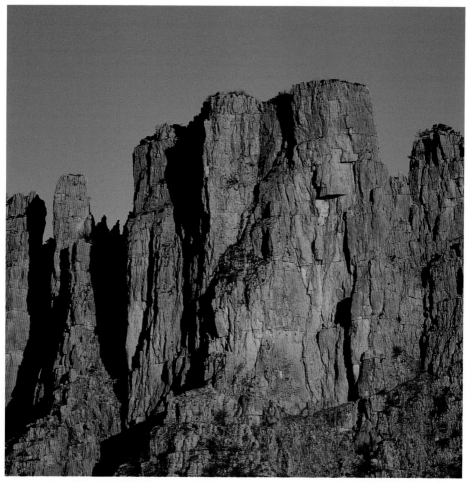

Cadières de Brandis in the Verdon valley.

preceding double page
The Rochers des Mées,
in the Durance valley, known as
Les Pénitents (the Penitents).

The Sainte-Beaume massif
near Marseille and the
Grotte Sacrée (the Holy Cave).

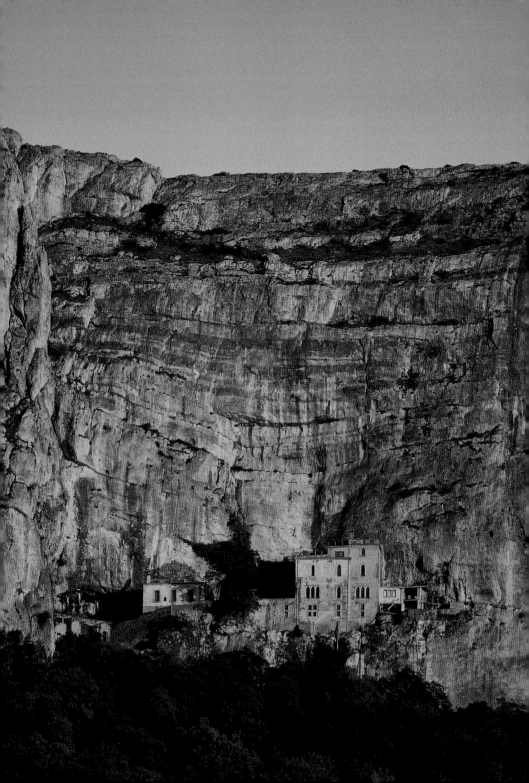

Landscapes

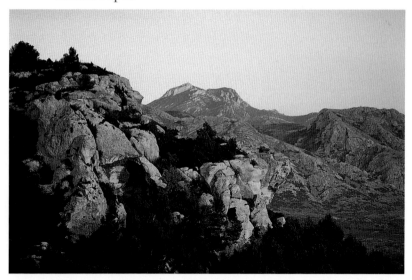

View from the Val d'Enfer in Les Alpilles with the Mont des Opies
in the background; the summit of the range is 1,600 feet (492 m) high.

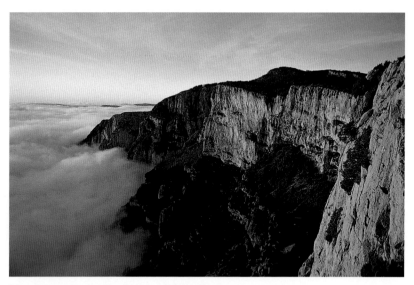

The ridge pass in the Gorges du Verdon.

following double page
The gigantic Cadières de Brandis rocks
overlook the Clue de Saint-Jean
in the Verdon valley.

The steep Calanques de Cassis
inlets with the Cap Canaille
promontory in the background.

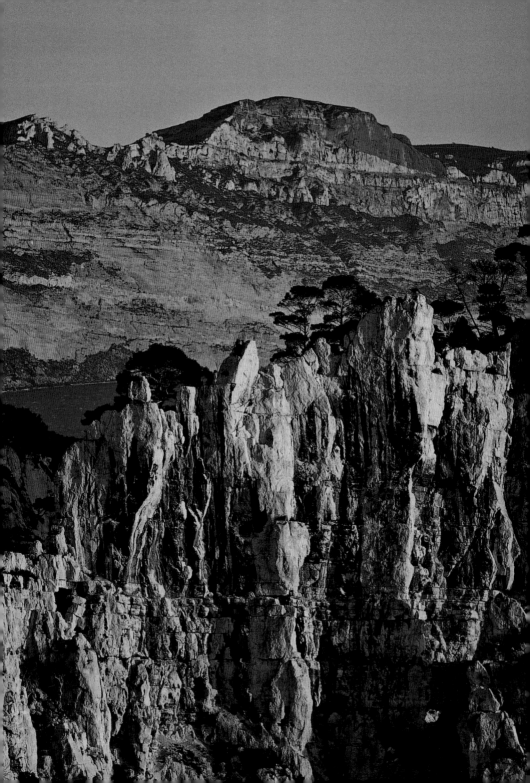

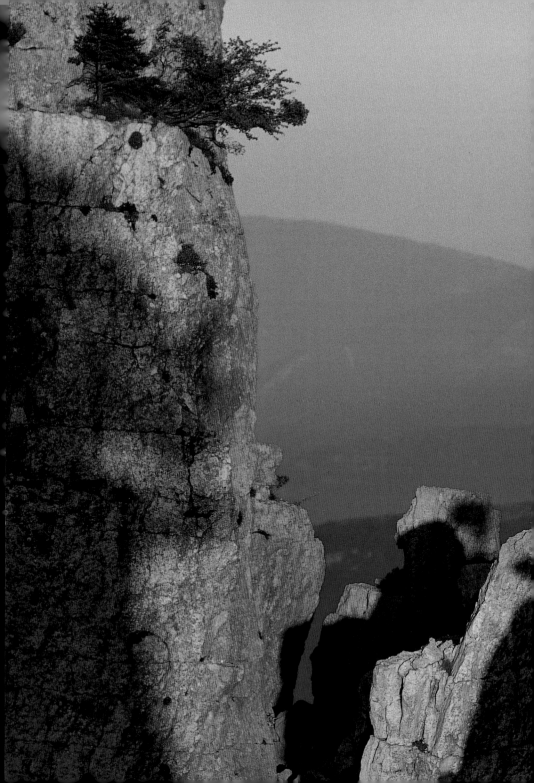

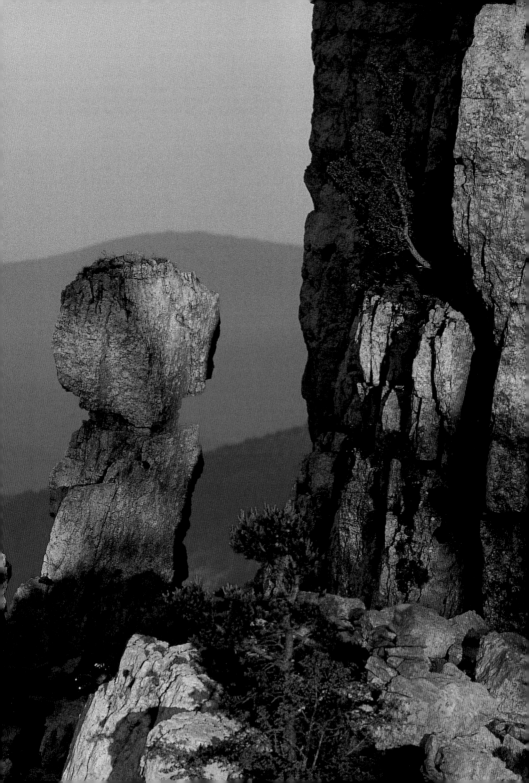

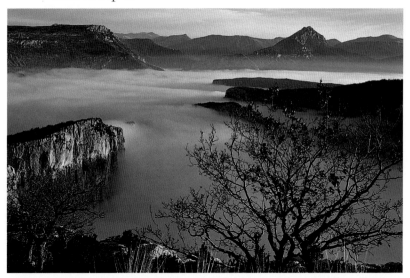

A sea of clouds conceals the cliffs of Verdon's own Grand Canyon.

As they reach the end of their journey, not far from Lake Sainte-Croix, the waters of the Verdon river are becalmed.

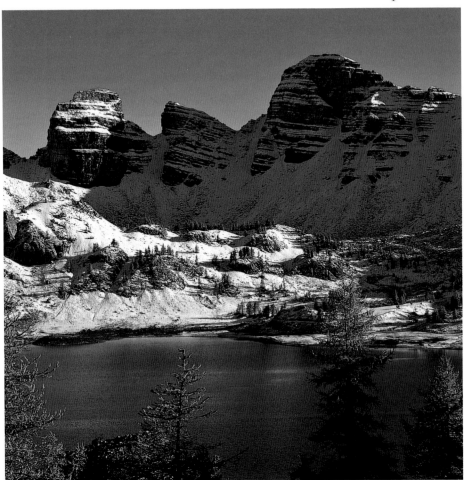

The Lac d'Allos at 7,300 feet (2,225 m) altitude
is cloaked in white during the long winter months.

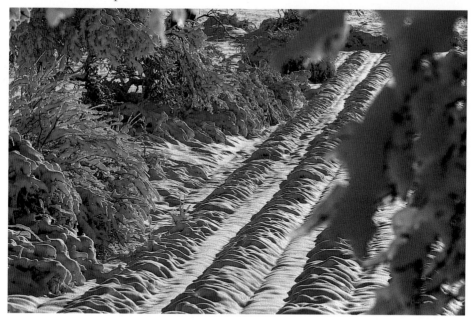

Furrows of lavender beneath a mantle of snow,
rare in this region of Provence.

Sault plateau lavender beneath the snow.

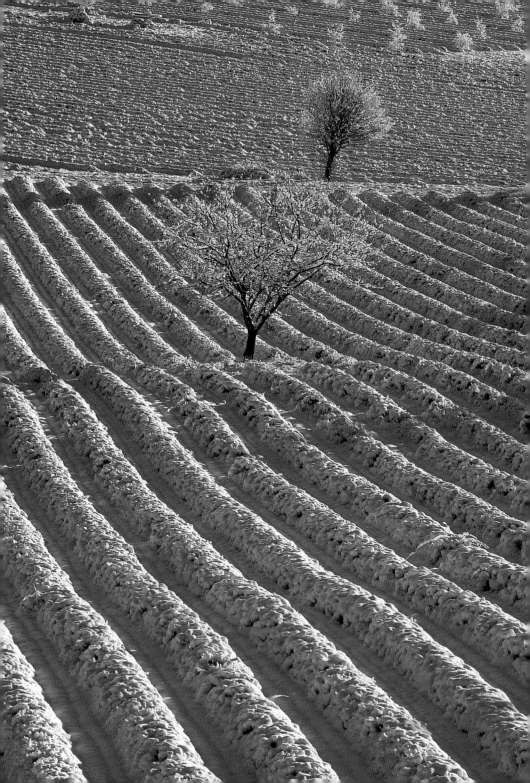

Landscapes

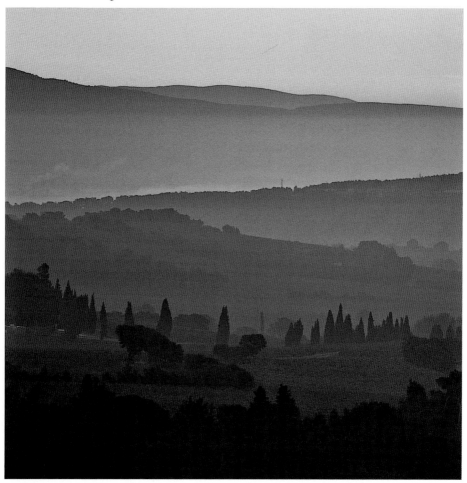

Landscape at dawn not far from Châteauneuf-du-Pape.

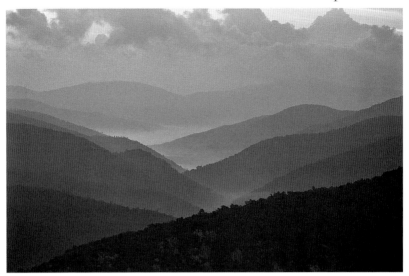

Morning mist on the forest-clad hills of the Maures massif,
which stretches from Hyères to Fréjus in the Var.

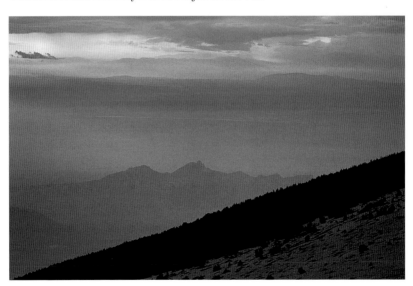

The Dentelles de Montmirail to the south of Vaison-la-Romaine,
viewed from Mount Ventoux.

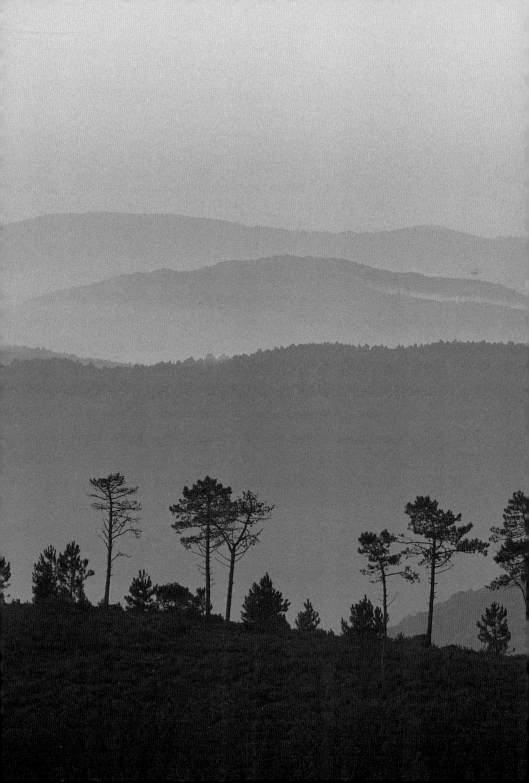

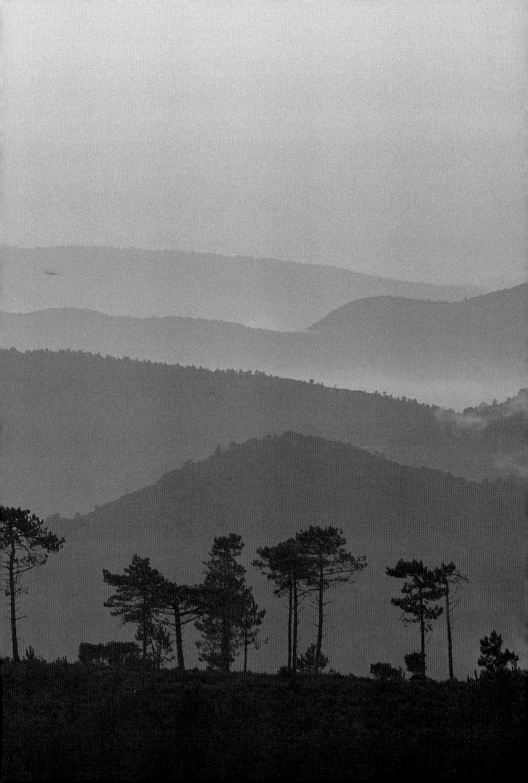

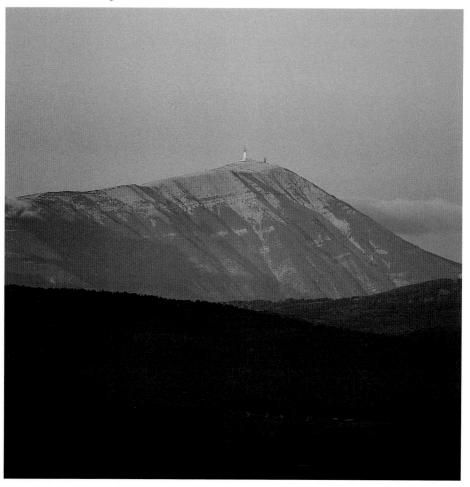

Mount Ventoux viewed from the Lure mountain.

preceding double page
The ridge pass across
the Maures massif.

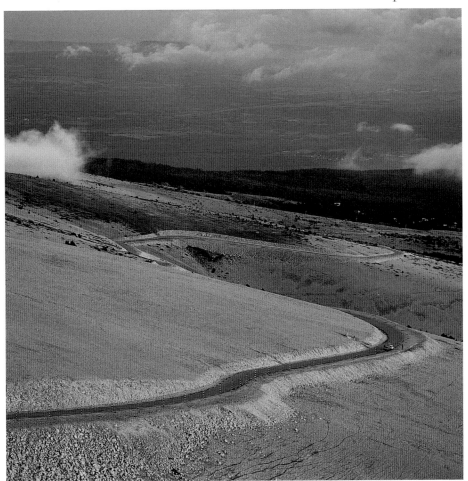

The lunar landscape of the limestone dome of the Ventoux summit.

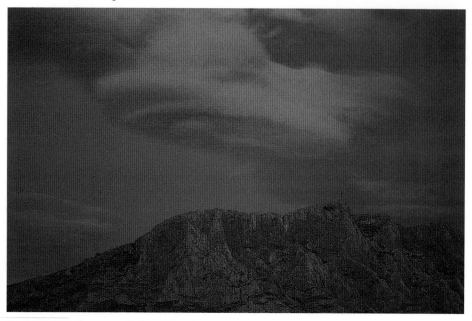

Sunset over Montagne Sainte-Victoire.

following double page
The imposing mass of Montagne Sainte-Victoire
inspired Cézanne who depicted
it in dozens of paintings.

The Croix de Provence
on Montagne Sainte-Victoire
near Aix-en-Provence.

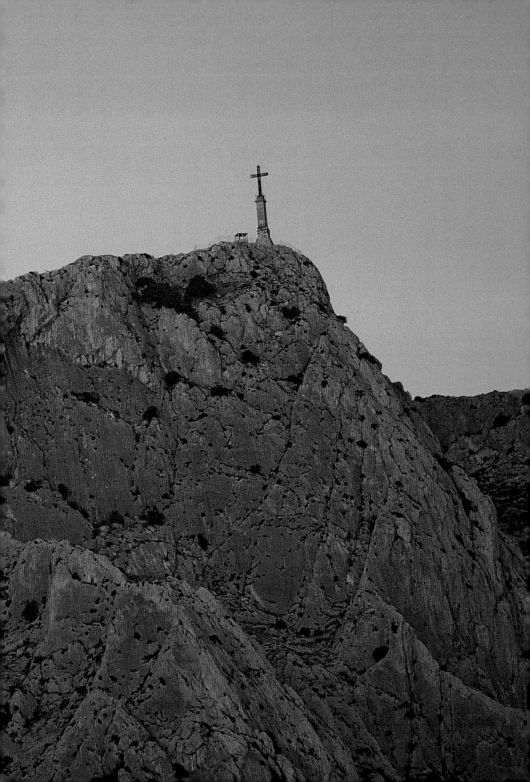

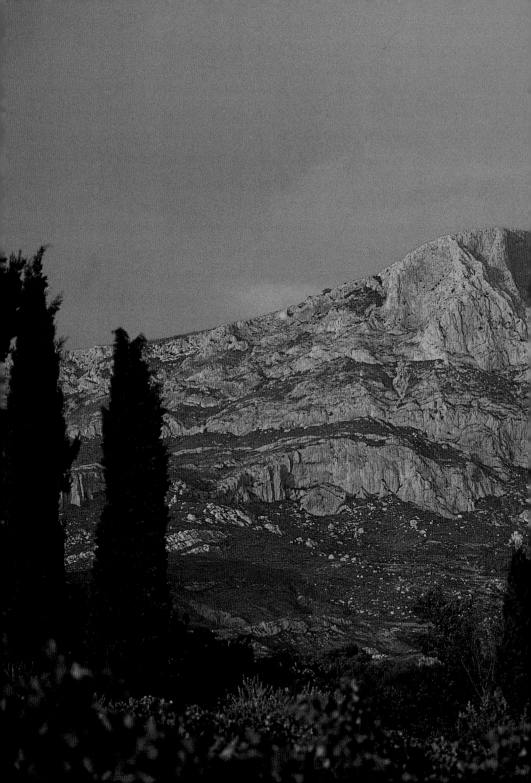

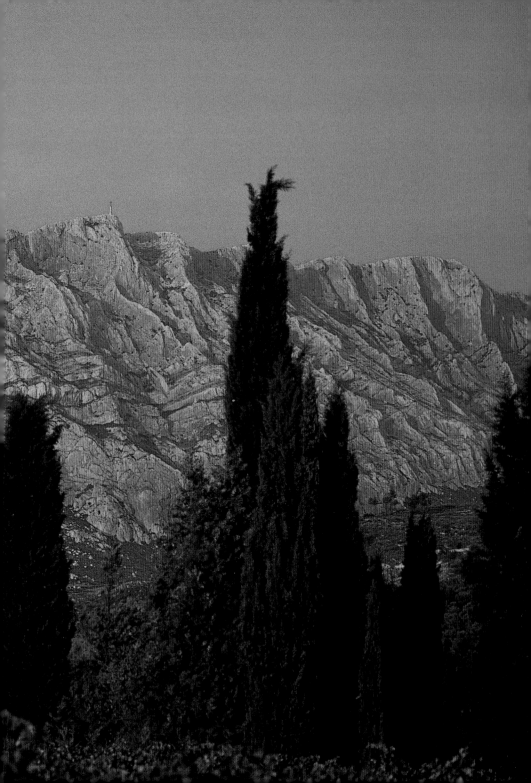

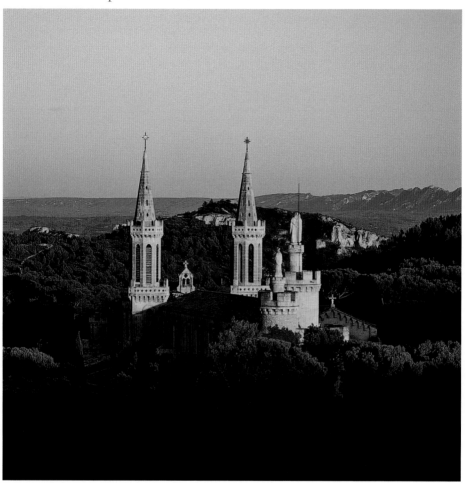

The church and abbey of Saint-Michel-de-Frigolet in the Montagnette hills,
between Tarascon and Avignon.

The striking church in Pierrelongue,
a small village near Vaison-la-Romaine.

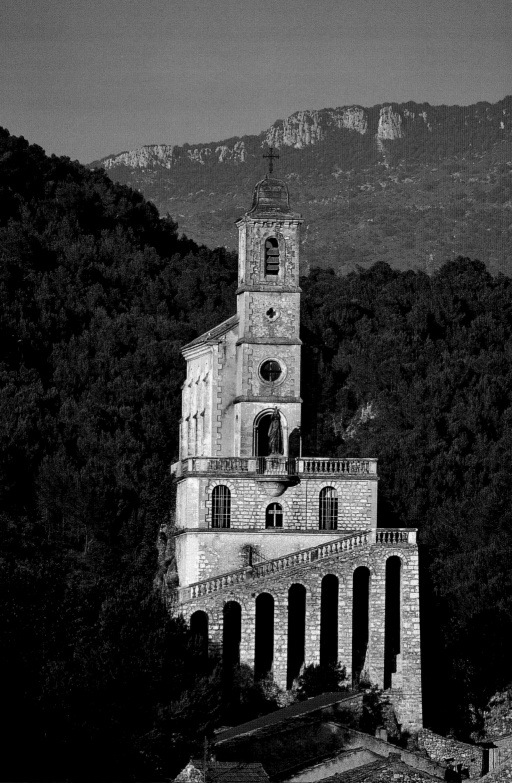

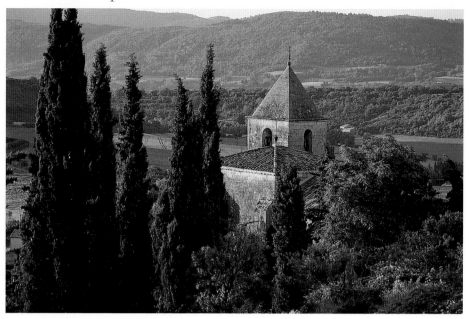

The Saint-Michel-l'Observatoire chapel, Forcalquier,
surrounded by cypress trees.

Montmajour abbey near Arles, is built on a hill
surrounded by pine trees. The beauty of the
site matches the splendor of its architecture.

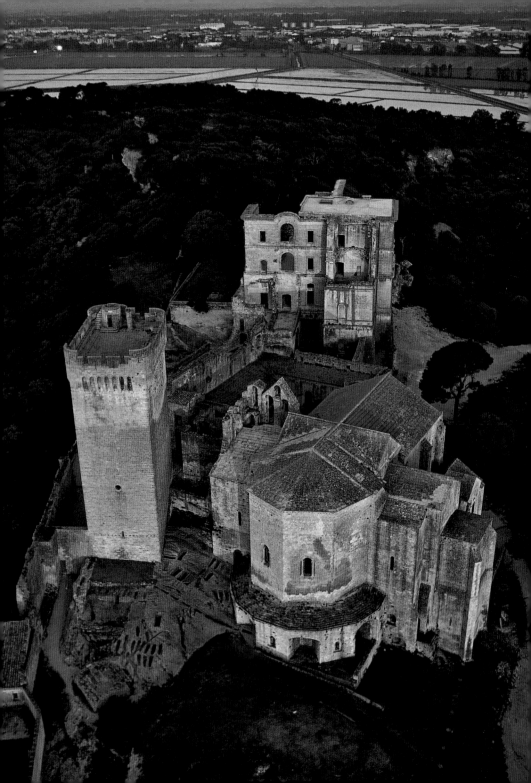

The Saint-Pierre chapel, Forcalquier.

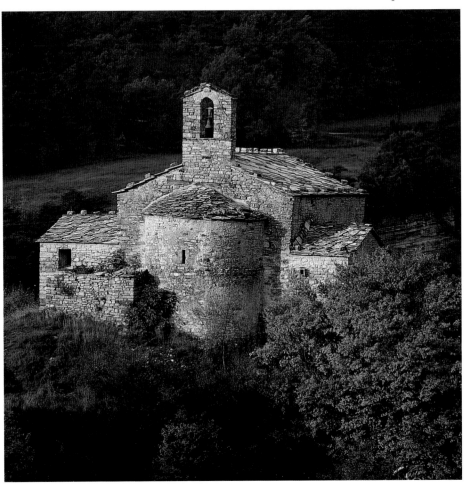

The Romanesque chapel of Revest-du-Bion, in the Forcalquier area.

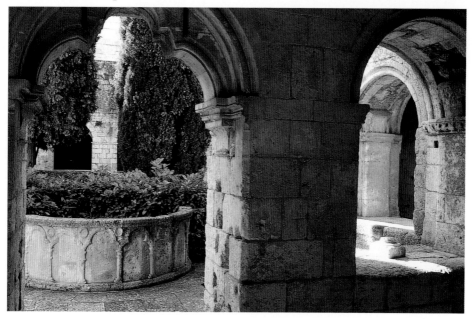

The cloister of the Cistercian abbey of Sivacane on the left bank of the Durance.

The cloister of the Cistercian abbey of Thoronet,
well hidden in a wooded valley of the Var.

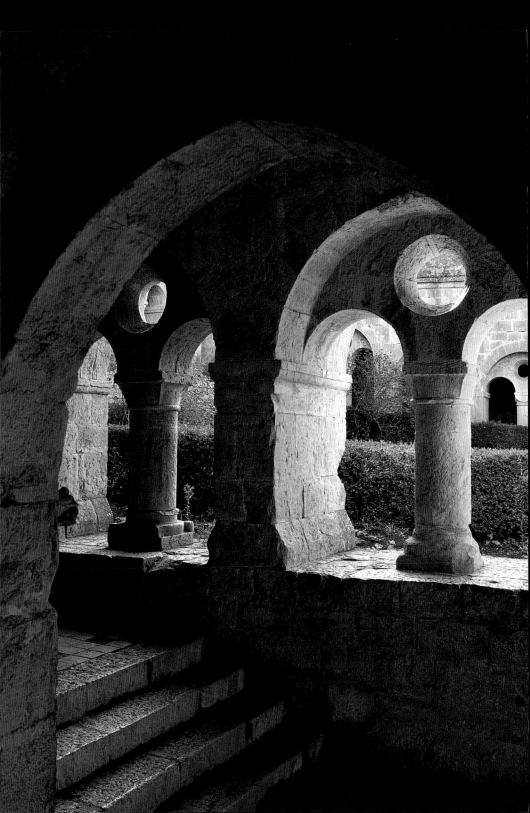

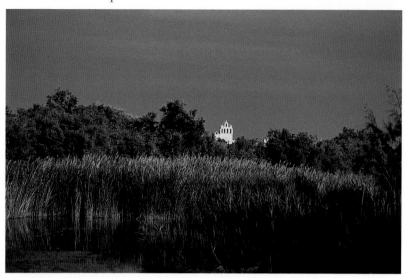

The bell tower of the fortified church of Saintes-Maries-de-la-Mer.

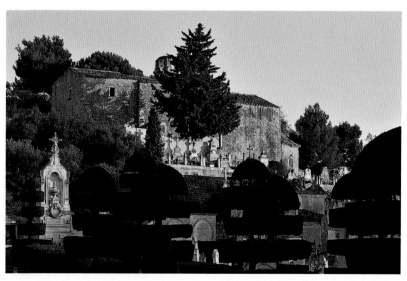

The topiary surrounding the Romanesque chapel of the Eyguières cemetery, between Crau and Les Alpilles.

following double page
Vineyard near Bonnieux
in the Lubéron.

The Romanesque priory of Saint-Symphorien
with its bell tower reaching above
the treetops in the Combe de Lourmarin.

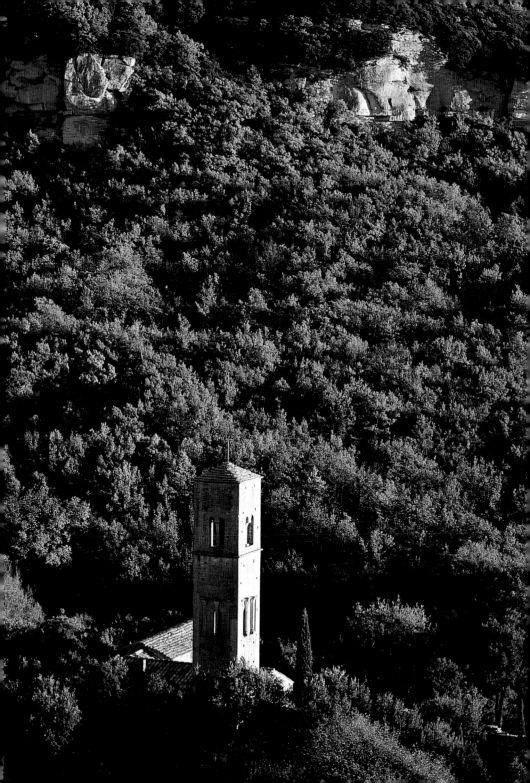

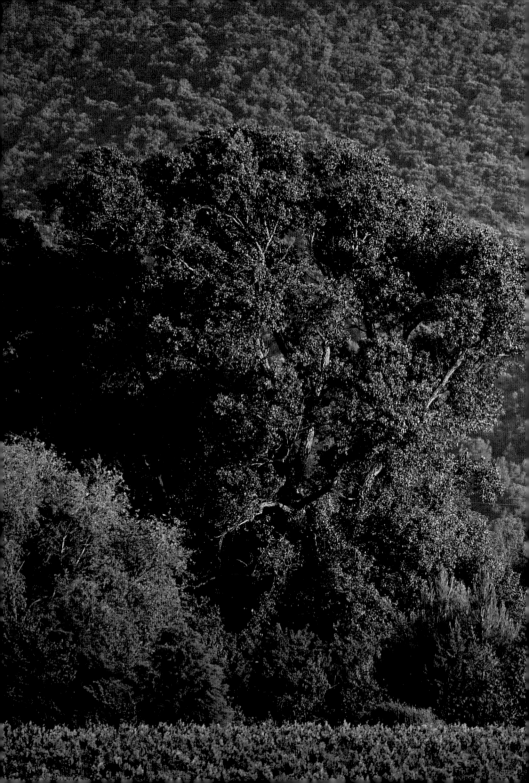

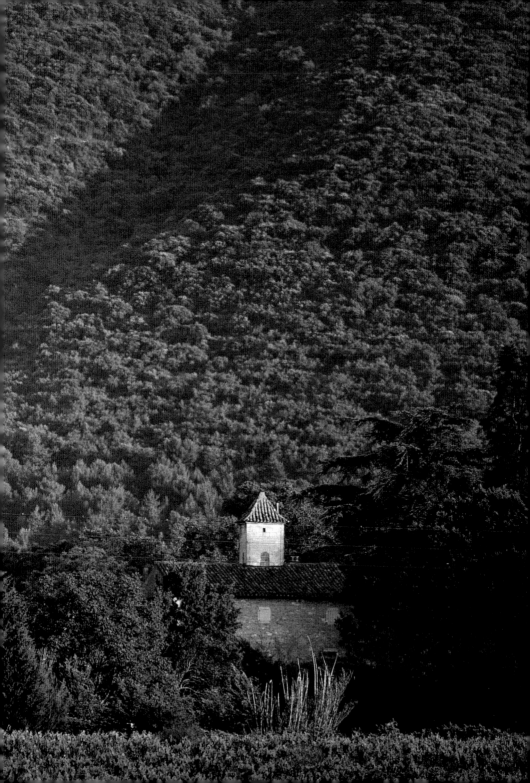

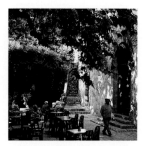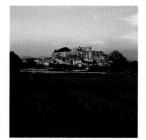

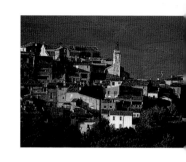

Towns and Villages

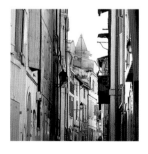

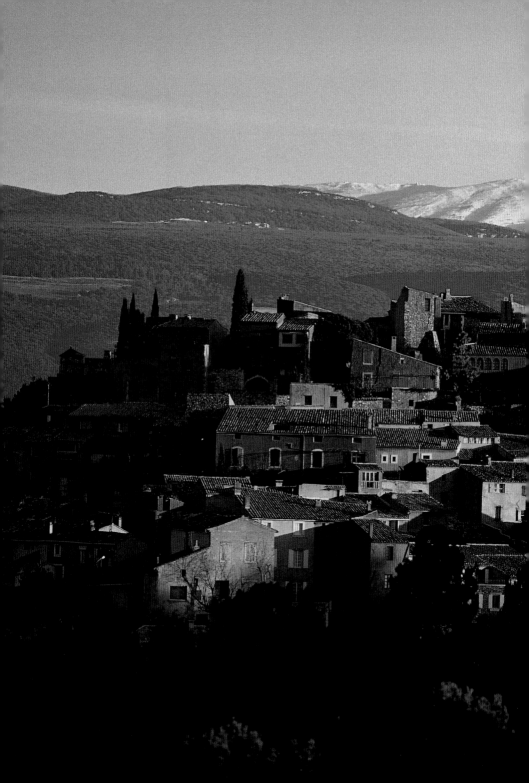

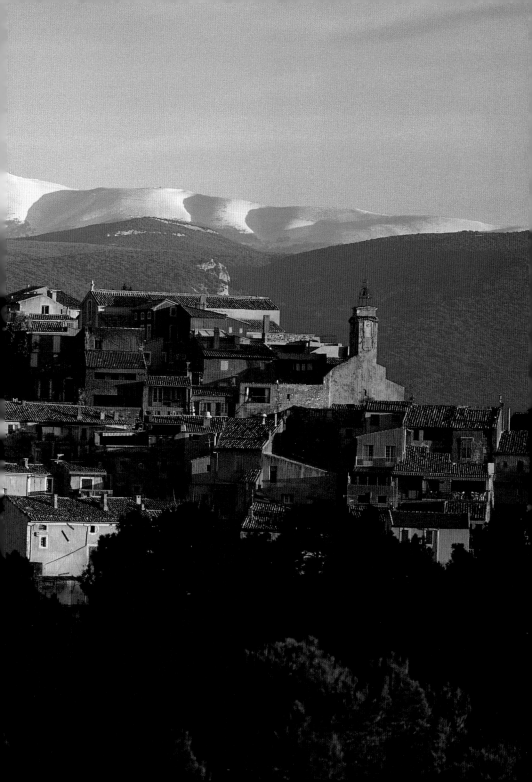

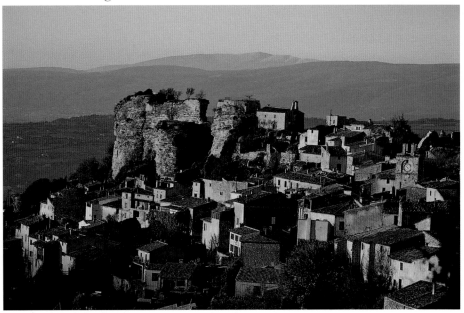

The village of Saignon above the town of Apt in the Lubéron.

preceding double page
The village of Roussillon with
Mount Ventoux in the background.

Murs, a hillside village
of the Vaucluse plateau, near
the renowned Sénanque abbey.

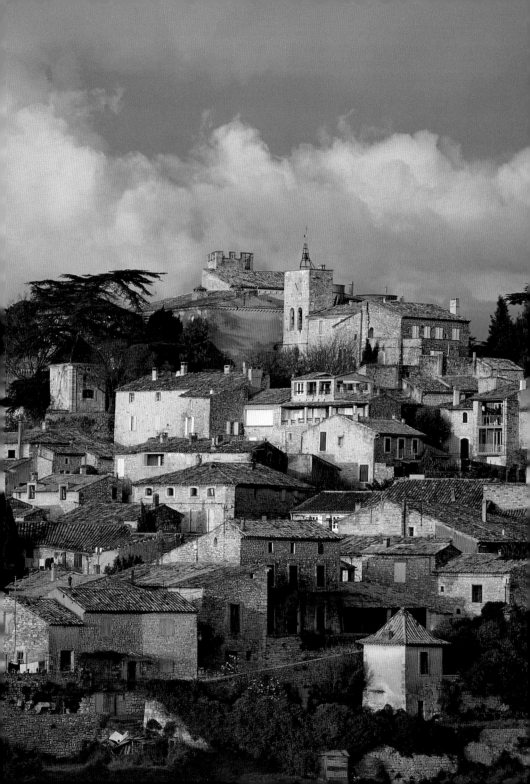

Towns and Villages

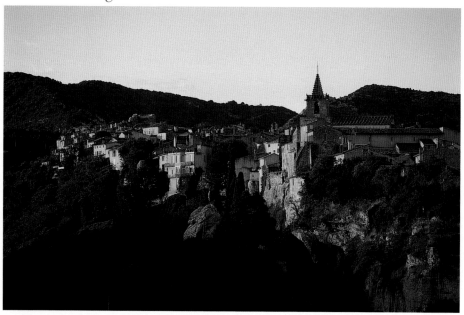

Venasque, one of the most beautiful villages in France, which gave its name to the former county of Comtat Venaissin, situated between the Rhône, the Durance, and Mont Ventoux.

following double page
The beautiful sixteenth- and seventeenth-century dwellings in Ménerbes have been perfectly restored.

The village of Oppède-le-Vieux on the north side of the Lubéron.

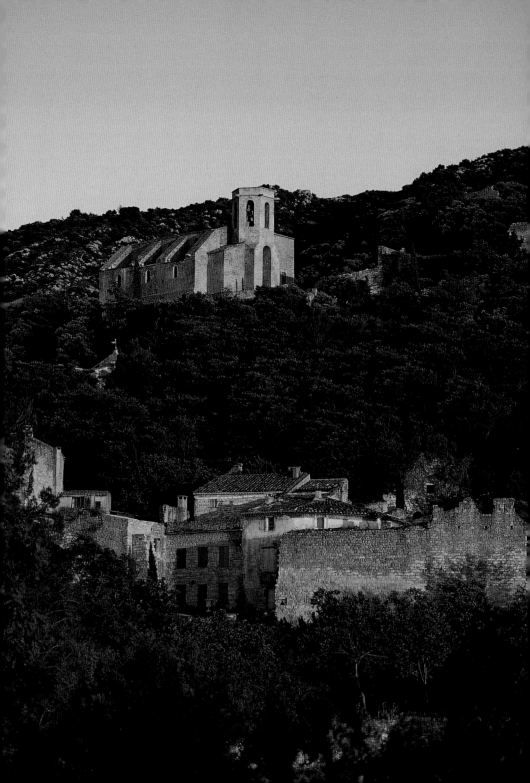

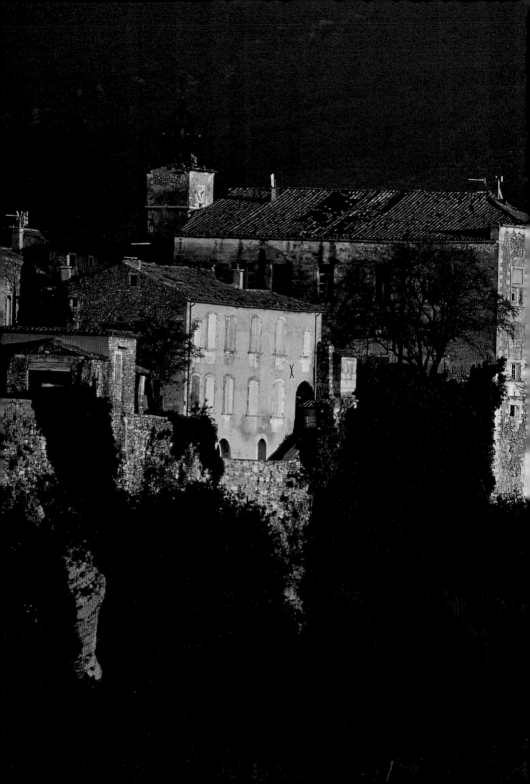

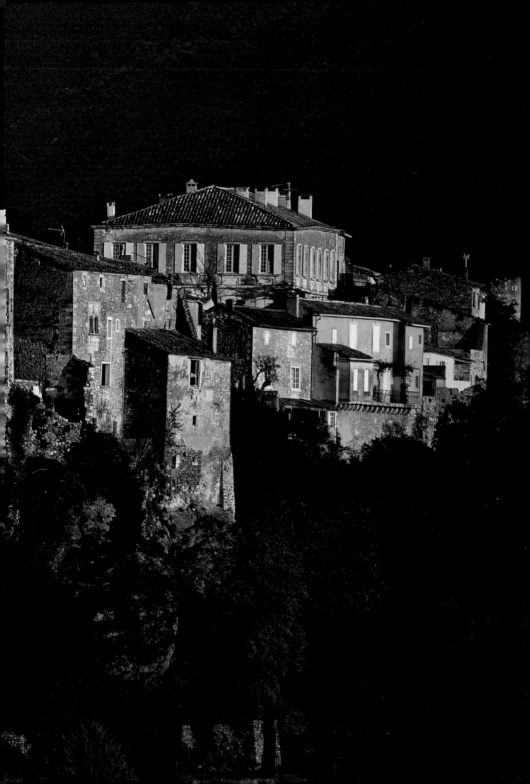

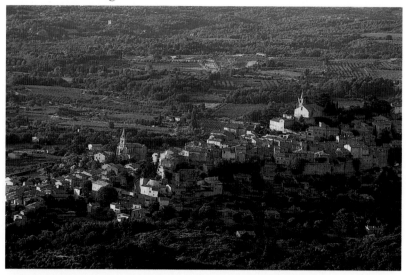

In the Lubéron, the village of Bonnieux and its two churches.

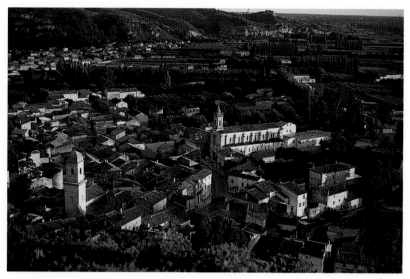

The village of Boulbon in the Montagnette hills.

Bonnieux, a low-lying town,
with its nineteenth-century church.

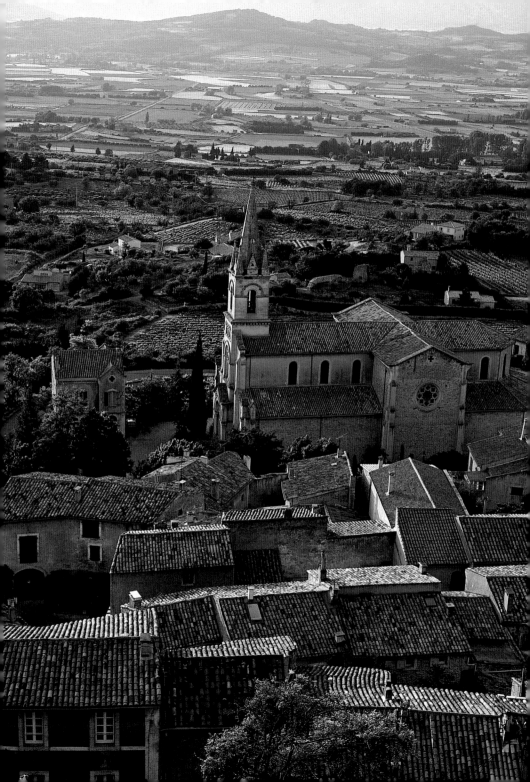

The village of Lacoste with its prominent château, where the Marquis de Sade once lived.

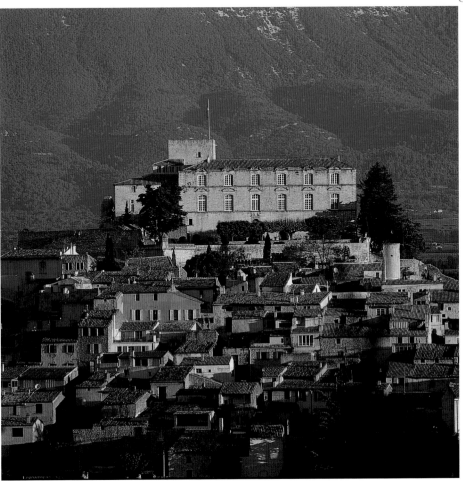

The Château d'Ansouis belonging to the great Provençal family the Sabran-Pontevès.

following double page
On the Vaucluse plateau, facing the Lubéron,
the village of Gordes, with its Renaissance château.

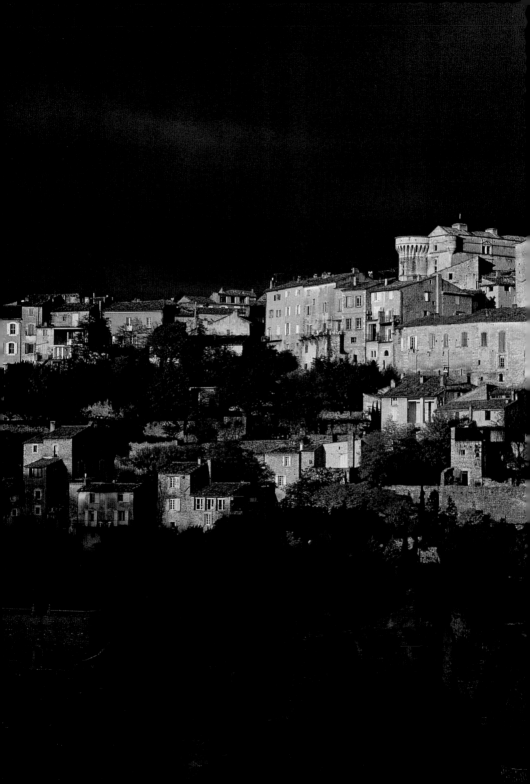

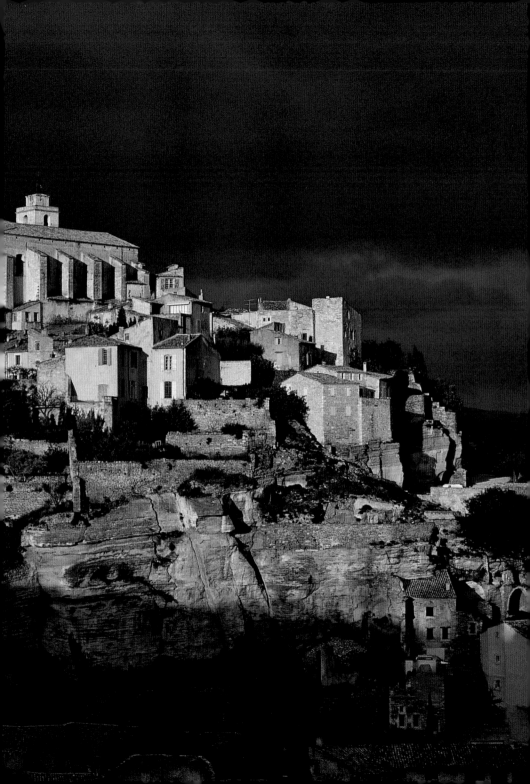

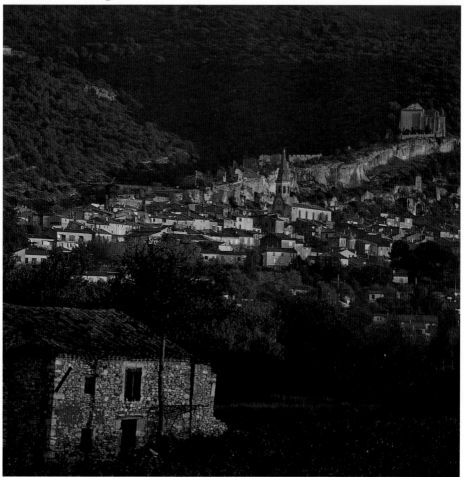

The village of Saint-Saturnin-lès-Apt
built into the foothills of the Vaucluse plateau.

Sainte-Anne Cathedral in
Apt overlooks the Lubéron town
with its famous Sunday market.

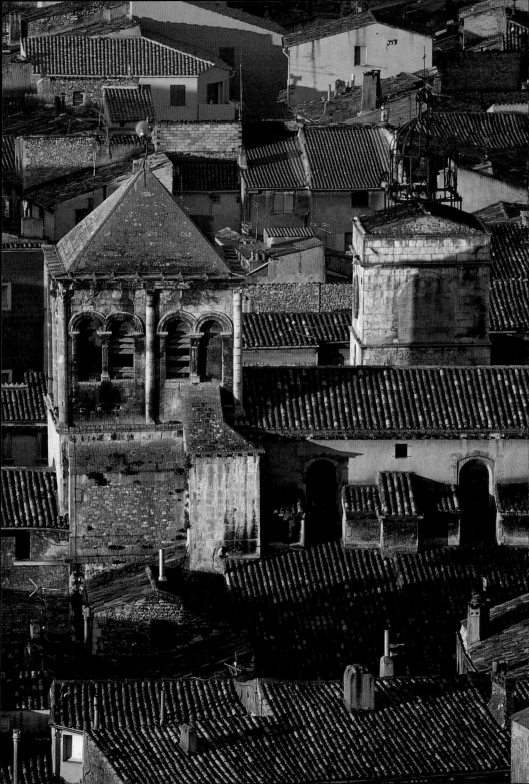

Towns and Villages

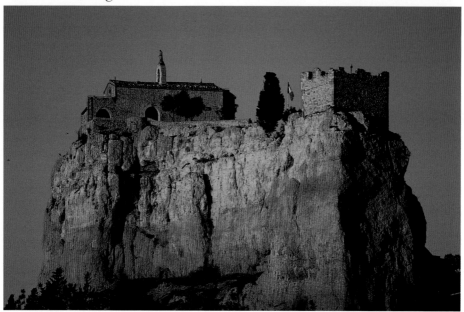

Near Marseille, the red Vitrolles rock and its Notre-Dame-de-Vie chapel,
which commands a view of the Berre lake.

The attractive village residences
of Baux-de-Provence in Les Alpilles.

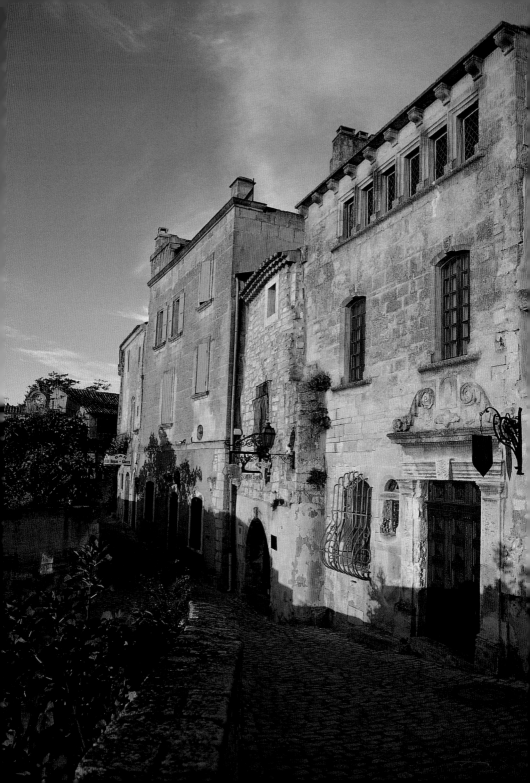

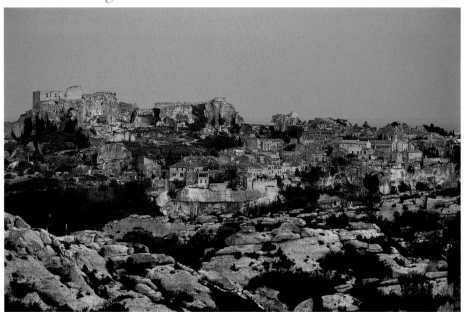

Baux-de-Provence seen from Val d'Enfer.

An aerial view of the village of
Baux-de-Provence, which looks
like a ship of white rock.

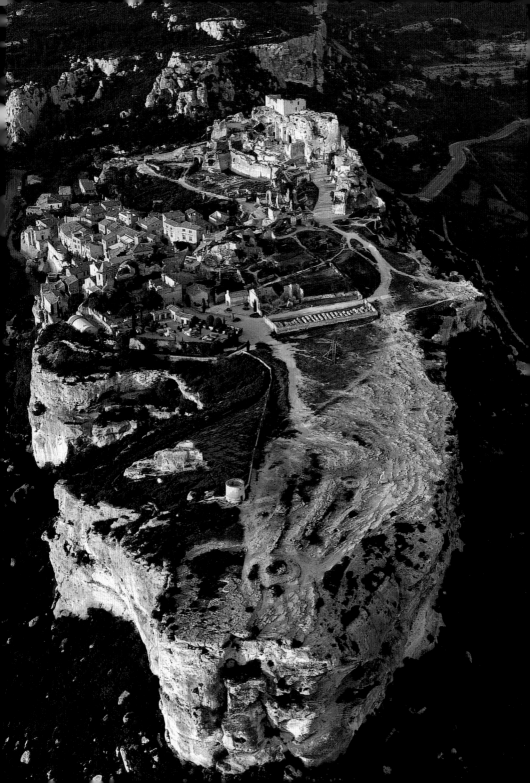

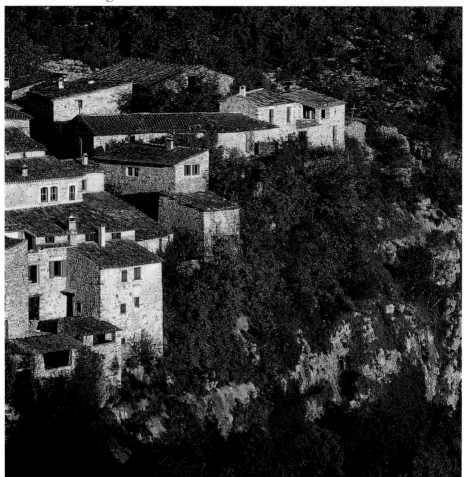

Oppedette, a remote village overlooking the Calavon gorges.

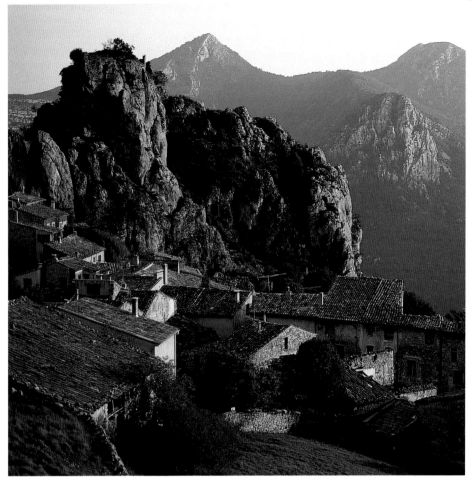

The village of Rougon seems to stand guard on the Gorges du Verdon.

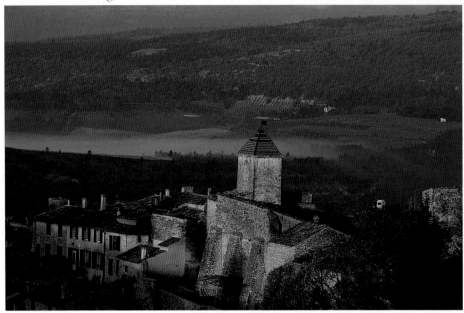

The village church of Aurel, one of the most attractive hillside villages of the Vaucluse.

pages 142 and 143
The hillside village of Brantes
with its view of the north
face of Mount Ventoux.

To the south of Mount Ventoux, the
hillside village of Crillon-le-Brave.

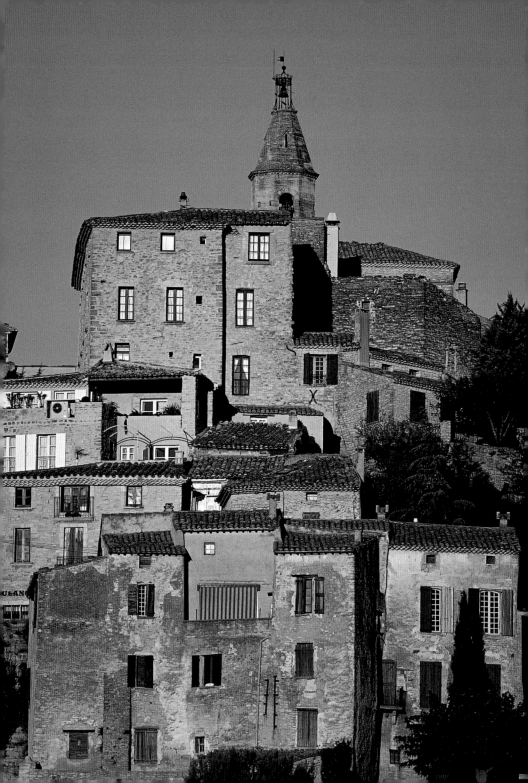

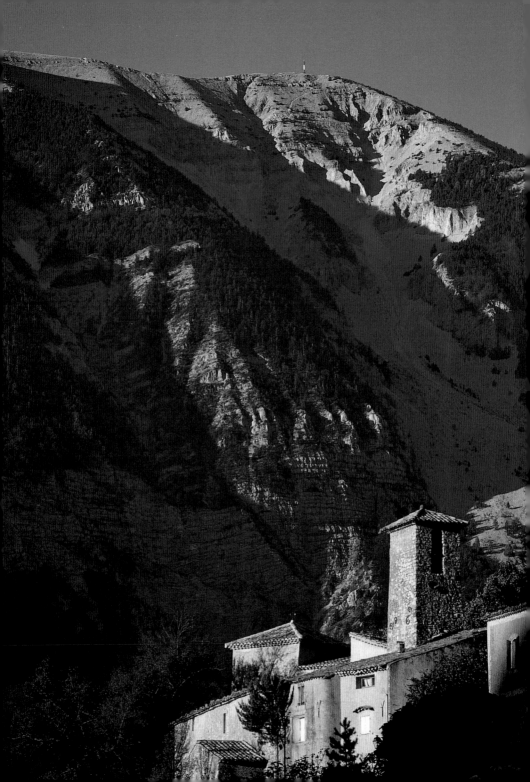

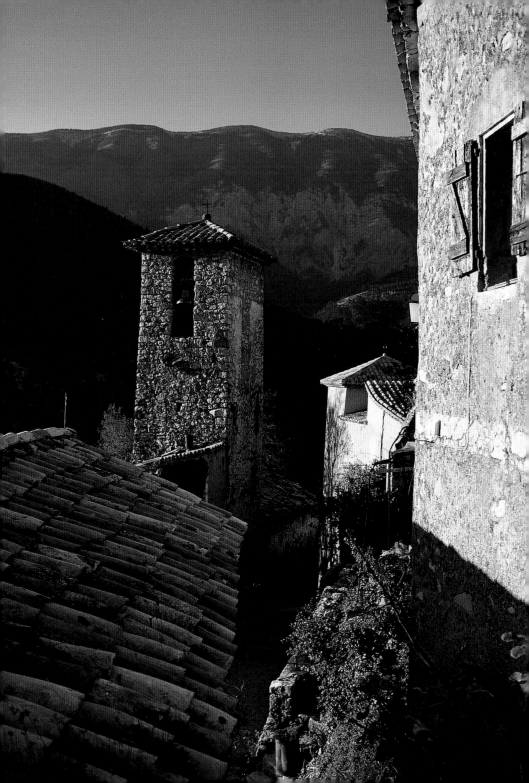

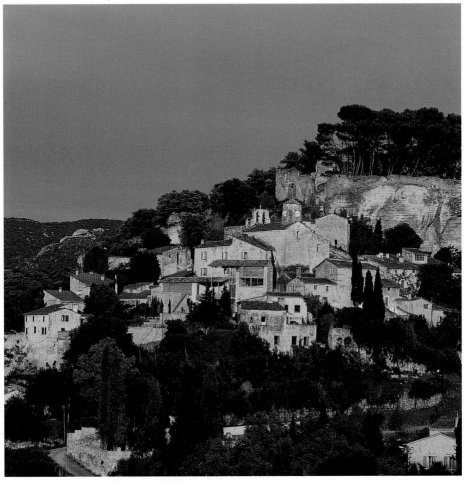

Le Beaucet, a village in the Comtat Venaissin area,
built on a cliff between two valleys.

Not far from Venasque, Le Beaucet
is a relatively unknown village.
Its houses are hollowed into the
side of the cliff. Mount Ventoux
dominates the landscape.

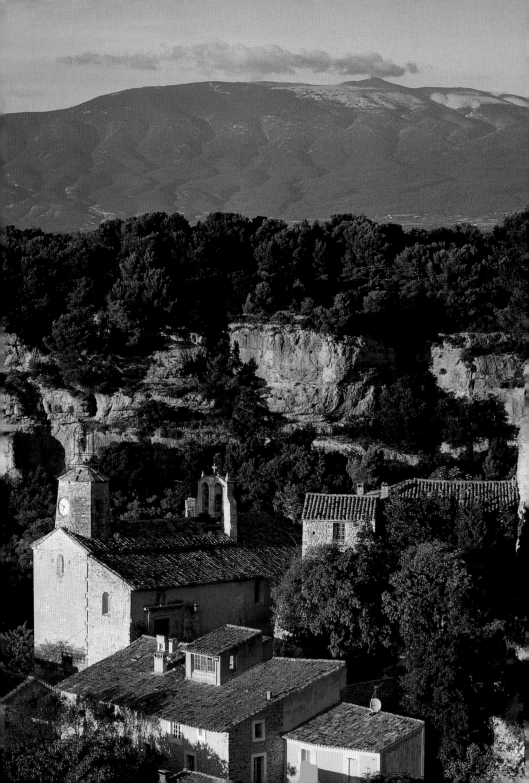

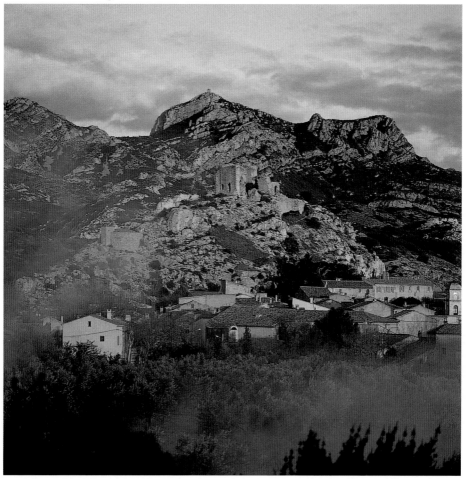

Aureille and the ruins of its seventeenth-century château built on a foothill of Les Alpilles.

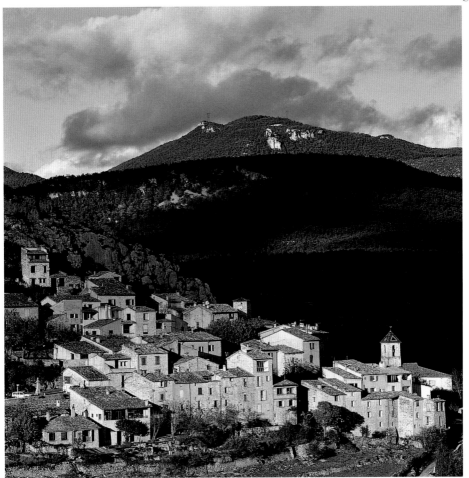

Trigance on the Var side of the Verdon.

Towns and Villages

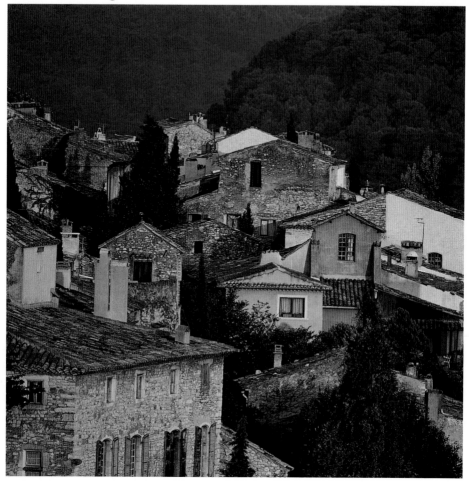

The mountain town of Vaison-la-Romaine.

following double page
The west side of the Dentelles de Montmirail, with the village of Séguret in the background.

La Roque-Alric, a minuscule village built into an isolated peak of the Dentelles de Montmirail massif.

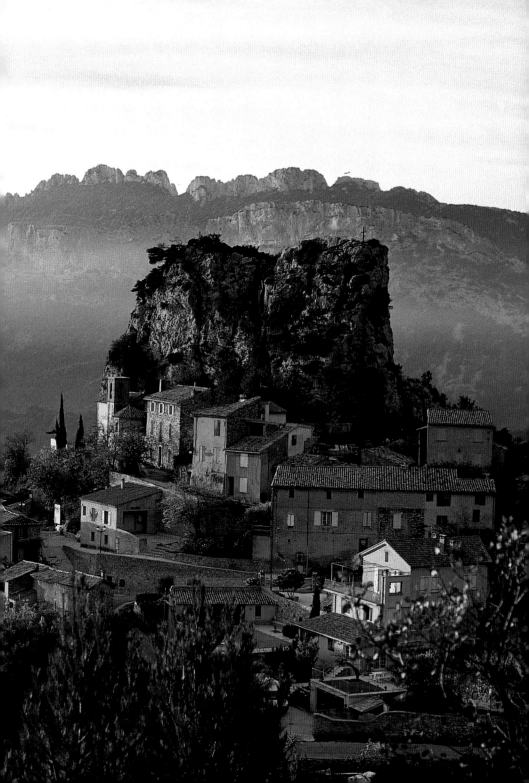

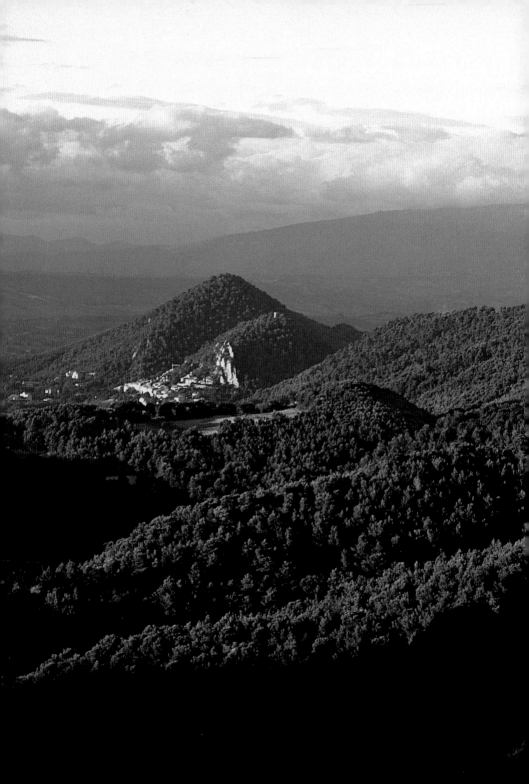

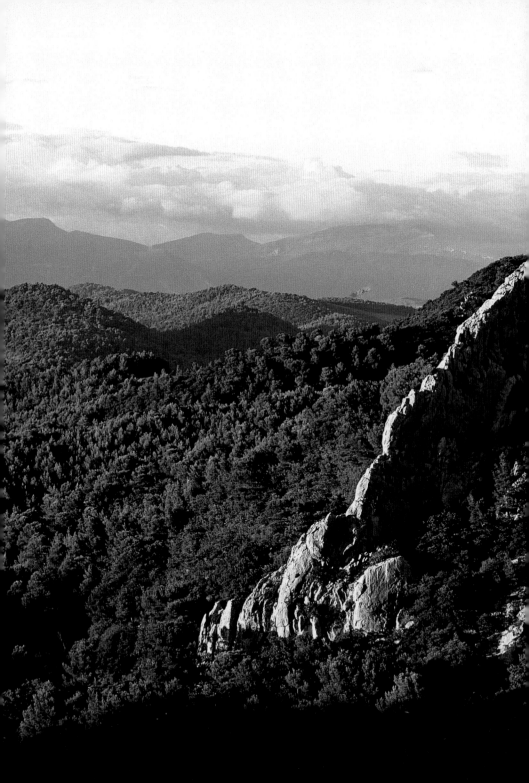

Towns and Villages

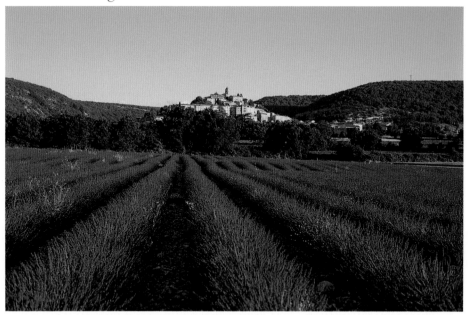

Banon, perched on the foothills of the Albion plateau, is surrounded by lavender fields.

The houses of the village
of Banon are huddled around
the church, forming a rampart.

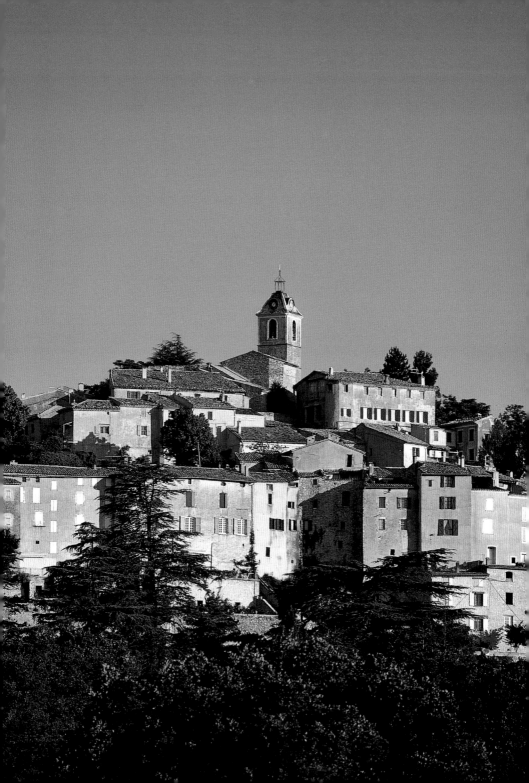

Towns and Villages

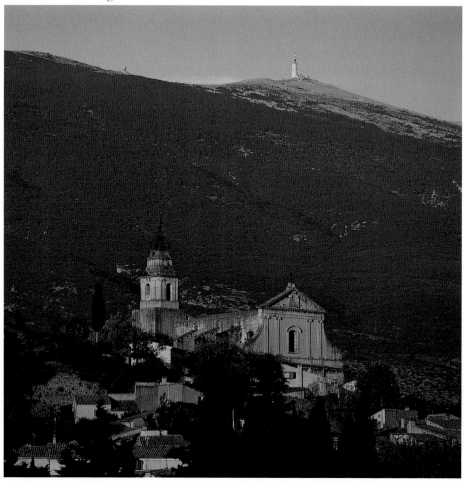

The village of Bédoin, built on one of the first foothills of the Ventoux,
with its eighteenth-century Jesuit-style church towering above the houses.

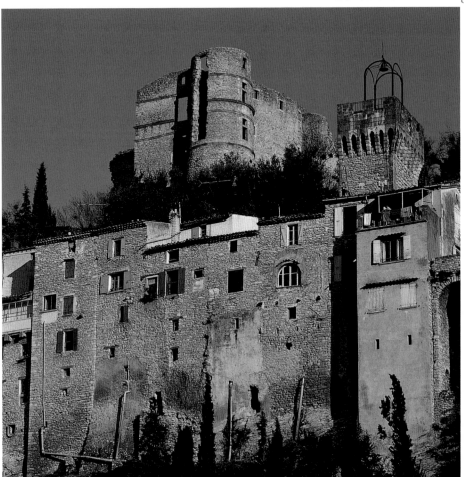

The ruins of the sixteenth-century château in Montbrun-les-Bruns
overlook the hillside village with its houses, buttresses, and arcades.

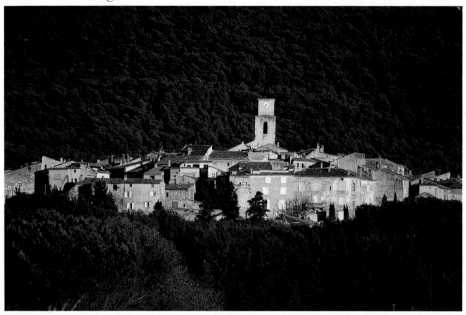

The village of Sablet situated in the heart of the Côtes-du-Rhône-Villages wine region.

following double page
The ancient village of Eygalières
in Les Alpilles, ranged in tiers
up the hillside.

The village of Gigondas in
the Dentelles de Montmirail,
renowned for the quality
of its wines.

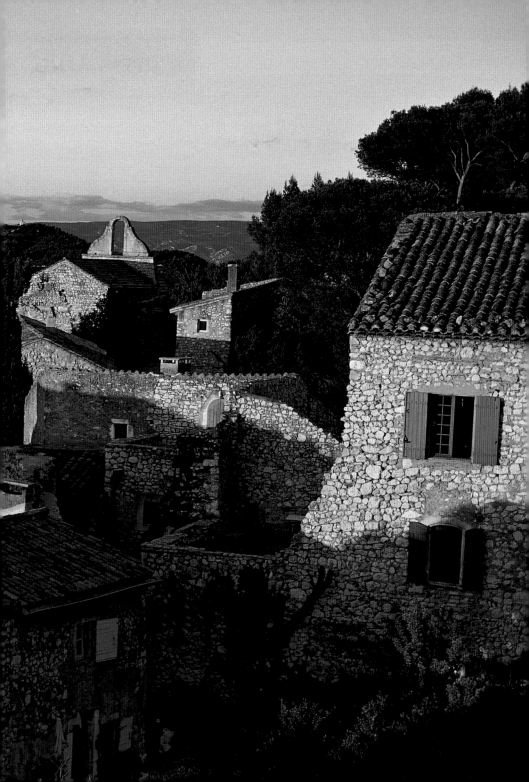

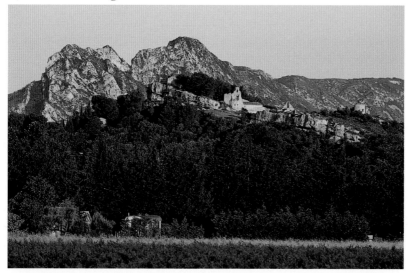

Built on a rocky peak, Eygalières is certainly
one of the most beautiful villages of Les Alpilles.

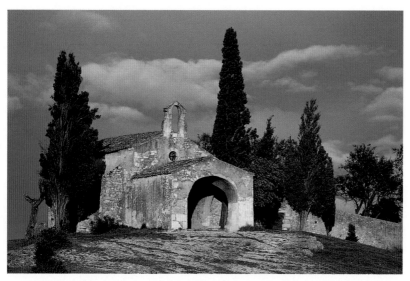

The Romanesque chapel of Saint-Sixte, built in
the twelfth century on a rocky spur, overlooks Eygalières.

The view of Les Alpilles from
the well-restored houses of
Eygalières is impressive.

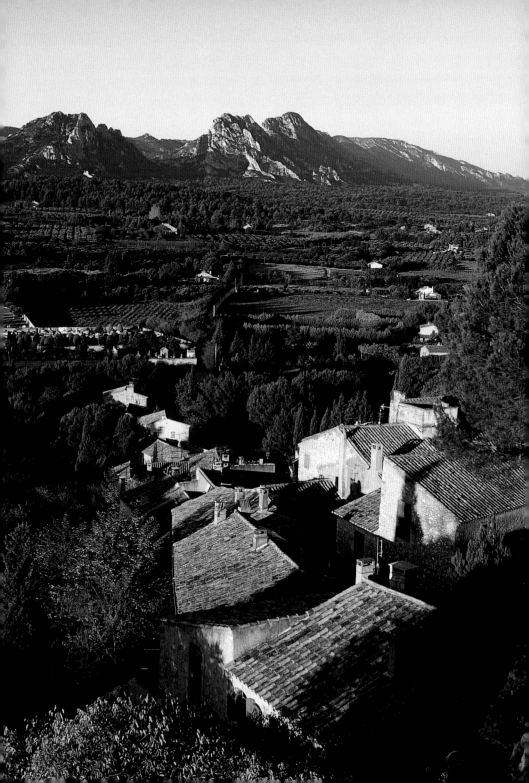

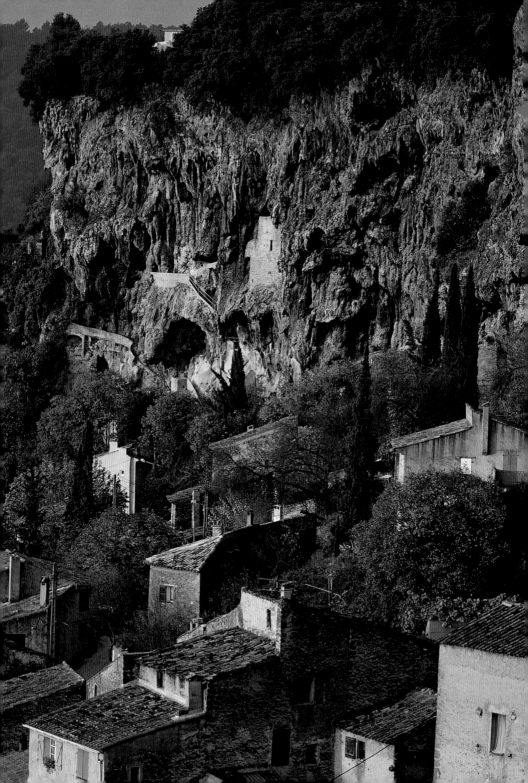

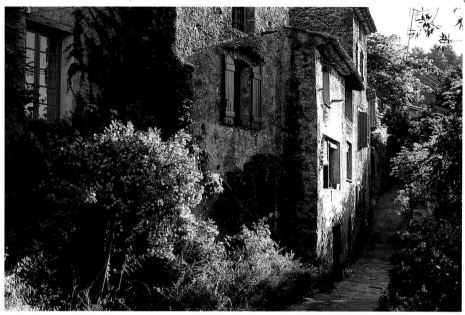

A lane in bloom in the old village of Cotignac in "green Provence."

Cotignac, a village of
the Haut-Var, nestles at
the foot of a cave-pitted cliff.

following double page
The village of Lourmarin,
in the south of the Lubéron,
charmed Albert Camus
who is buried in its cemetery.

163

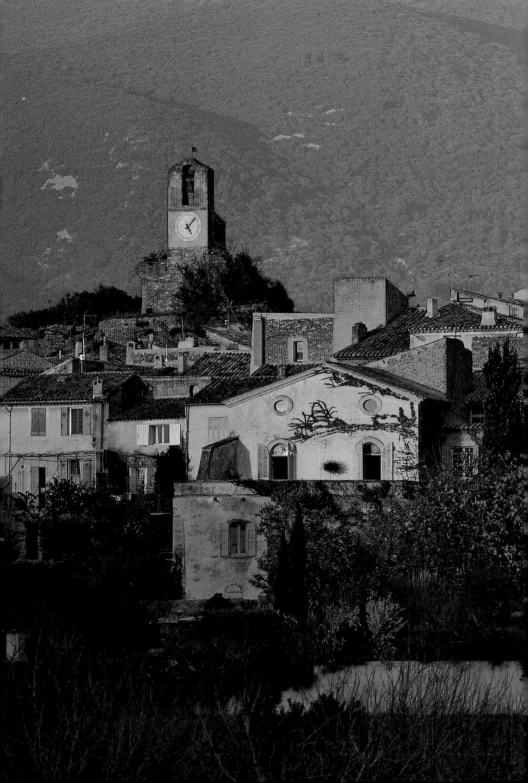

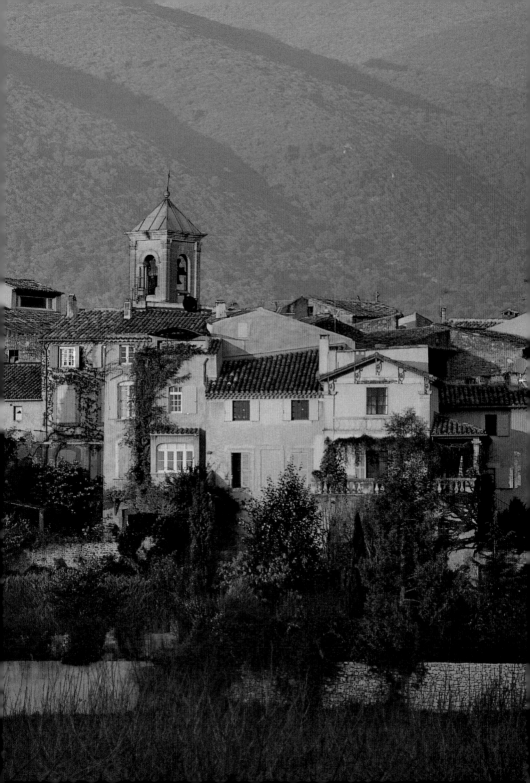

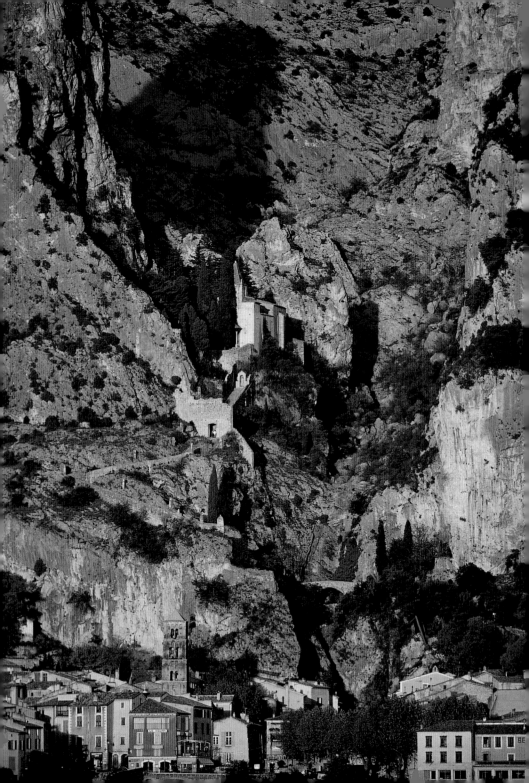

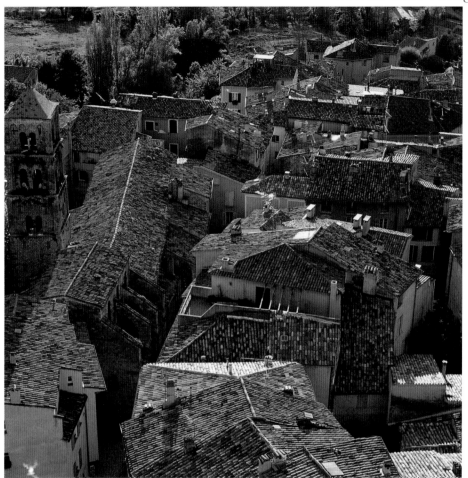

The Romanesque bell tower of the collegiate church stands tall above the roofs of Moustiers-Sainte-Marie and their perfectly overlapping brown tiles.

Moustiers-Sainte-Marie,
which is built downstream
of the Gorges du Verdon.

The Château of the Chevaliers of Saint-Jean-de-Jérusalem at Poët-Laval in the Drôme.

The medieval village of Poët-Laval,
near Dieulefit, is set in a superb
panorama of wooded foothills.

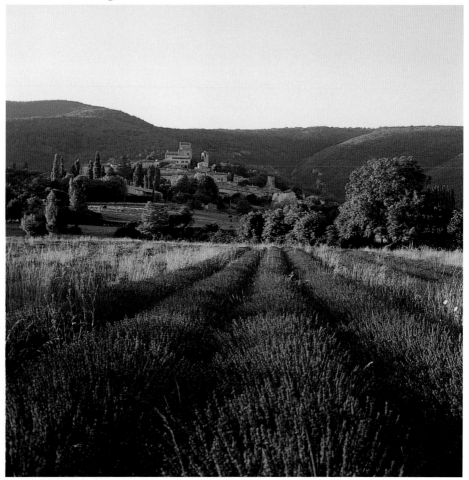

Poët-Laval, surrounded by lavender and wheat. The village's curious name is derived from "mount in the valley."

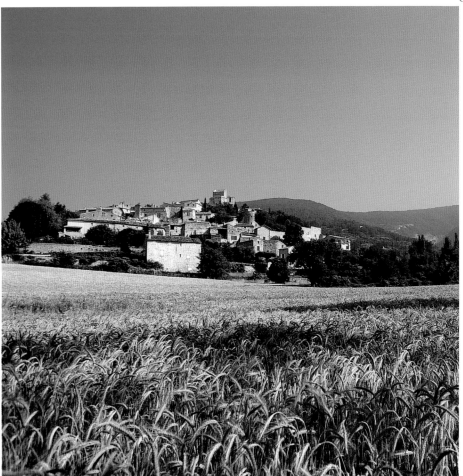

Poët-Laval is one of France's most beautiful villages
and is off the beaten tourist track.

Towns and Villages

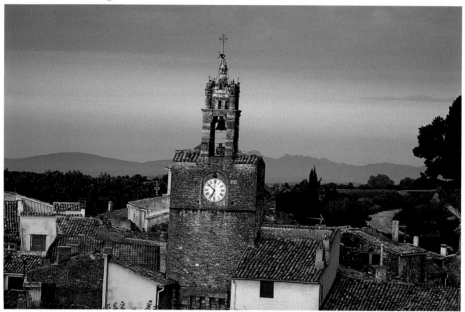

Bell tower of the church of Cucuron in the Lubéron.

page 174
Bell tower and sundial in
Roussillon in the Lubéron.
page 175
The ironwork frames of the bell
towers allow the wind easy passage.

On the southern slopes of the
Lubéron, Cucuron is dominated
by its square keep, the only trace
of the village's medieval past.

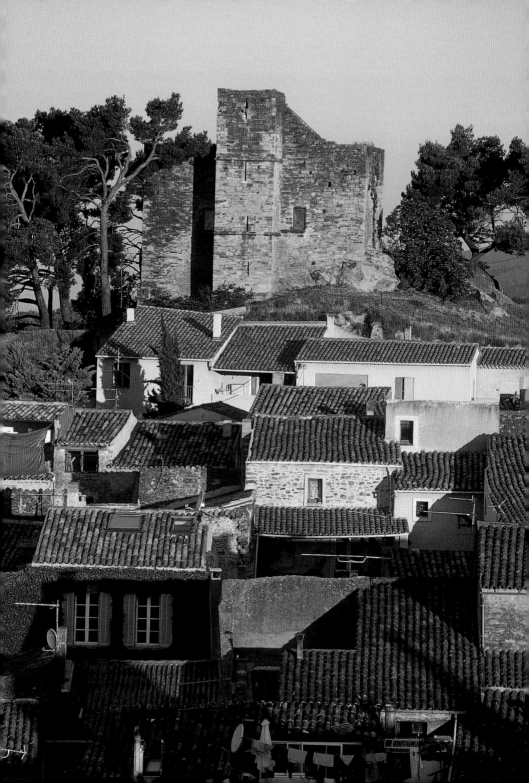

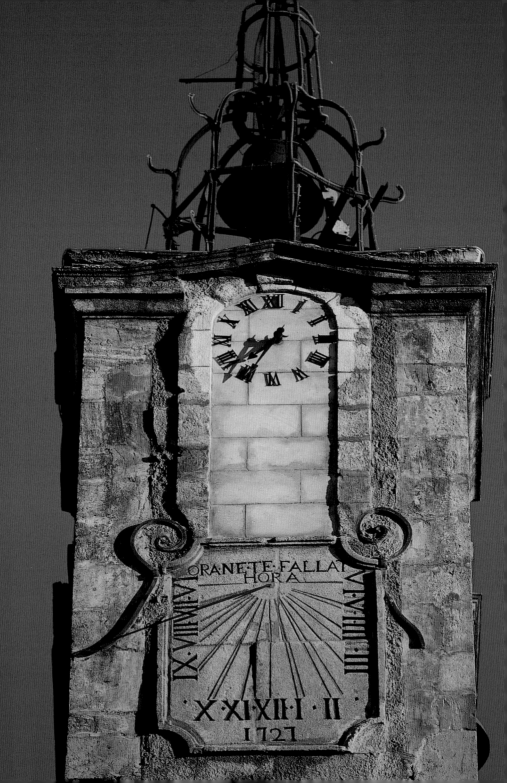

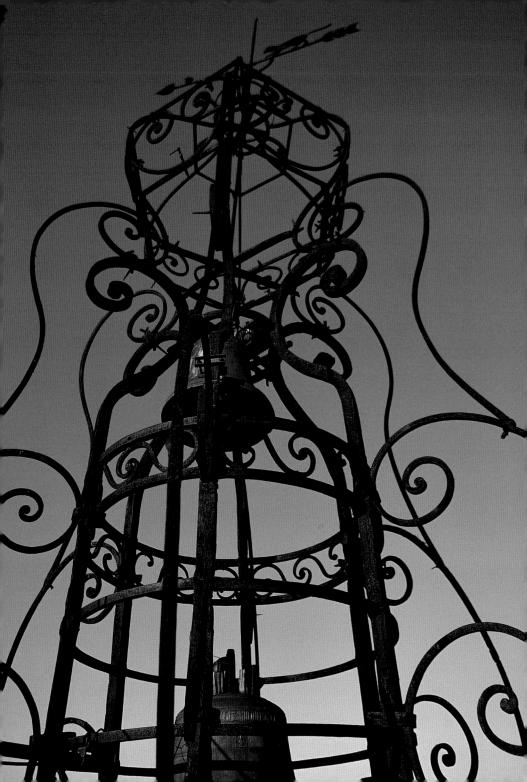

Towns and Villages

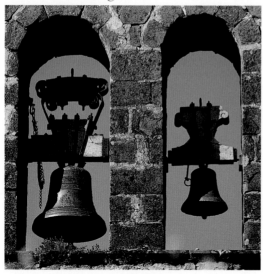

Bell tower of a church near Nyons.

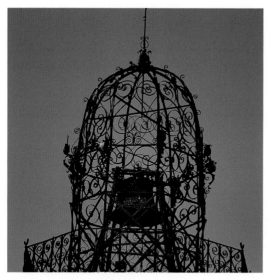

The frame of this bell tower, in Aix-en-Provence, looks like wrought-iron lace.

The region's bell towers are testament to the artistry of Provençal blacksmiths. This example is at Pernes-les-Fontaines.

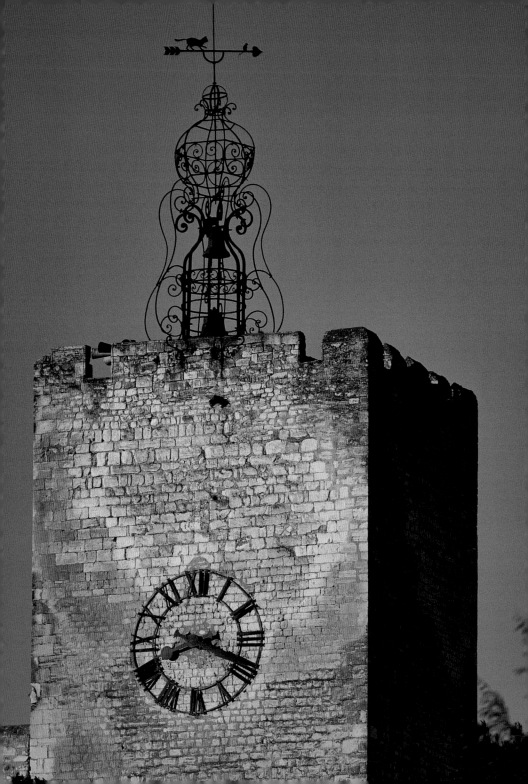

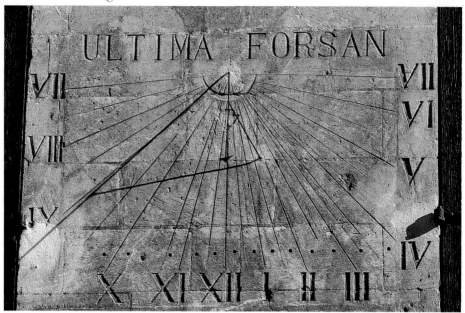

Ménerbes sundial in the Lubéron.

following double page
In winter, the most famous villages
of the Lubéron lose their colors
beneath a blanket of white,
such as Roussillon here.

The gate of the Château
de la Tour-d'Aigues in
the south of the Lubéron.

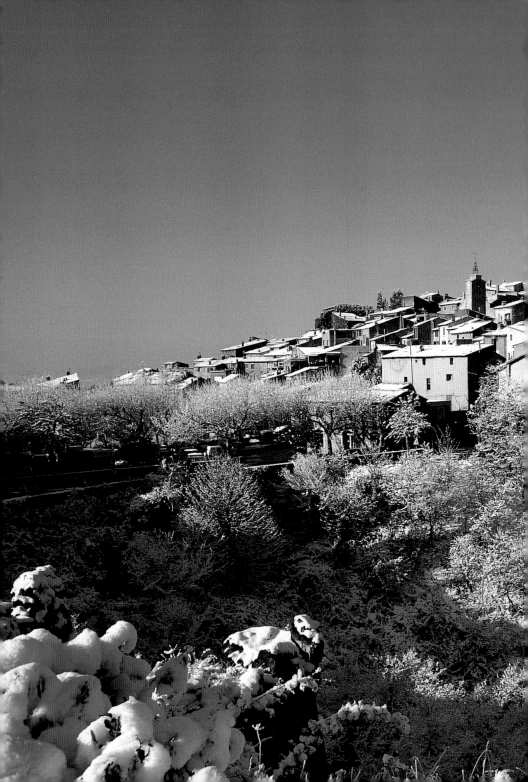

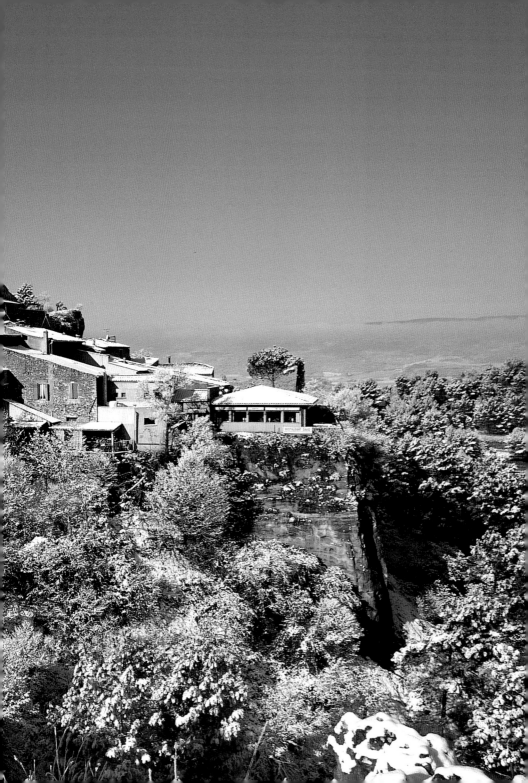

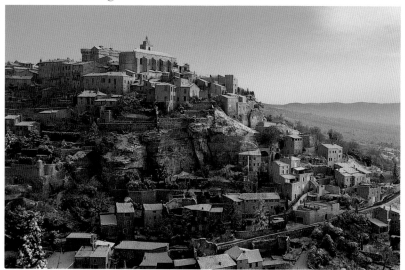

The old houses of Gordes sprinkled with snow.

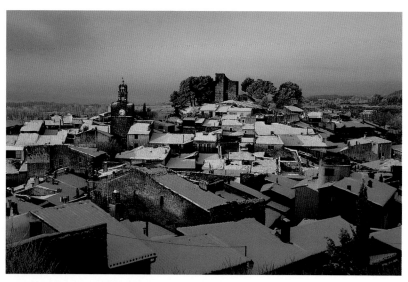

The beautiful harmony of the rooftops of Cucuron;
its population is greatly diminished in winter.

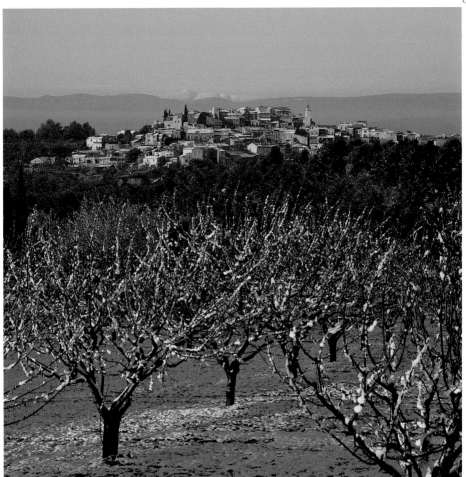

Orchards and pine forests form a green belt around the village of Roussillon.

Towns and Villages

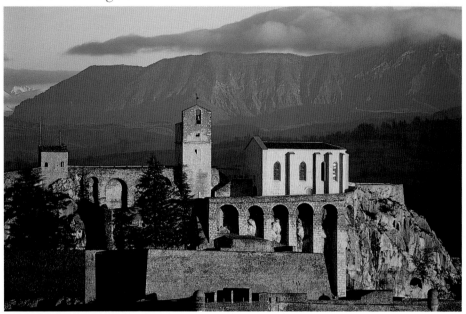

Sandwiched between the Provence and Dauphiné regions, the town of Sisteron, on the banks of a bend in the river Durance and surrounded by rocks, has a spectacular location.

The old town of Sisteron
is characterized by its dense
terraced houses that climb
the base of the rock.

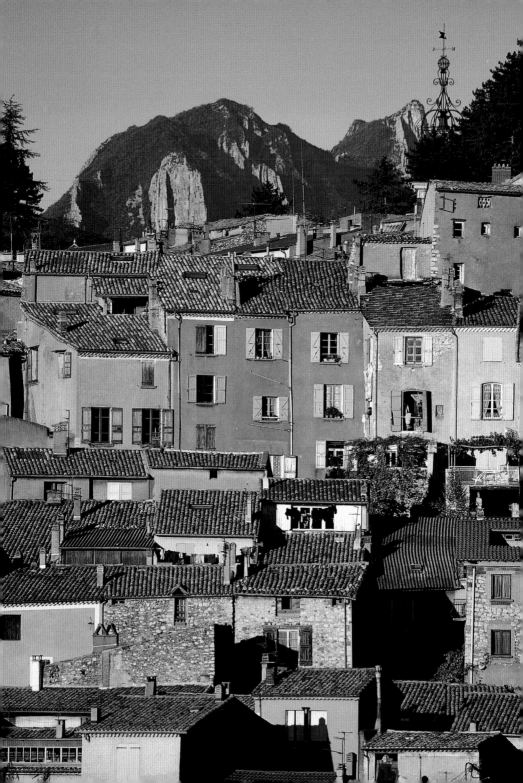

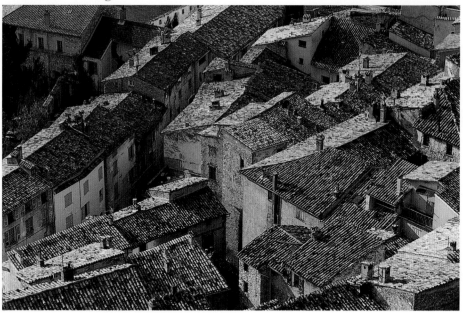

Entrevaux, overlooking the valley of the Var,
is one of the most beautiful fortress towns of Provence.

following double page
Located north of Avignon,
Châteauneuf-du-Pape is overlooked
by a ruined papal summer residence.

The main gate of Entrevaux
dates from the eighteenth century.

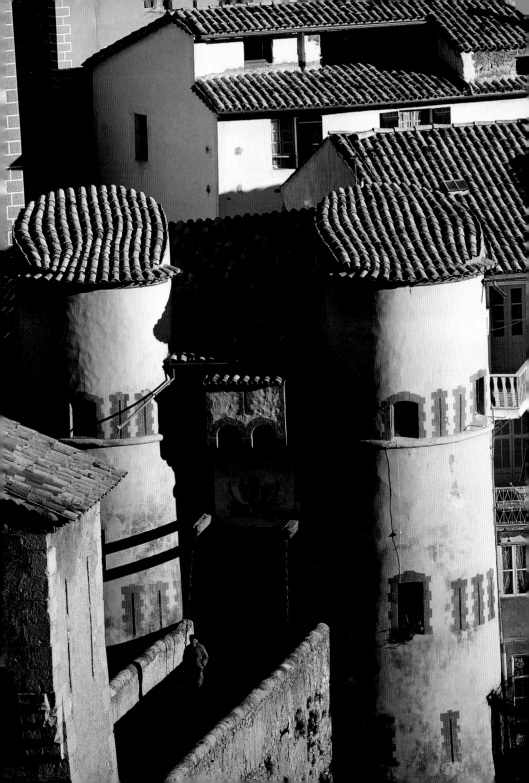

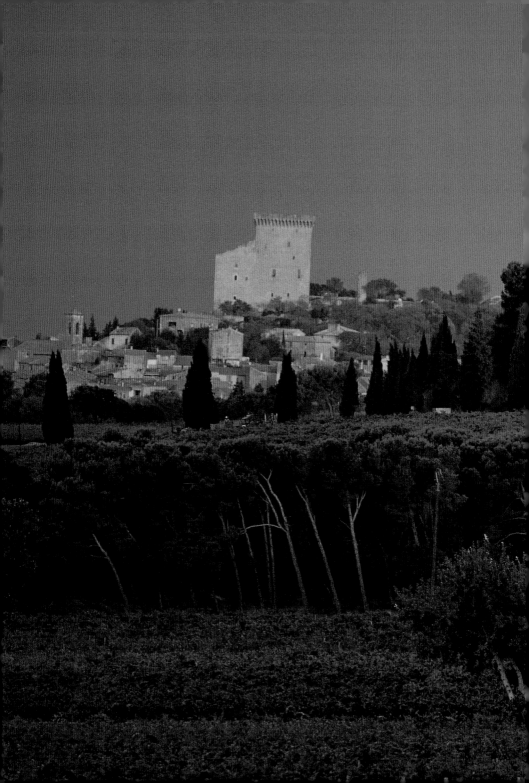

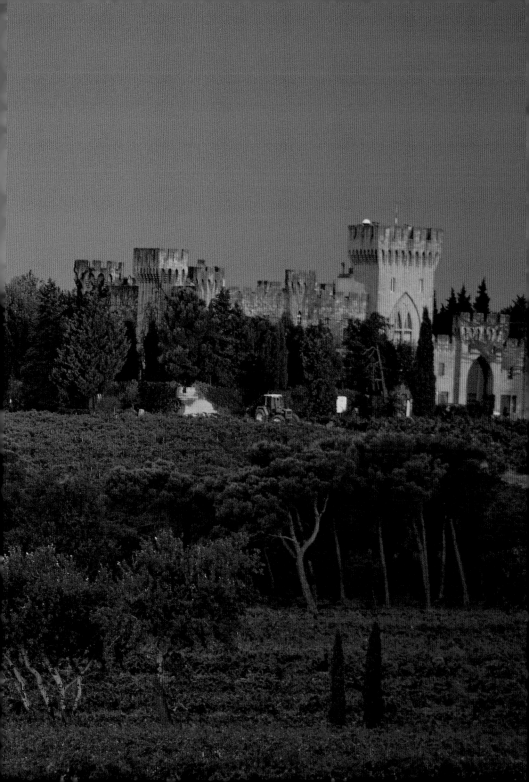

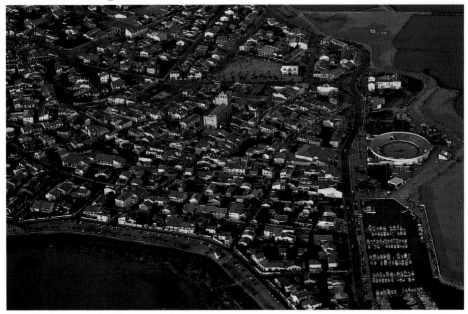

In the Camargue, Saintes-Maries-de-la-Mer with its amphitheater on the right.

following double page
The boundaries of the old town
of Saint-Rémy-de-Provence are marked
out by a ring of trees, remnants
of the former ramparts.

The ramparts and the Constance
tower border Aigues-Mortes,
a village similar to Saintes-Maries-
de-la-Mer. To the south, the village
is surrounded by lakes.

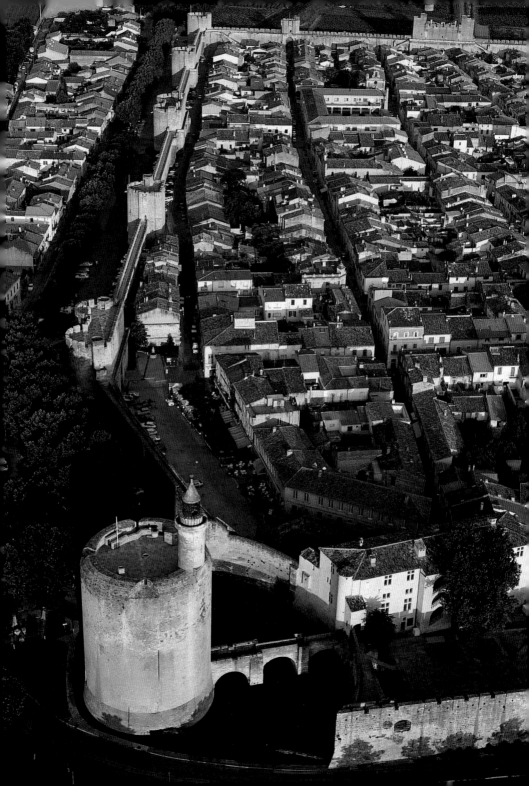

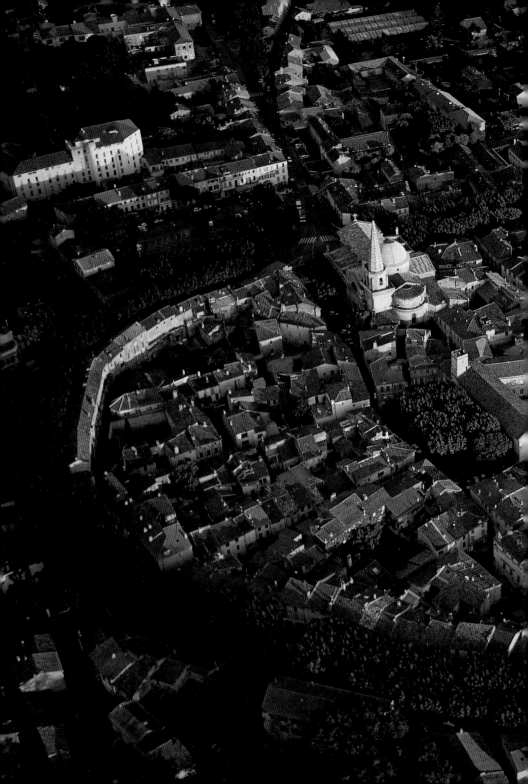

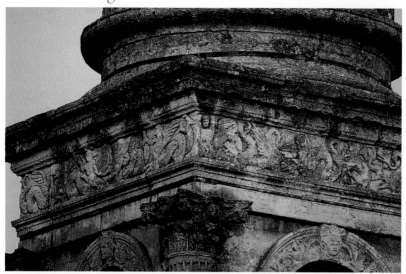

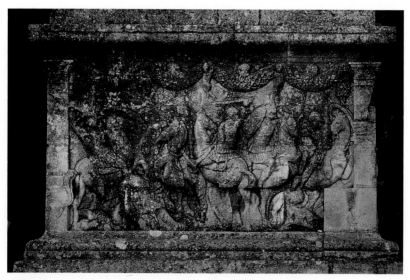

The Julii mausoleum is one of the most famous monuments
of the Roman city of Glanum, the remains of which
have been unearthed near Saint-Rémy-de-Provence.

The park and monastery of Saint-Paul-de-
Mausole in Saint-Rémy-de-Provence
evoke Van Gogh, who once lived there.

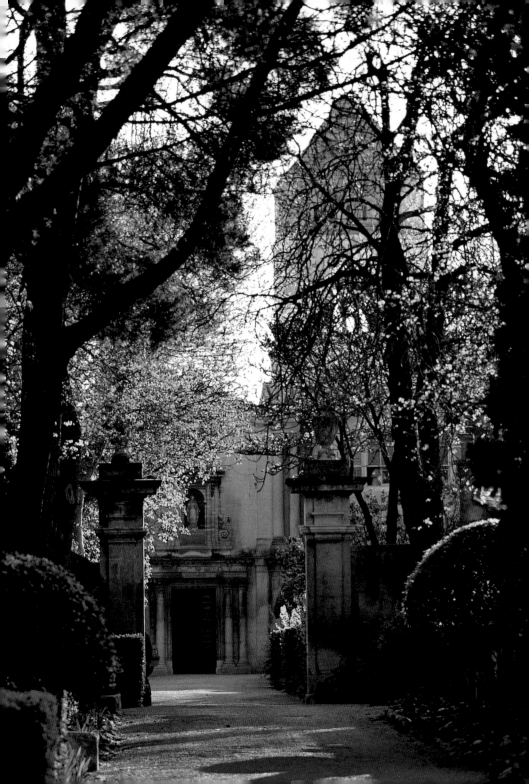

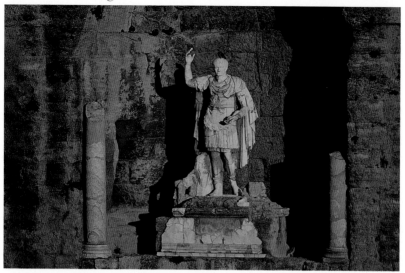

Provence abounds in Roman ruins. This is the ancient theater of Orange.

The "silver-bust" house in the ancient Roman city of Vaison-la-Romaine.

following double page
The Château d'If as viewed from
Notre-Dame-de-la Garde in Marseille.

Pompeii portico in the Puymin
area of Vaison-la-Romaine.

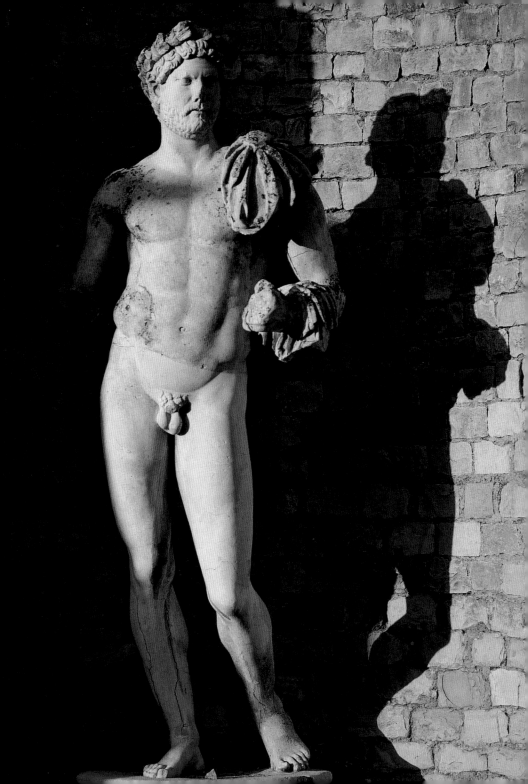

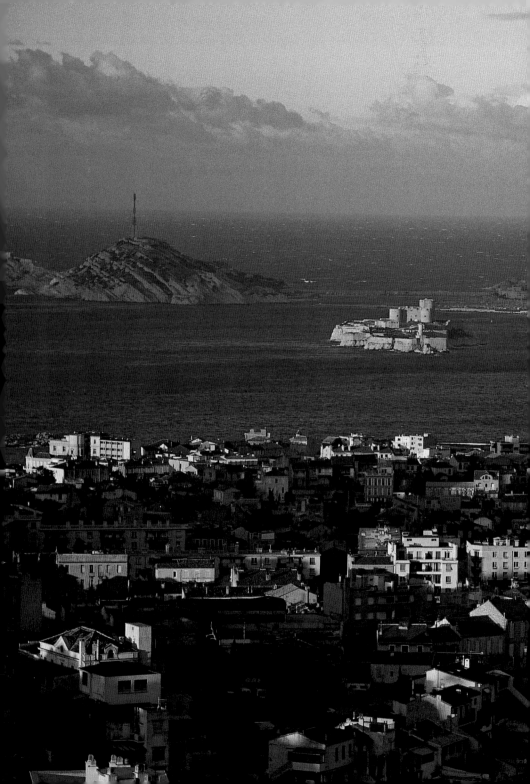

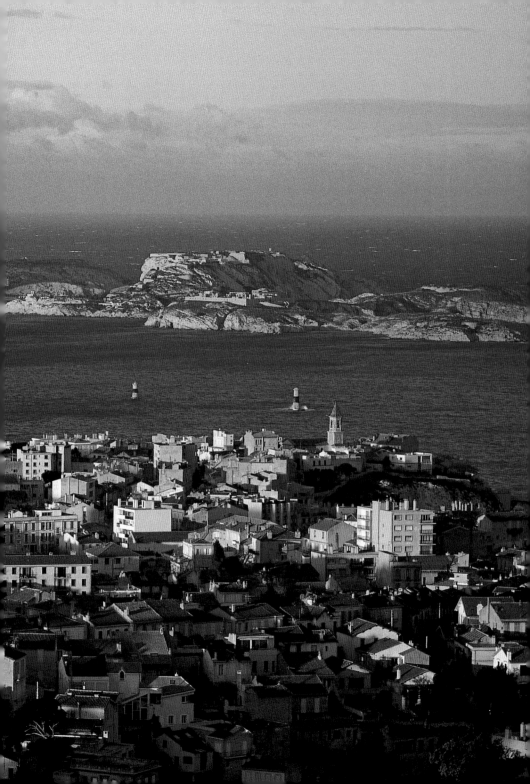

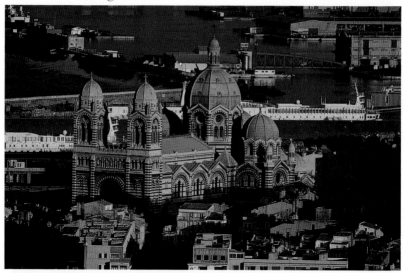

La Major Vathedral, in Marseille, which was
built in the nineteenth century.

Marseille city hall in the old port.

The Notre-Dame-de-la-Garde
basilica, built on a rocky peak,
overlooks the old port of Marseille.

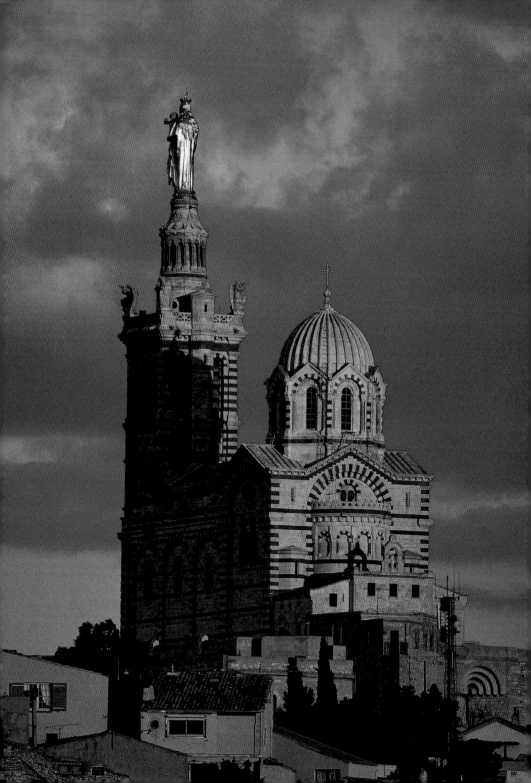

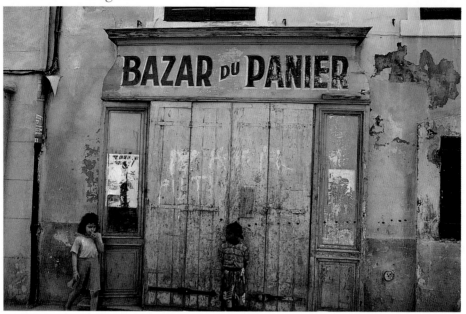

An old boutique in the "Panier," one of Marseille's working class districts.

A back street of the Panier district
in Marseille, with its tall houses
crowding the narrow streets.

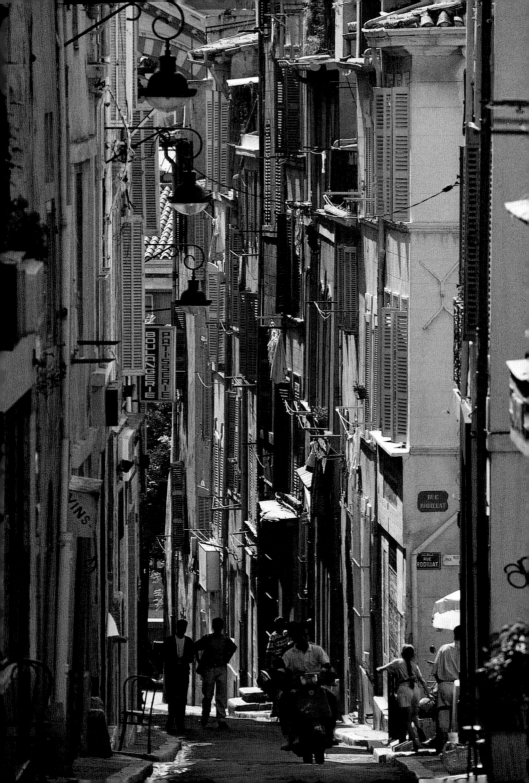

The sun has not completely erased the billboards of yesteryear
from their stone hoardings on cottage walls.

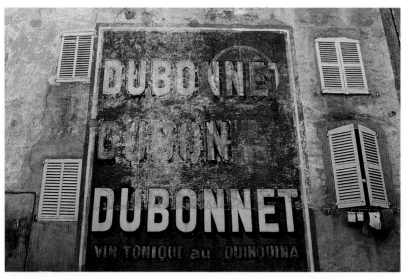

In Aups, Haut Var, nothing seems to have changed for a century.

On the walls of country towns,
such as here in Carpentras, the
faded roughcast of the houses
still retains traces of the past.

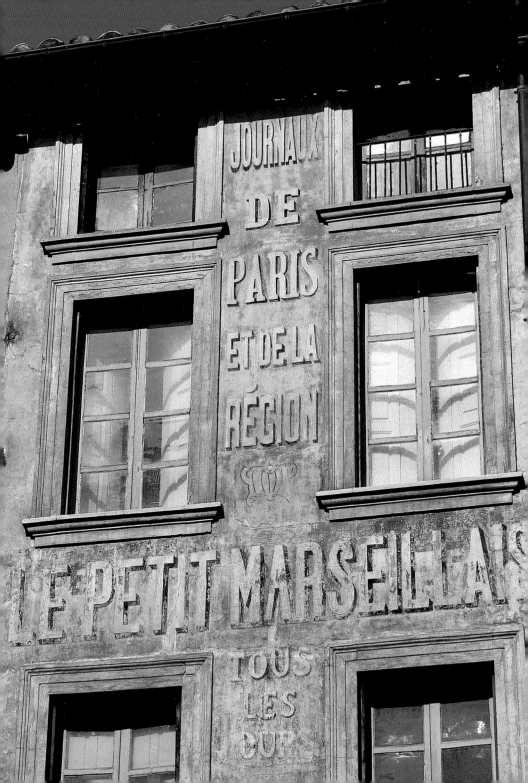

Deep in the heart of Provence, here in Cotignac,
the villages have preserved their ancient storefronts.

In Rians, not far from Montagne Saint-Victoire,
banks and village cafés have the same storefronts.

How long can the region's antique
stores continue to survive? This
well-known shop is in Cotignac.

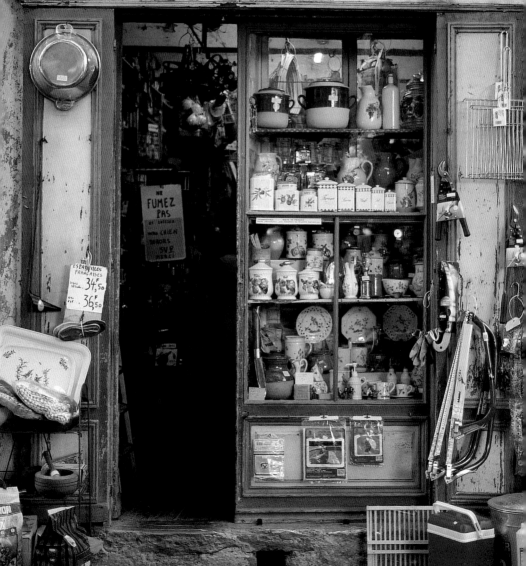

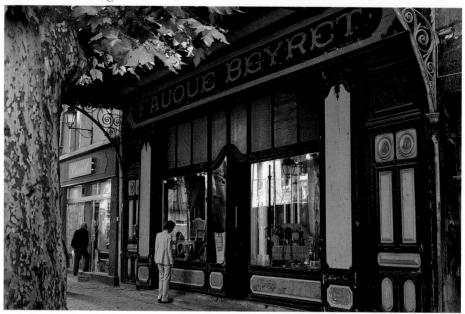

Old storefront opposite the very attractive church of L'Isle-sur-la-Sorgue,
a village famous for its antiques dealers.

The Café de France
in L'Isle-sur-la-Sorgue, is a
meeting place on market days.

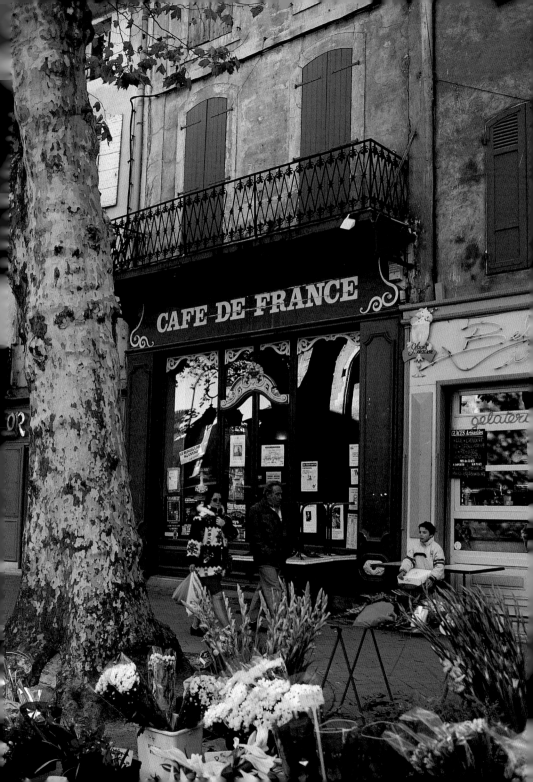

The town of Salon-de-Provence bustles around its centerpiece, the Château de l'Empéri.

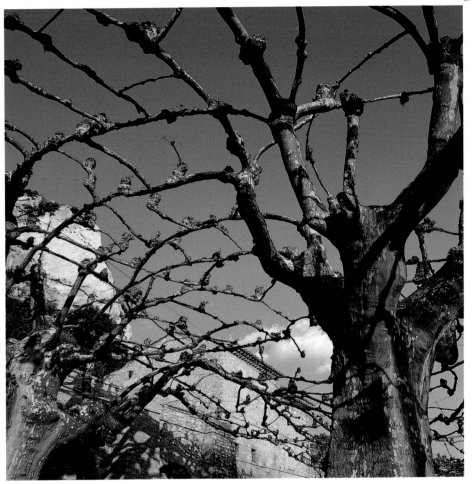

Plane trees in winter light, Séguret, near Vaison-la-Romaine.

following double page
Panorama of Uzès, at the
gateway to Provence, one of
the prettiest towns in France.

211

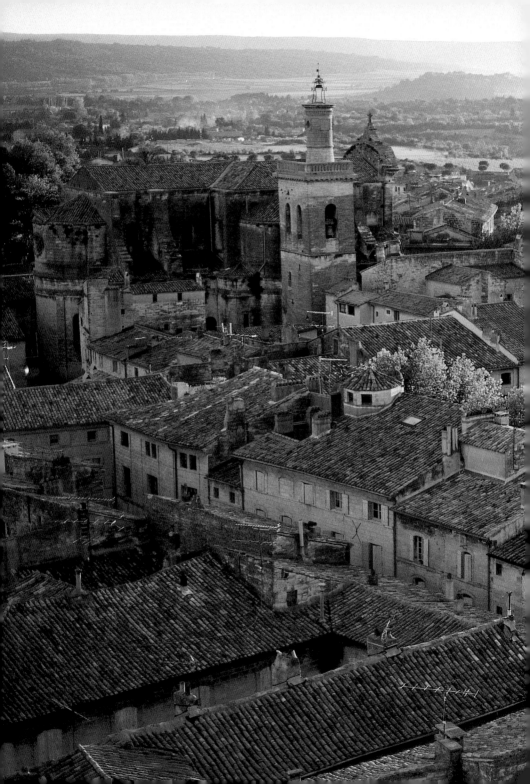

The arcades of the Place aux Herbes, Uzès,
are hidden behind the plane trees.

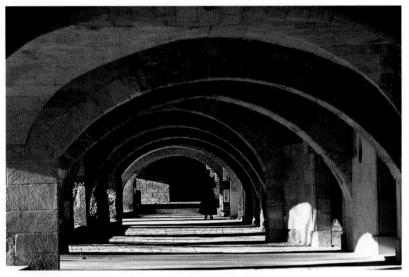

The charming vaults of Uzès, a town that is a maze of archways,
are found in the Place aux Herbes and neighboring streets.

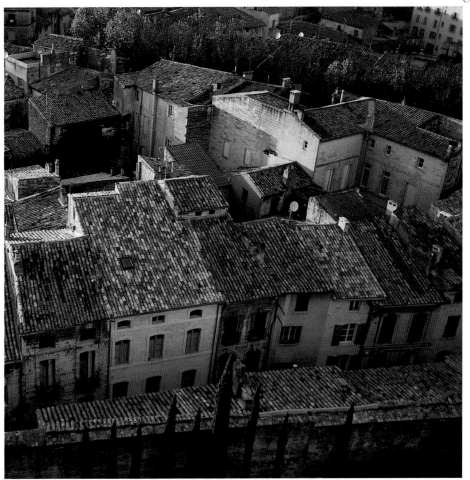

The carefully restored houses of Uzès have preserved their tiled rooftops.

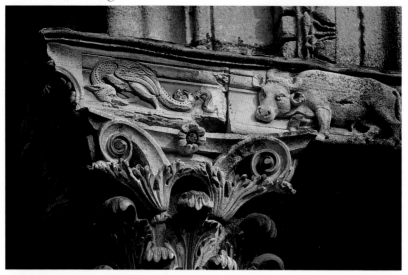

Close-up on the façade of the Saint-Gilles abbey.

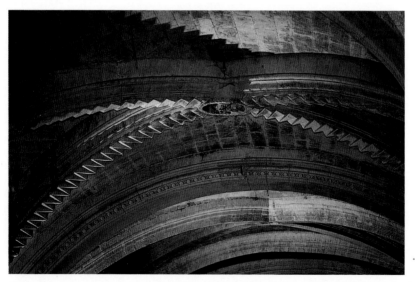

Sixteenth-century ogive vaults at the Saint-Gilles abbey, which stands among paddy fields, vineyards, and canals at the gateway to the Camargue.

The façade of the Saint-Gilles abbey is a listed Unesco World Heritage site due to its location on the Santiago de Compostela pilgrimage trail.

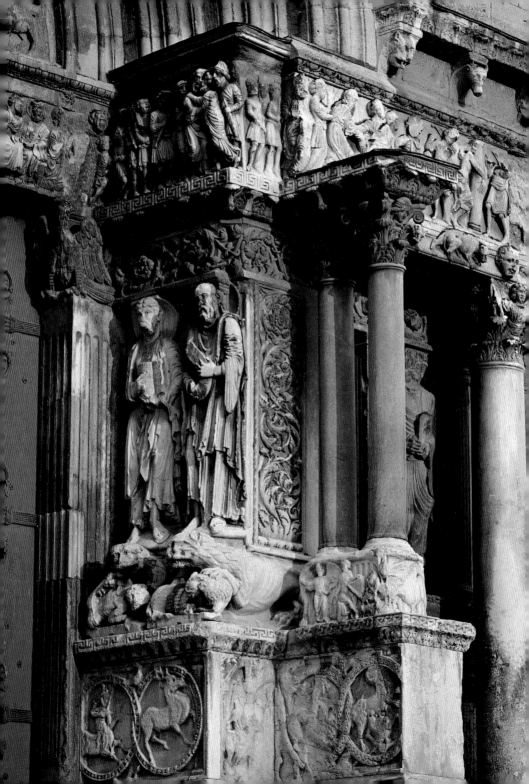

Towns and Villages

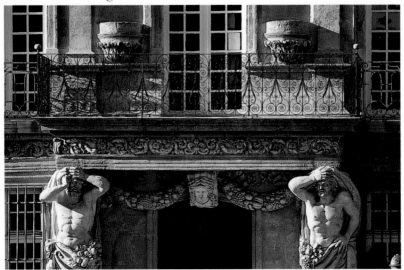

In Aix-en-Provence, the gateway to the Pavillon Vendôme entrance, framed by its two atlantes.

In Aix-en-Provence, the town hall with its magnificent wrought-iron courtyard gate and balcony, dating from the seventeenth-century.

Sculptures in the square in front of the Aix-en-Provence town hall where the flower market is held.

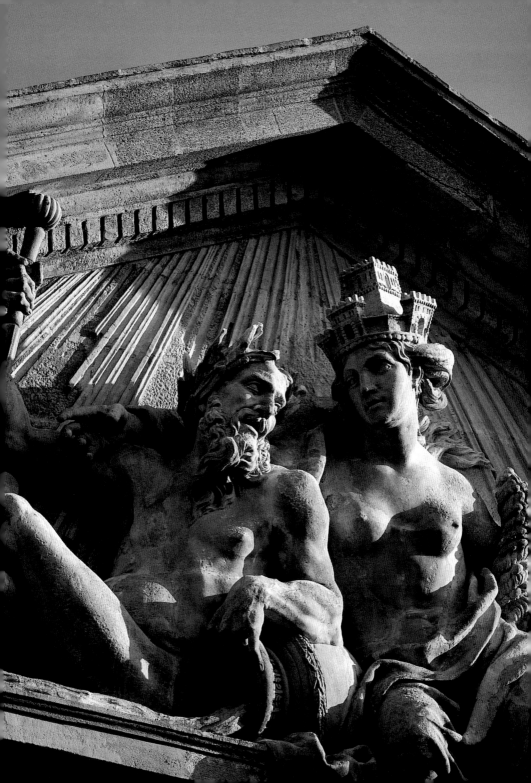

Towns and Villages

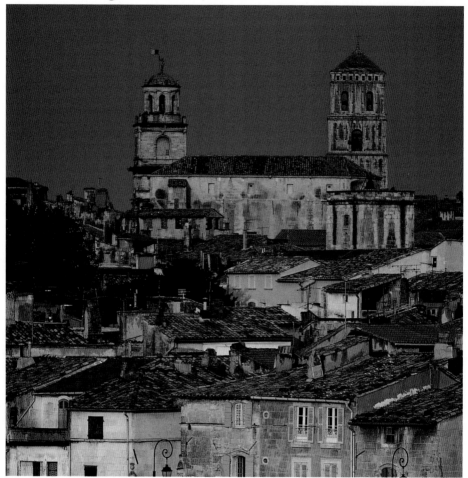

The old town of Arles on the banks of the Rhône.

The amphitheater in the old town of
Arles dates from the first century AD.

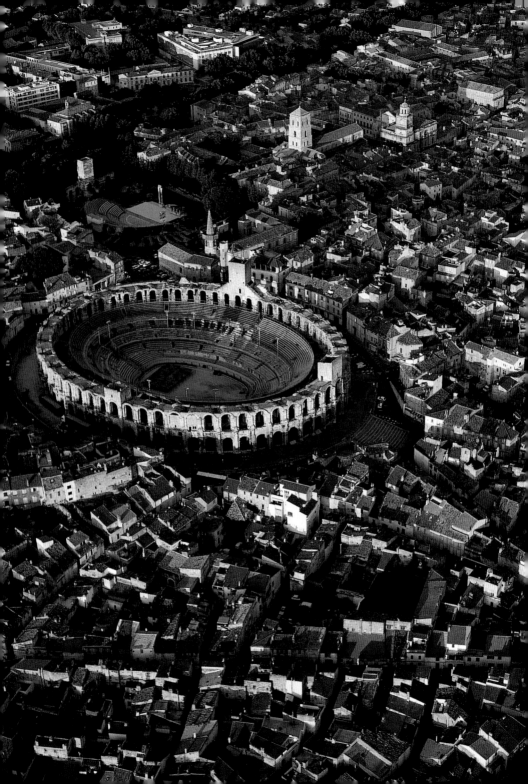

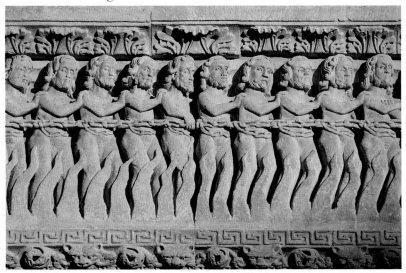

The Reprobates' Procession on the Saint-Trophime gateway in Arles.

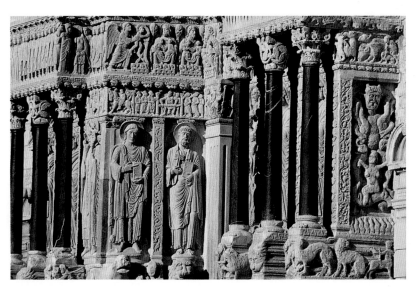

The gateway of the Saint-Trophime church in Arles,
a jewel of Provençal Romanesque art.

Detail of the façade of the
seventeenth-century Hôtel des
Monnaies in Avignon, featuring
the coat of arms of Cardinal
Borghèse, who commissioned it.

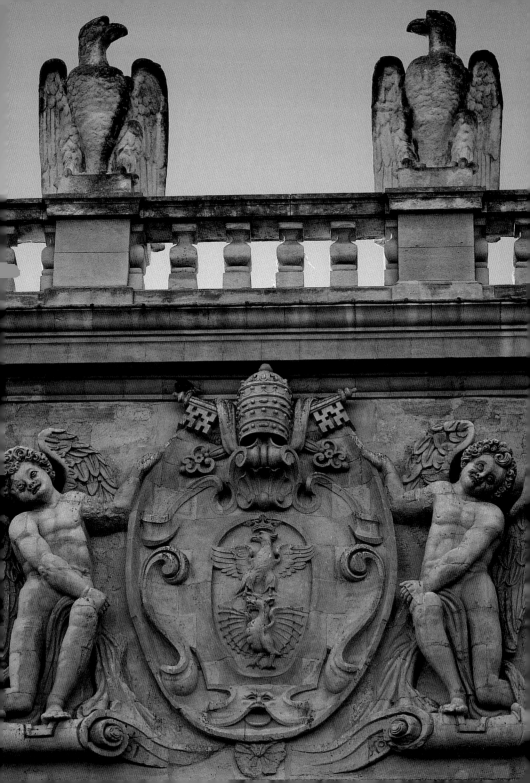

Towns and Villages

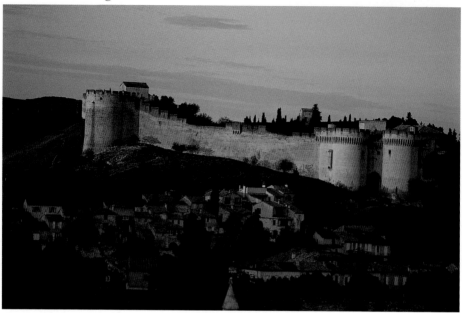

The fortifications of Villeneuve-lès-Avignon.

following double page
Avignon during Rhône flooding.
The fourteenth-century ramparts
have twelve gateways.

The Palace of the Popes, Avignon,
a masterpiece of fourteenth-century
Gothic architecture.

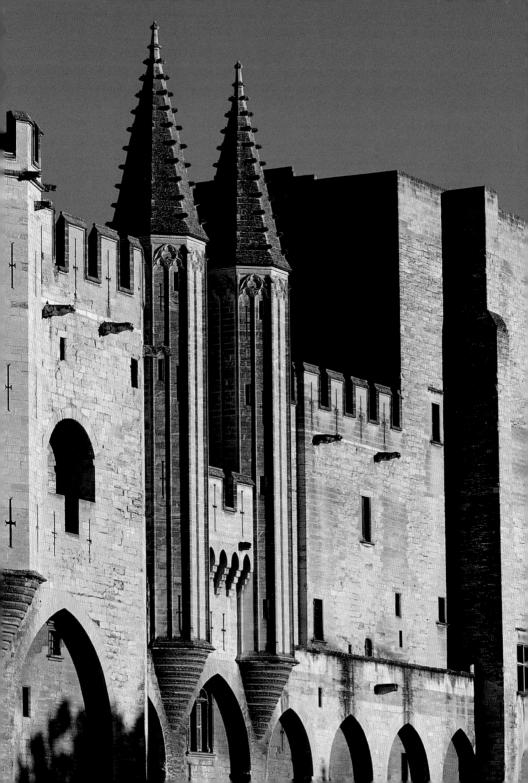

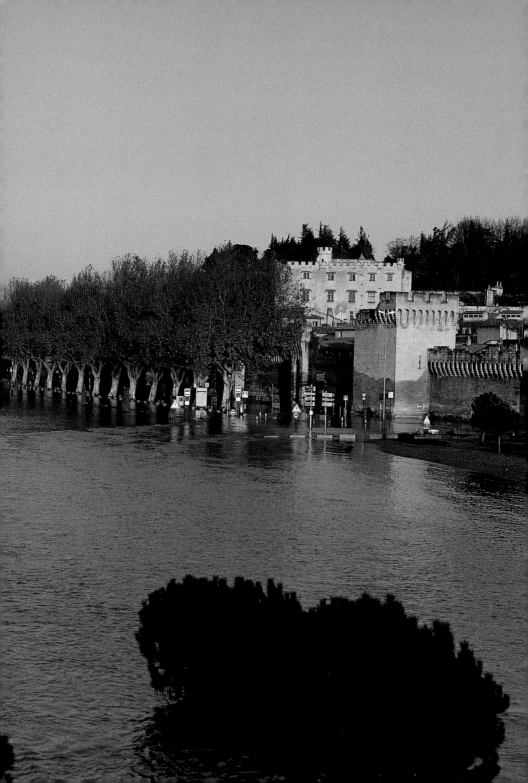

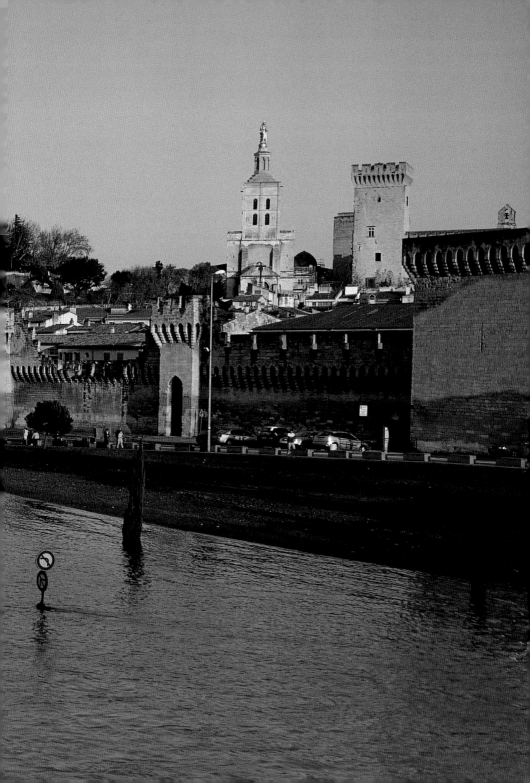

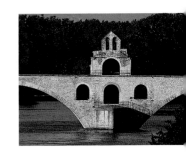

Water

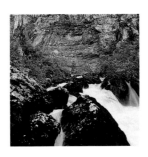

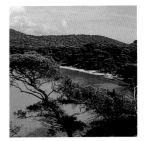

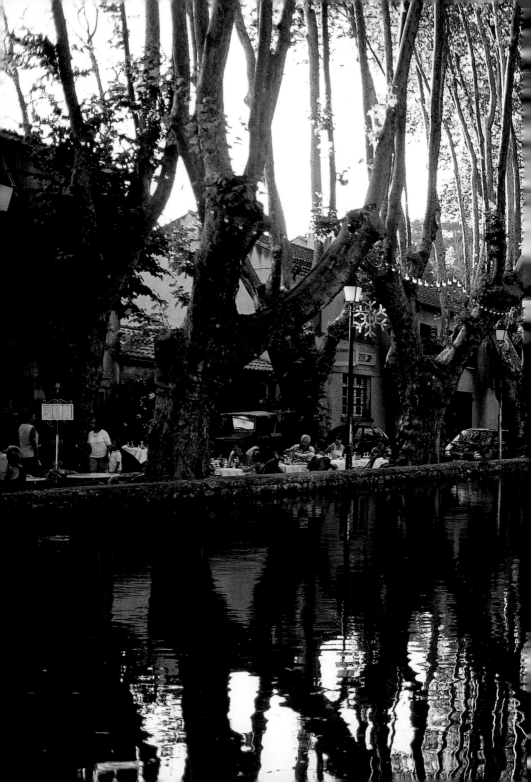

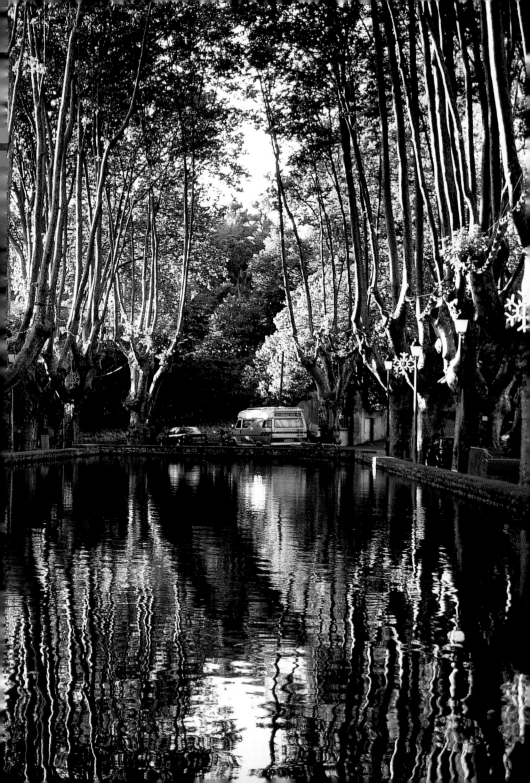

Water

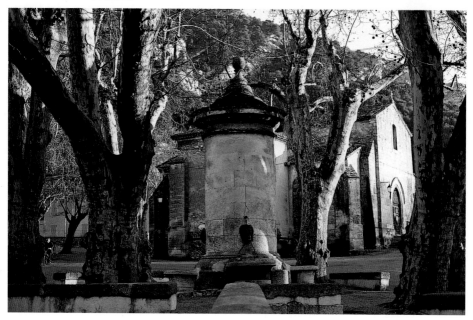

The fountain in the village of Robion in the Lubéron, not far from Cavaillon.

preceding double page
The fifteenth-century Bassin de l'Étang,
in the heart of the village of Cucuron,
surrounded by tall plane trees.

The mossy fountain in
the village of Vaugine
in the Lubéron.

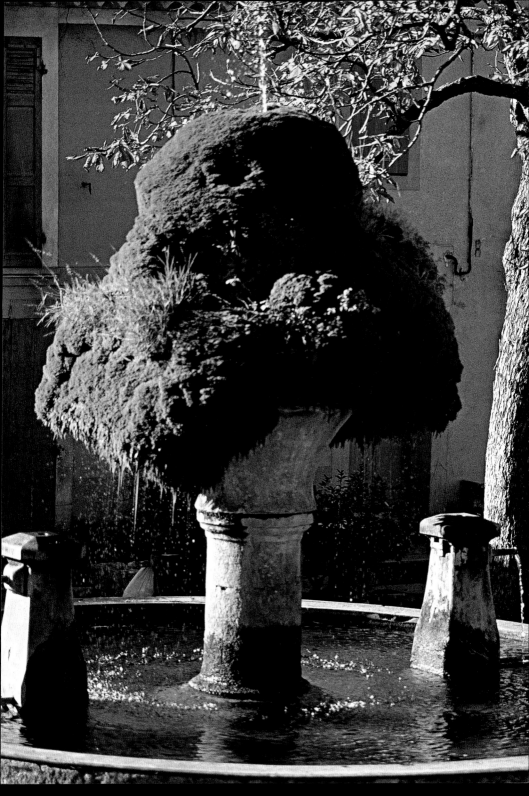

Water

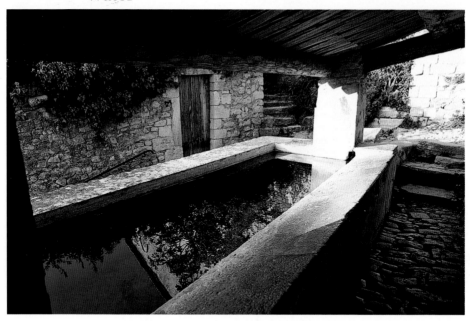

Washhouse in the hillside village of Crestet in the Dentelles de Montmirail.

Tourtour, a medieval village
of the Haut Var, has conserved
its old houses and washhouse.

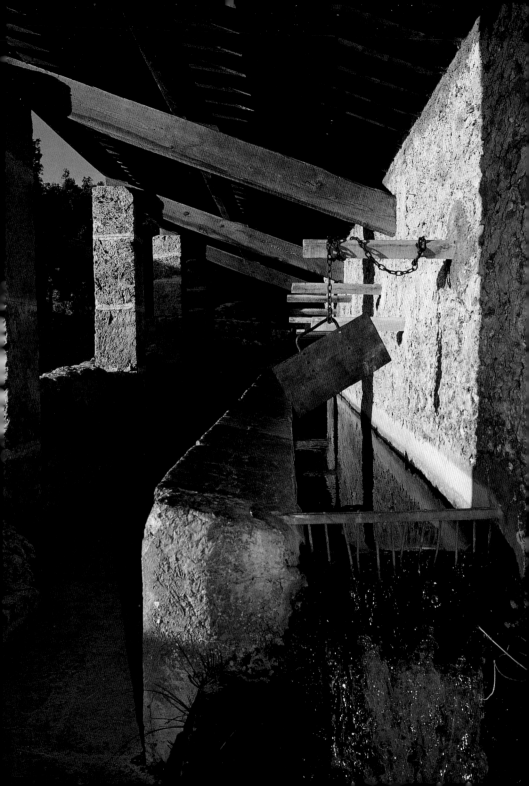

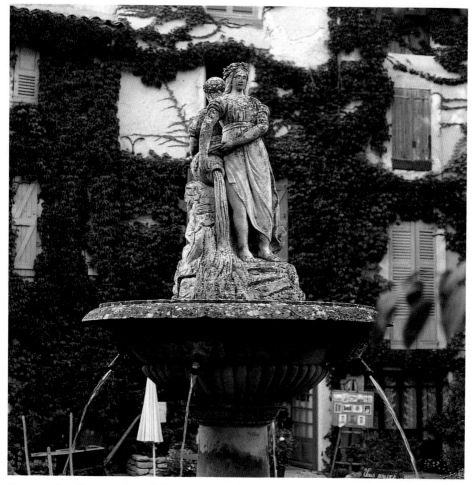

Fountain in village square of Saignon in the Lubéron.

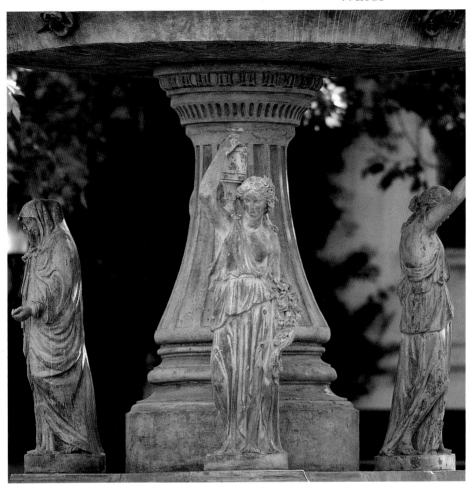

Fountain in Maussane in Les Alpilles, a village famous for its olives and olive oil.

Water

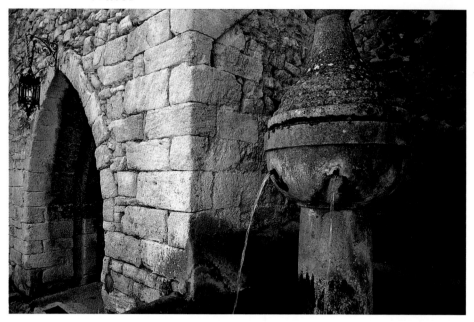

Fountain in Montbrun-les-Bains, a beautiful hillside village in the southern Drôme.

In the cloister of the Cistercian abbey of Thoronet, only the trickling of the "washbowl" fountain breaks the silence.

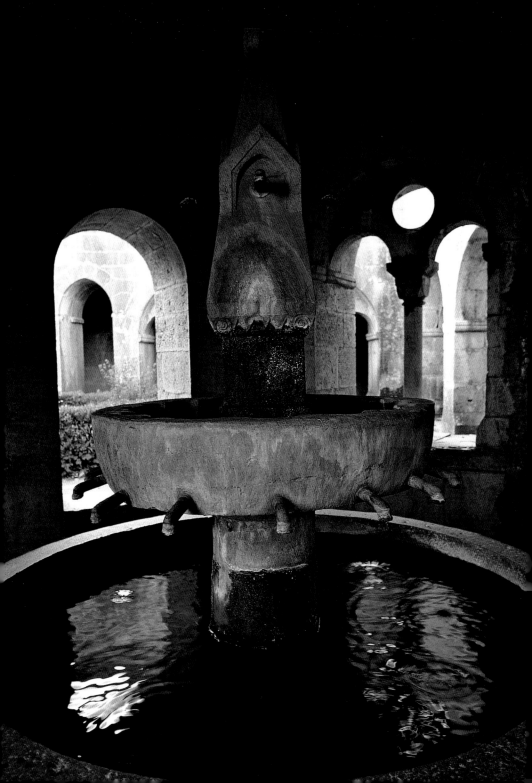

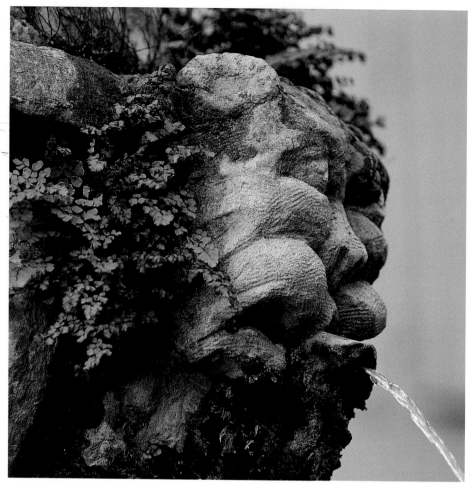

Stone gargoyle in Pernes, the town with thirty-six fountains.

following double page
Fontaine des Quatre Dauphins
in Aix-en-Provence, the town
with 101 fountains.

Fountains are a necessary luxury
in these hot climes; they are
often housed in village squares such
as here in Pernes-les-Fontaines.

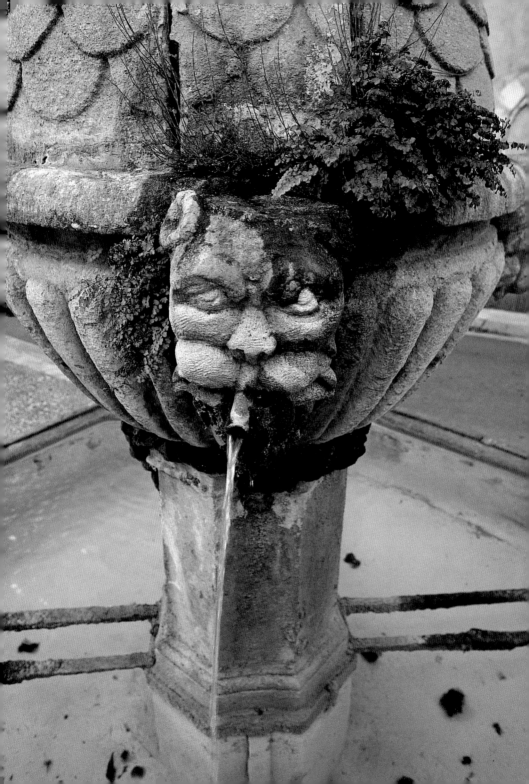

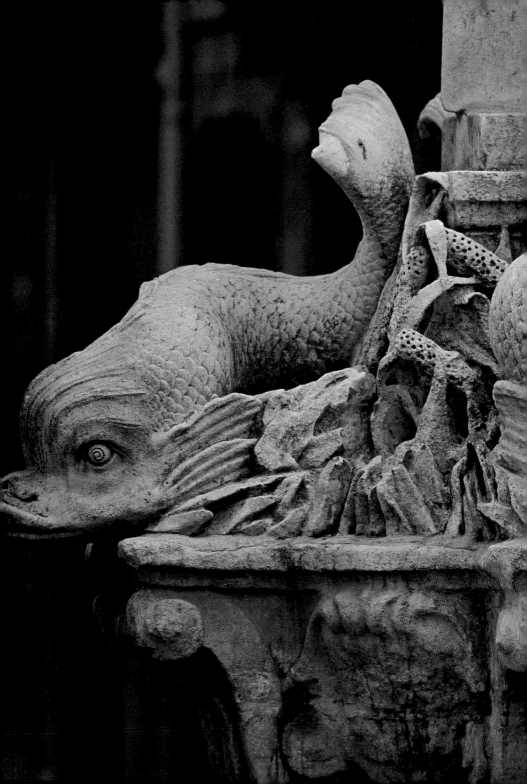

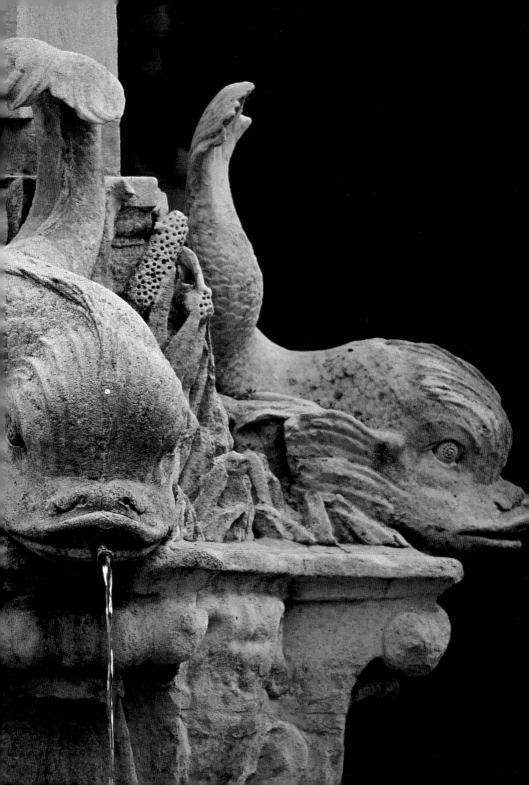

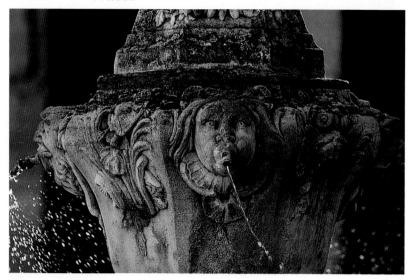

Eighteenth-century fountain in Pernes-les-Fontaines.

Close-up of the fountain on the main square
at the end of the Cours Mirabeau in Aix-en-Provence.

page 246
A fountain in Arles.

page 247
A fountain in Servances in Les Alpilles.

The maritime bestiary of the
Bonnieux fountain in the Lubéron.

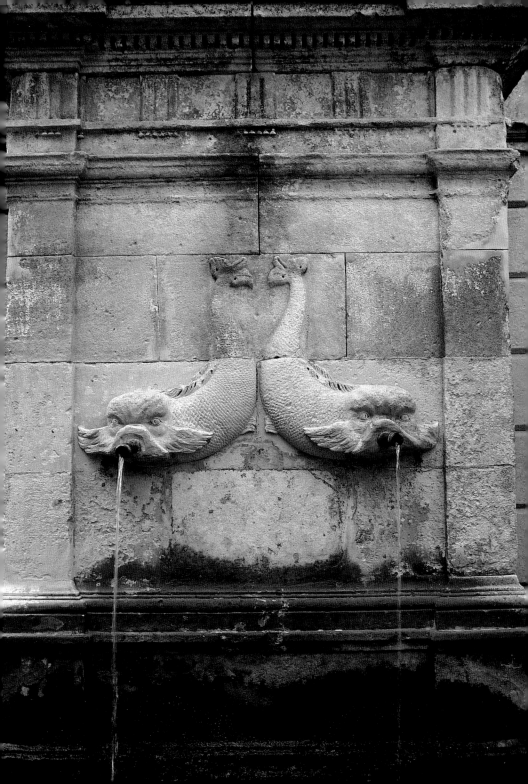

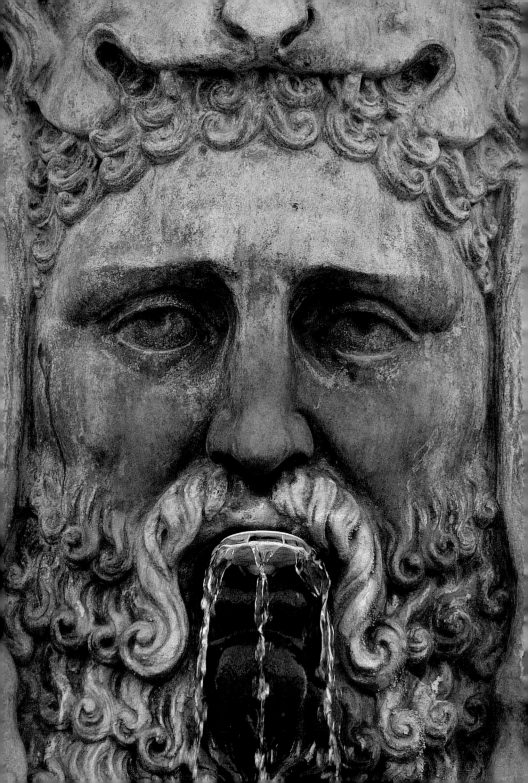

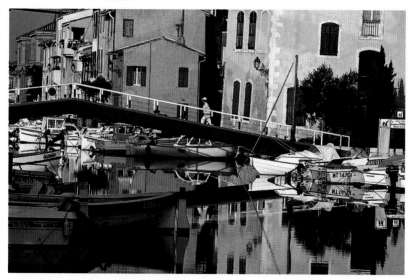

The Saint-Sébastien canal in Martigues; the colors
of the façades mingle with the reflections from the boats.

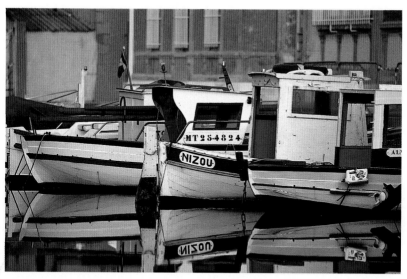

Martigues, a small fishing port on the lake of Berre.

following double page
Grau-du-Roi, a seaside town and
fishing port of the Petite Camargue.

The old sections of Martigues are
flanked by canals, hence the town's
nickname: "Venise provençal,"
the Venice of Provence.

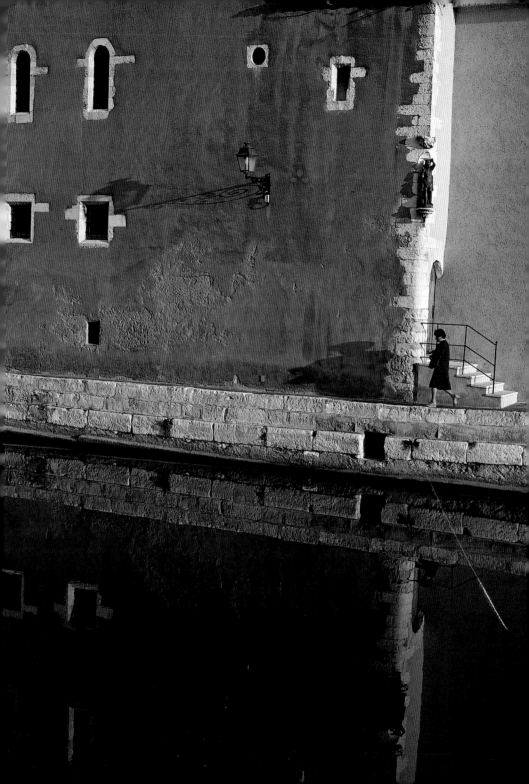

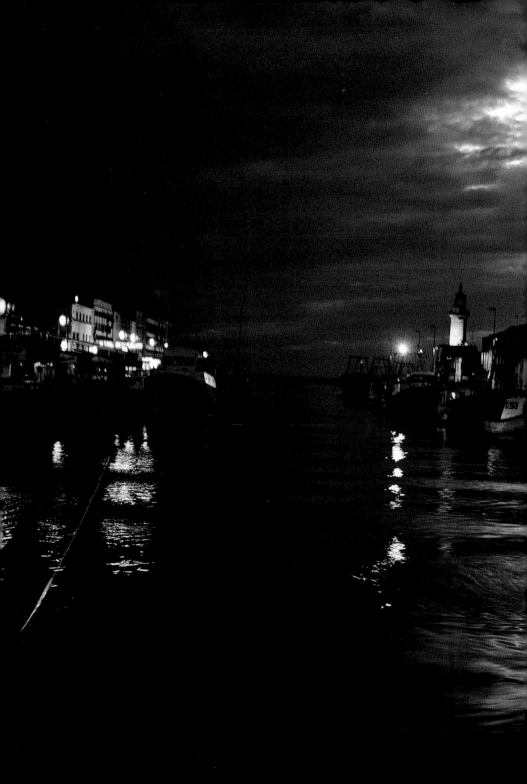

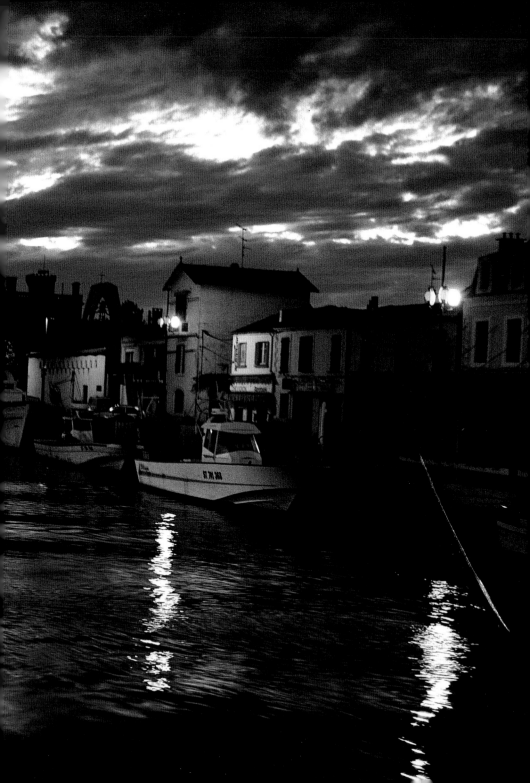

Water

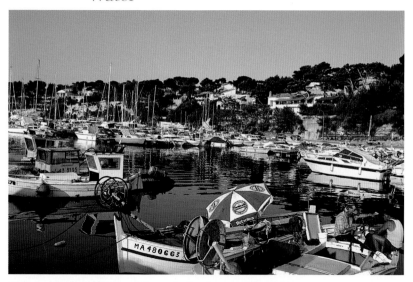

The small fishing port of Carry-le-Rouet near Marseille.

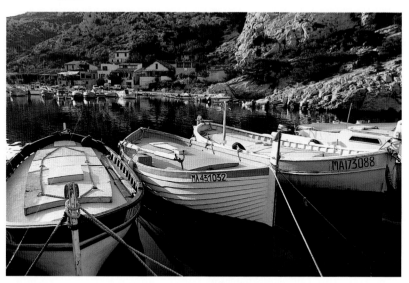

Fishing boats known as *pointus* in the Mediterranean inlets,
the Calanques de Morgiou, to the east of Marseille.

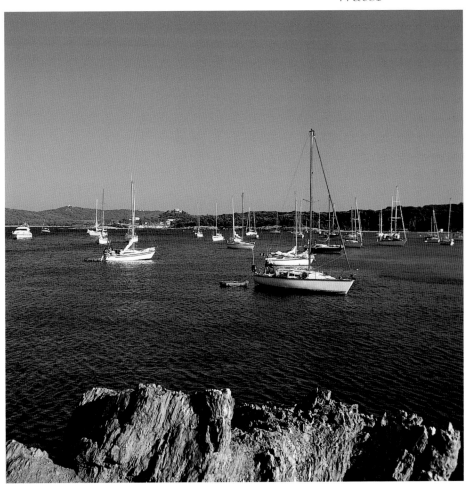

The Plage d'Argent on the island of Porquerolles.

following pages
Dubbed the Venice of Comtat Venaissin, L'Isle-sur-la-Sorgue
is flanked by five branches of the river. Waterwheels
from yesteryear add a touch of life to the canal.

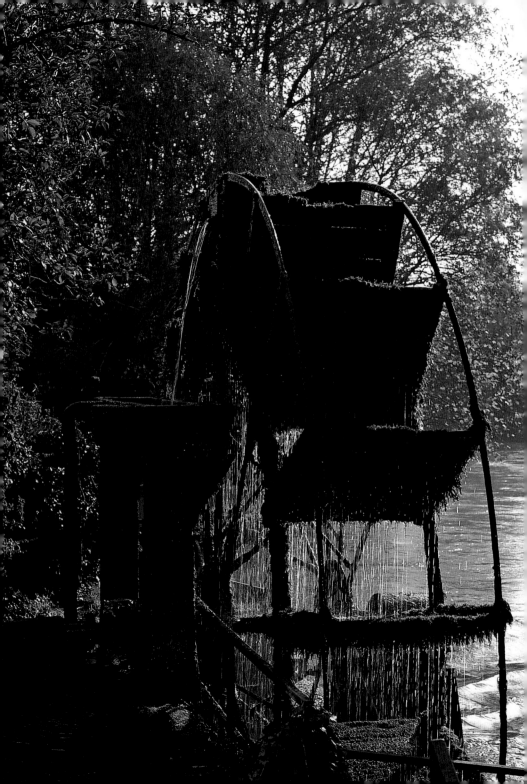

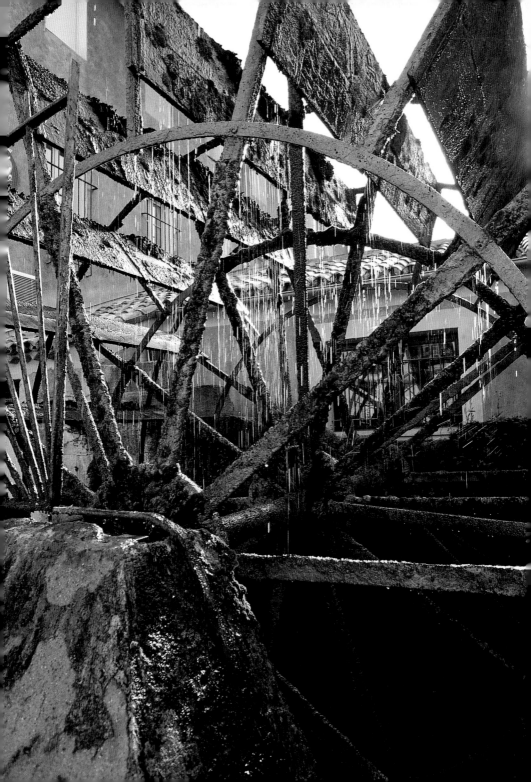

Water

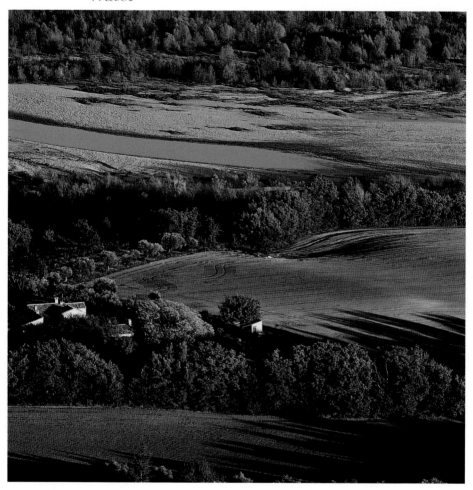

The Durance valley near Lurs.

page 258
Irrigation canal in Saint-Rémy-de-Provence.
page 259
The lush garden of a Ramatuelle hotel.

The Van Gogh bridge in Arles.

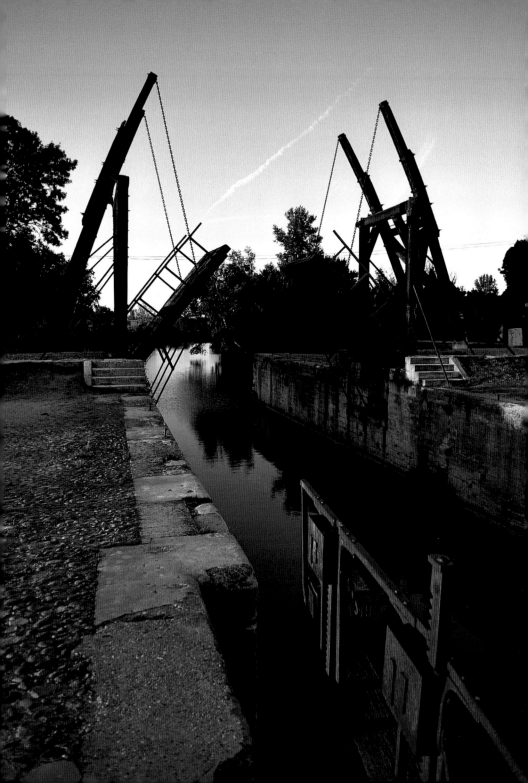

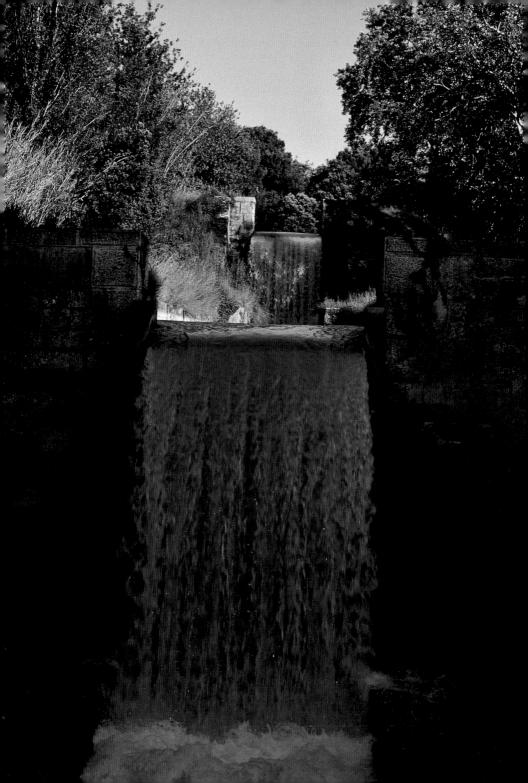

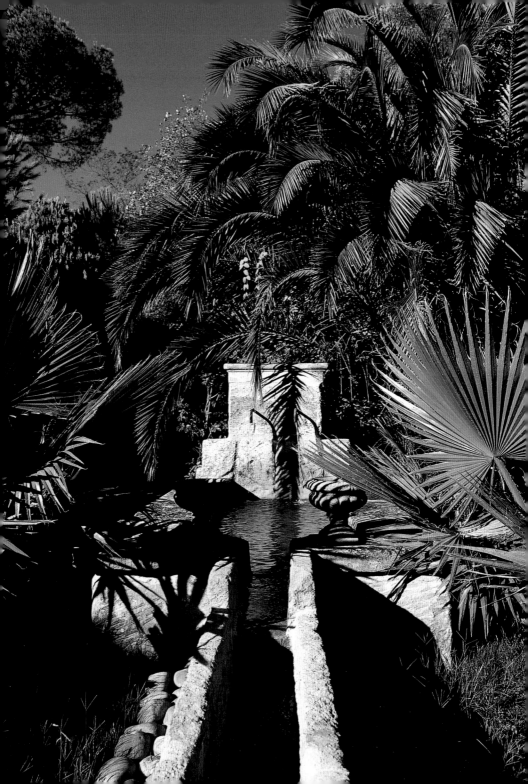

Water

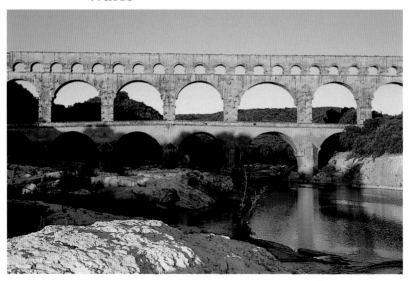

The Pont du Gard, the highest known Roman aqueduct bridge.

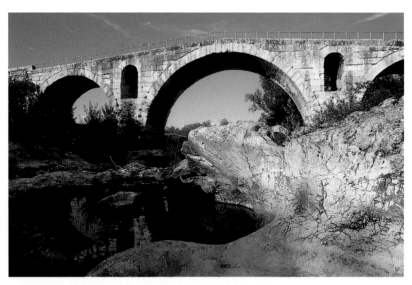

The Julien bridge, over the Calavon, near Bonnieux.

following double page
The Saint-Bénézet bridge in Avignon
during Rhône flooding.

The slender stacks of the
Roquefavour aqueduct in the gorges
of the Arc near Aix-en-Provence.

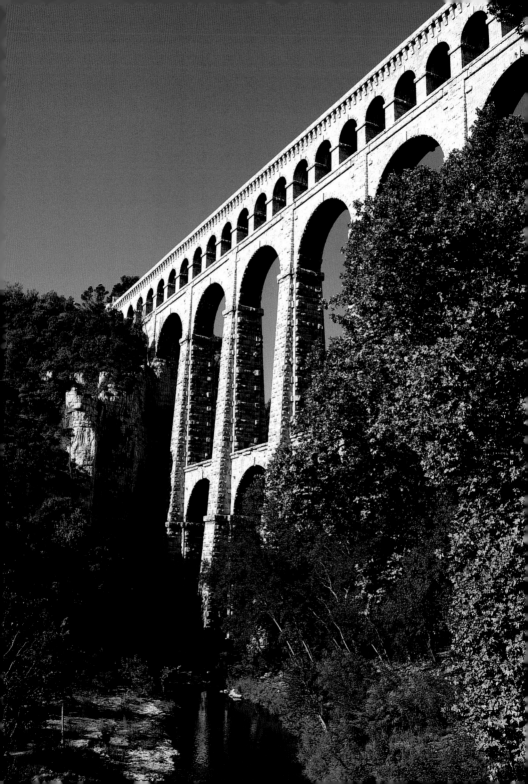

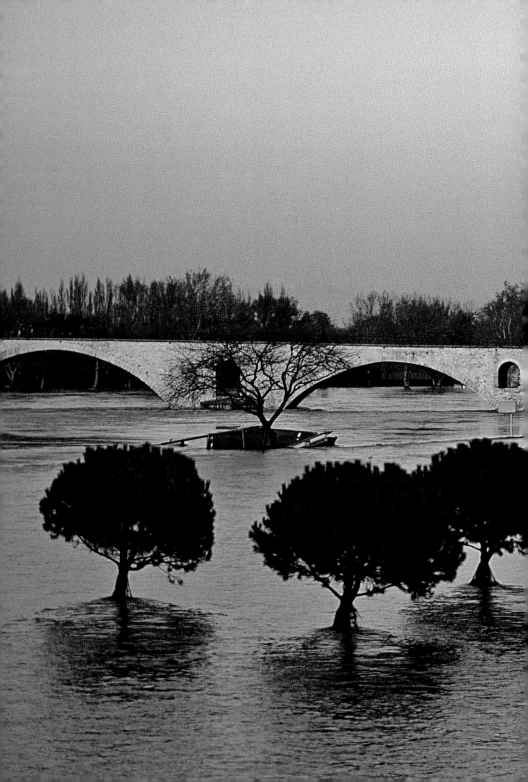

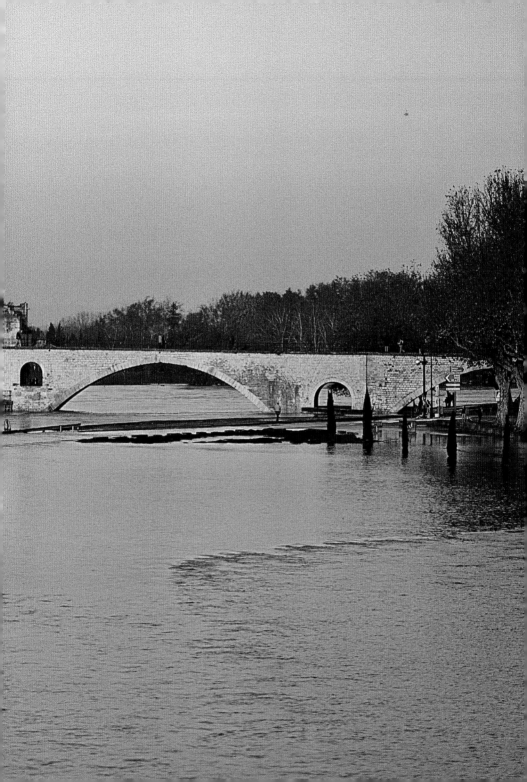

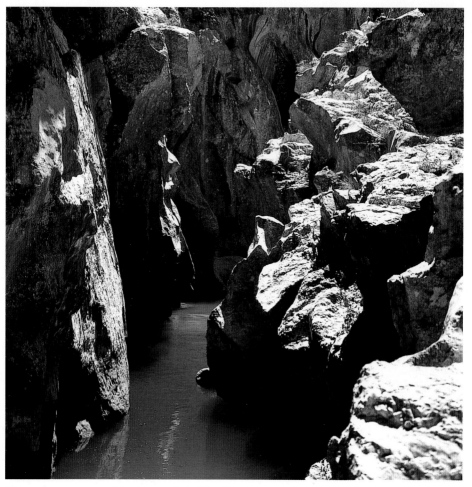

The green waters and jutting rocks of the Styx cave
in Verdon's own grand canyon.

following double page
The Sainte-Croix-du-Verdon
lake at sunset.

The river Verdon's name comes from
its emerald-green (*vert* in French) color.

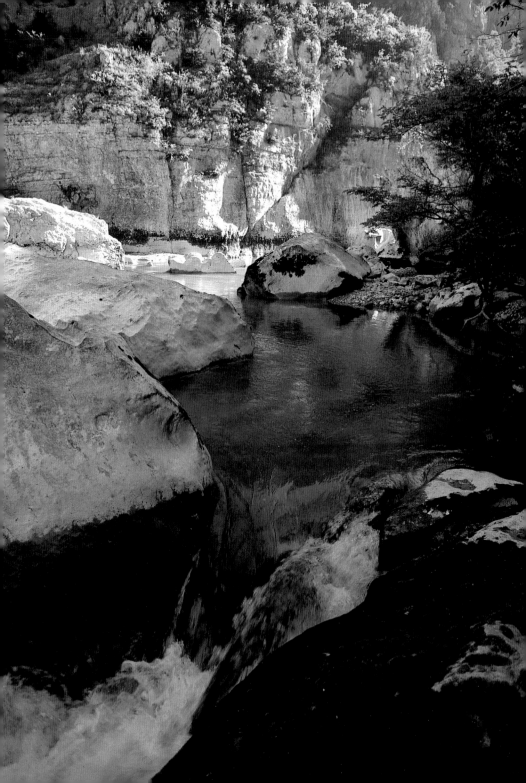

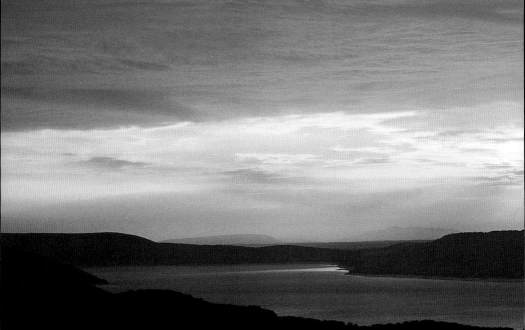

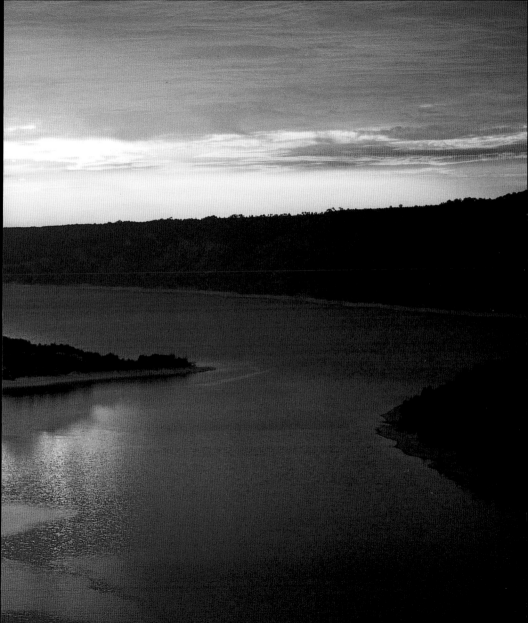

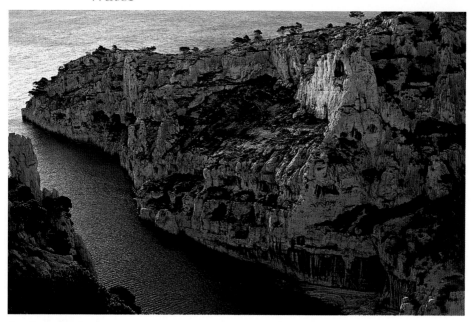

A *calanque*, a deep narrow indentation in the land into which the sea creeps.

With its sheer cliffs and bare ridges,
the *calanque* is a unique
geographical feature along
France's Mediterranean coastline.

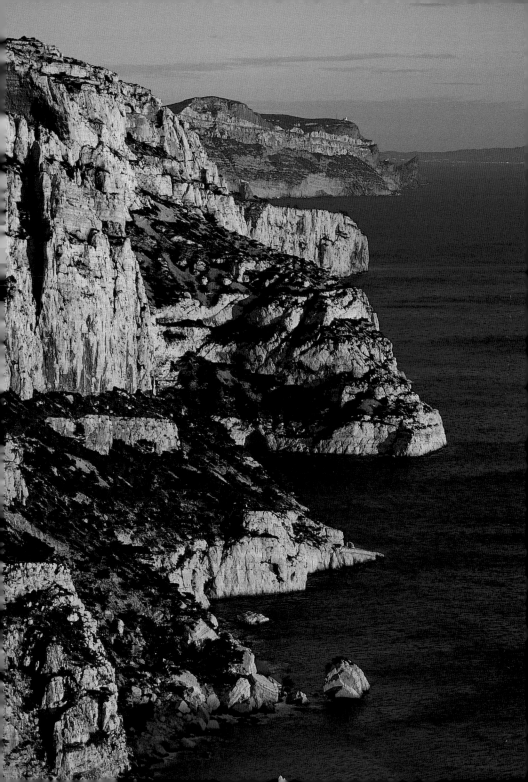

Water

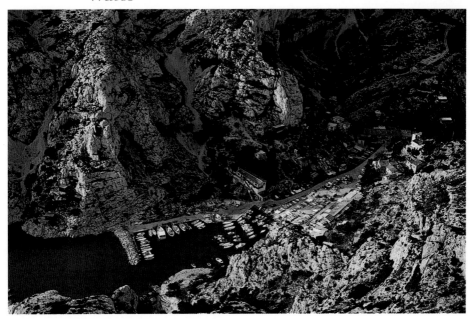

The Calanque de Morgiou near Marseille has a small port and fishing cabins.

The Calanque d'En-Vau
is one of the most spectacular
of its kind and bristles with
limestone needles, the most
picturesque of which is called the
"Doigt de Dieu" (finger of God).

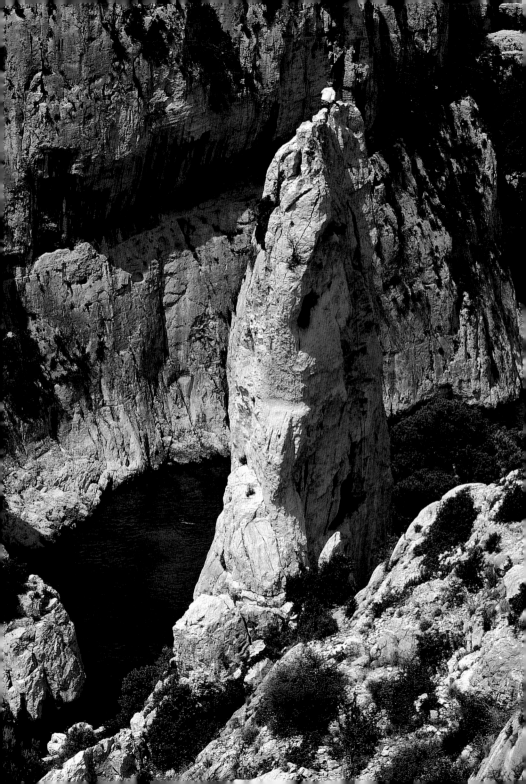

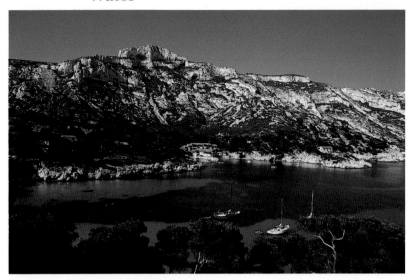

Calanques is the name given to the whole of the limestone massif that spreads between Marseille and Cassis.

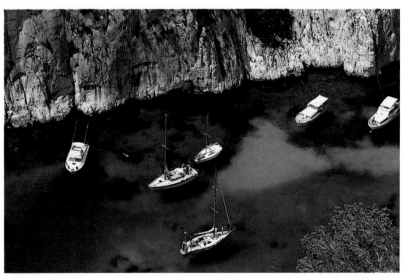

The Calanques de Cassis are only accessible by boat or on foot.

The Calanques de Cassis—cliffs of white limestone plunging into the deep blue waters.

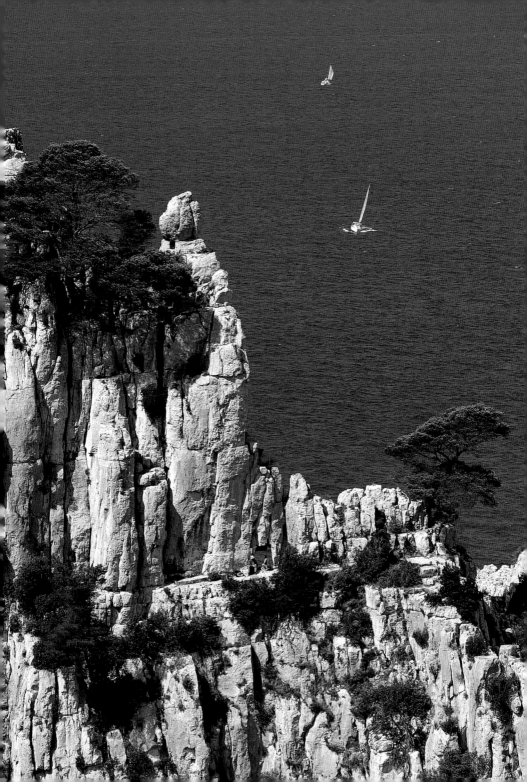

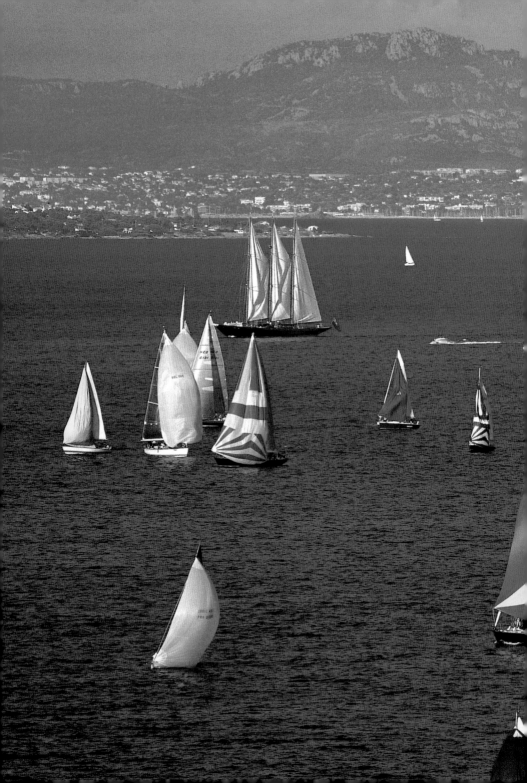

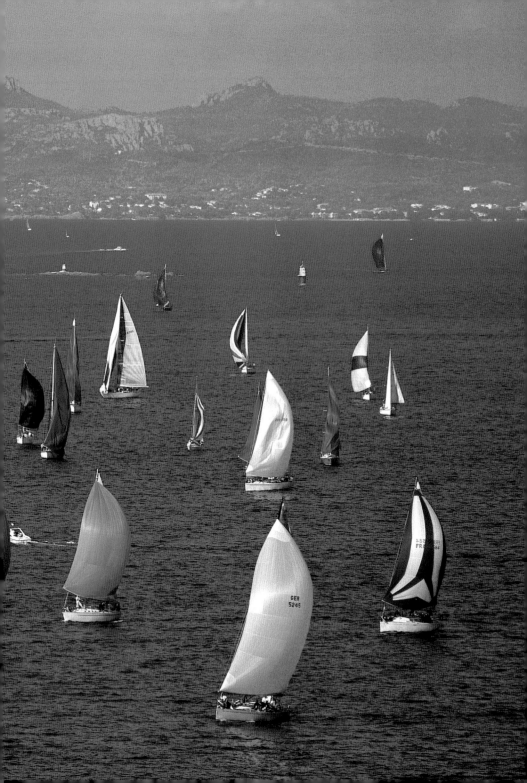

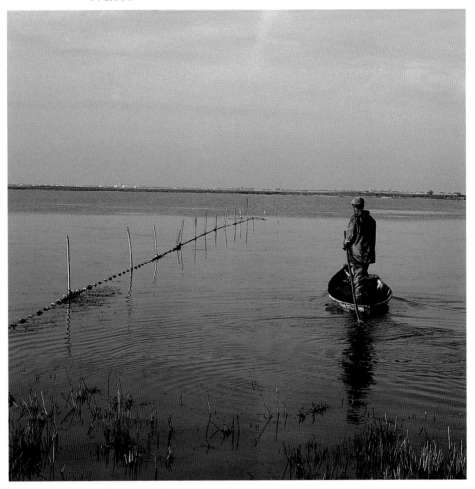

Eel fishing in the Camargue lakes.

preceding double page
A regatta during the Nioulargue yachting
festival in the gulf of Saint-Tropez.

Reeds in the Ginès lake
of the Camargue.

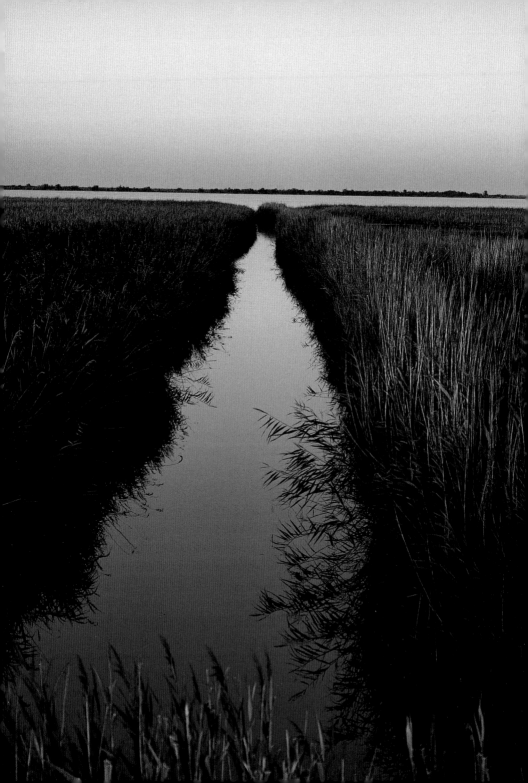

Water

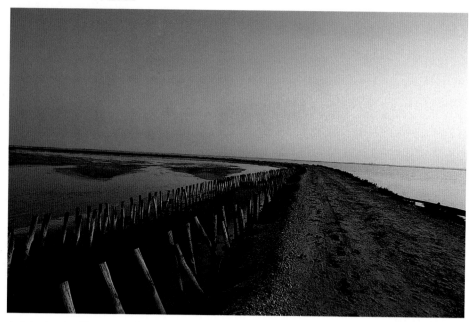

A dyke in the Camargue, between Saintes-Maries-de-la-Mer and the salt marshes of Giraud.

Reinforced dyke
in the Camargue.

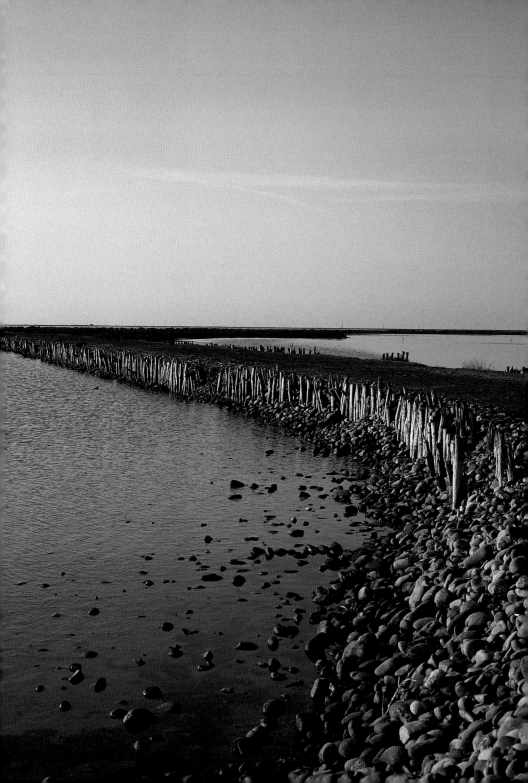

Camargue herdsman's cabin.

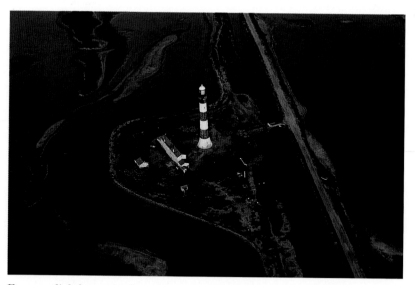

Faraman lighthouse in the salt marshes of Giraud in the Camargue.

The Beauduc site, famous for its shelters spread around the Giraud salt marshes in the Camargue.

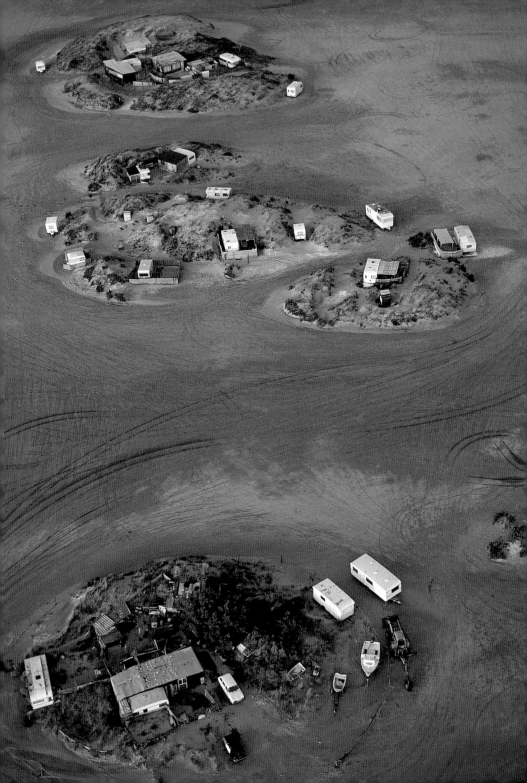

Water

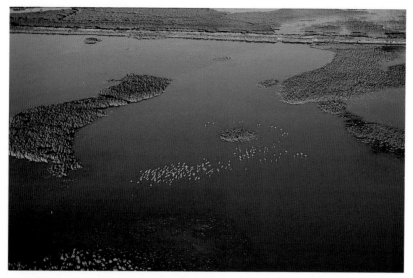

The Camargue is a bird reserve inhabited
by a large number of protected species.

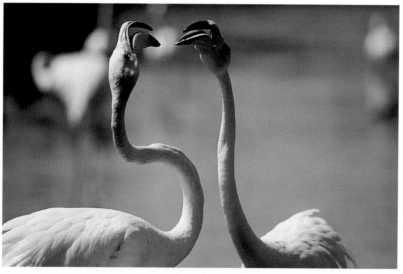

In the bird park of Pont-de-Gau in the Camargue,
it is possible to approach the pink flamingos and their nests.

The Camargue's many lakes
are inhabited by thousands
of pink flamingos.

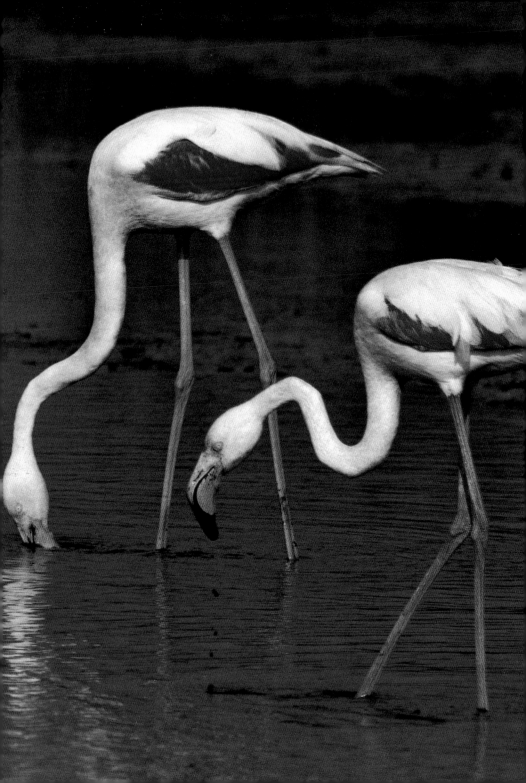

Water

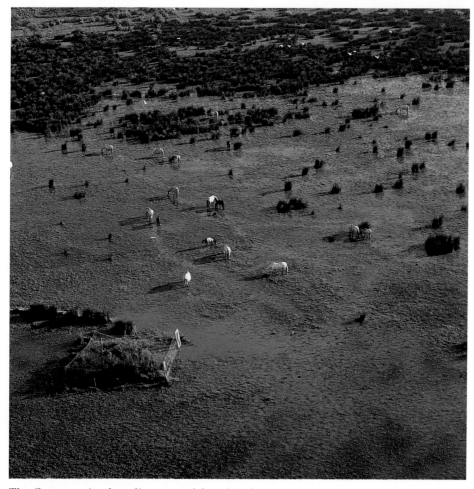

The Camargue is a breeding ground for white horses
and black bulls that live there in herds.

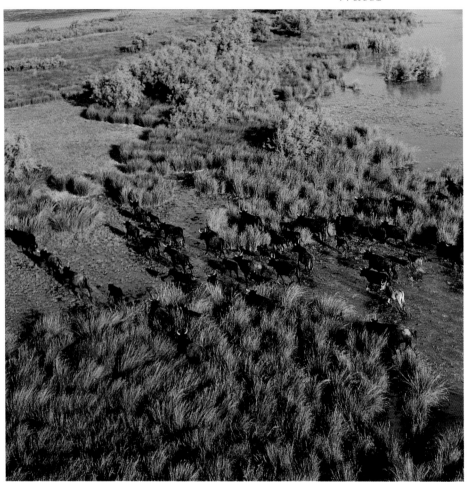

Bulls roaming free in the vast pastures of the Camargue.

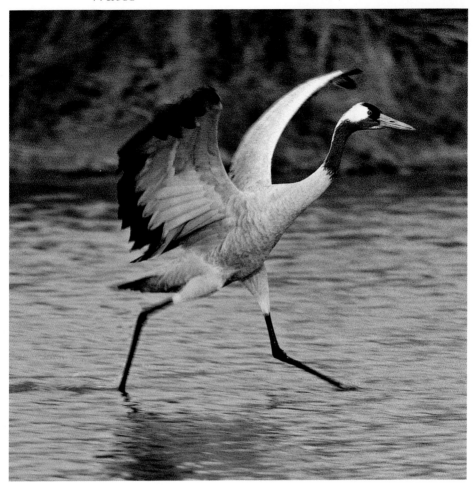

In the Camargue, a crane takes flight.

Herds of bulls or horses are known
as a *manade* in the Camargue.

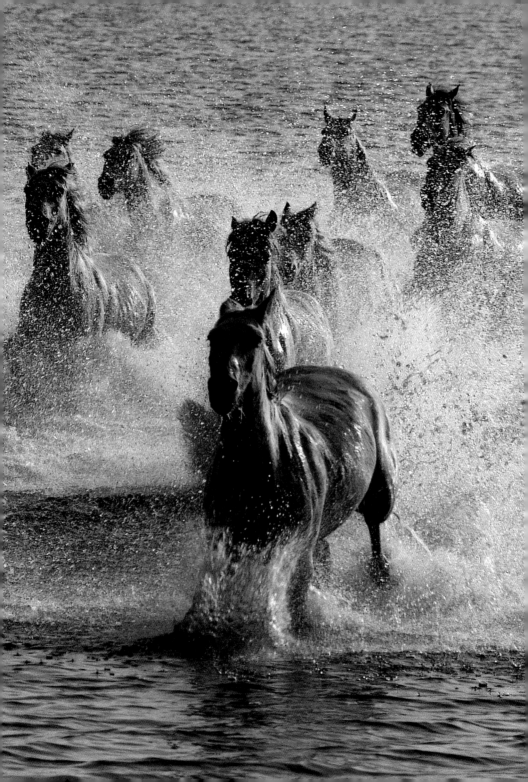

Water

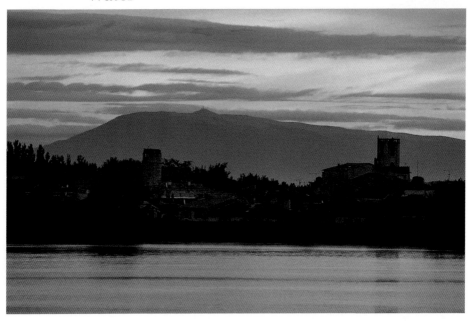

The Rhône river at Vallabrègues with Mount Ventoux in the distance.

preceding double page
Row of plane trees beside
a canal in Les Alpilles.

In Avignon, the Rhône bathes
the Île de la Barthelasse. Mount
Ventoux dominates the landscape.

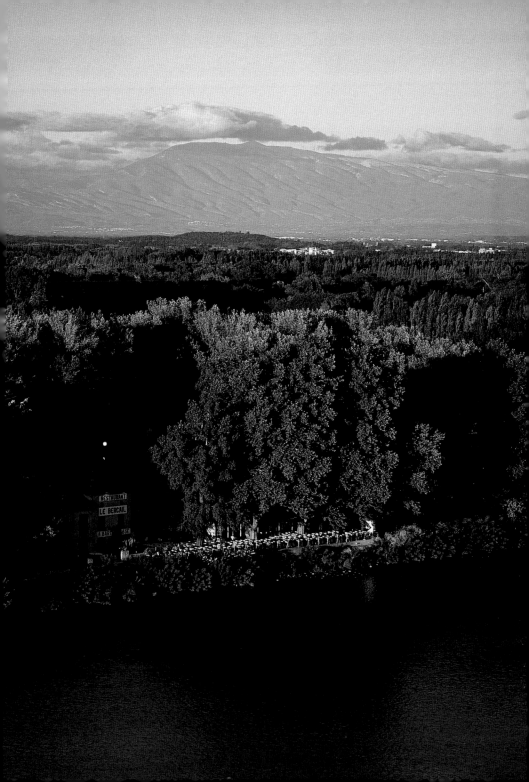

Water

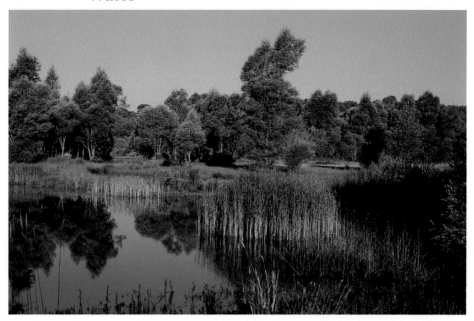

The lower valley of the Verdon before it flows into the Durance.

The valley of Verdon and
the village of Montpezat in
the Haute-Provence Alps.

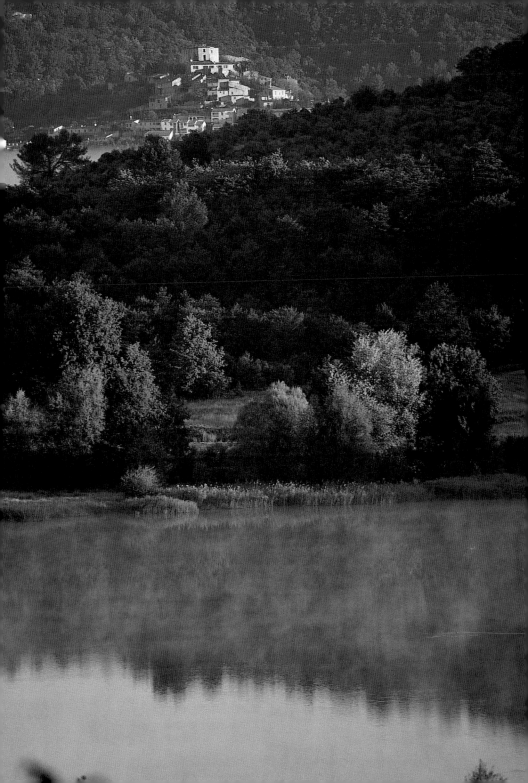

Water

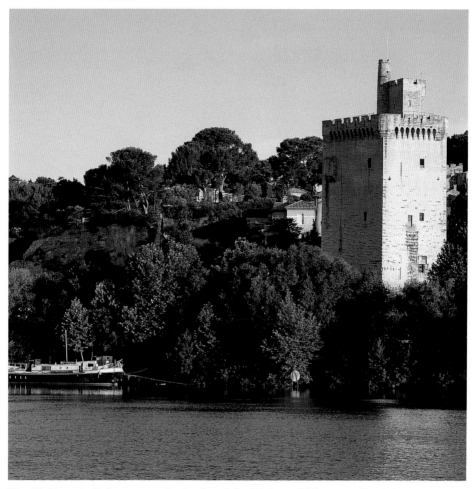

The Philippe-le-Bel tower on the banks of the Rhône at Villeneuve-lès-Avignon.

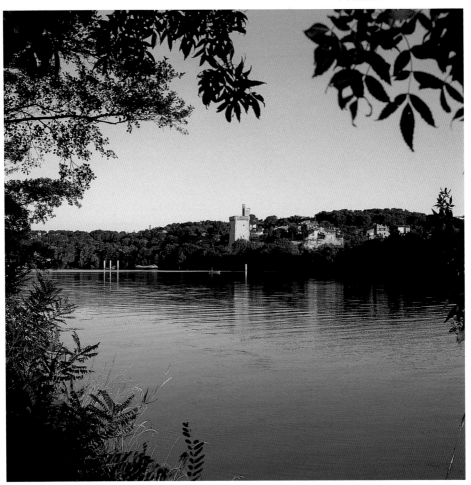

Villeneuve-lès-Avignon as viewed from the Île de la Barthelasse on the Rhône.

following double page
The gulf of Saint-Tropez
as seen from the Citadel.

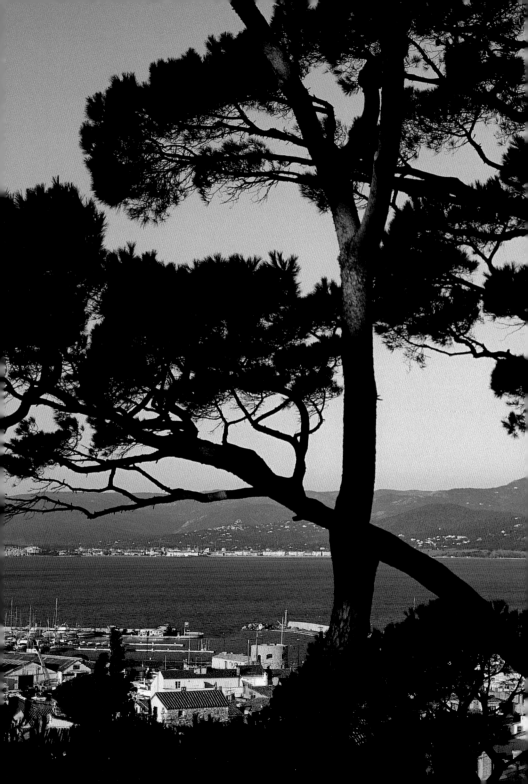

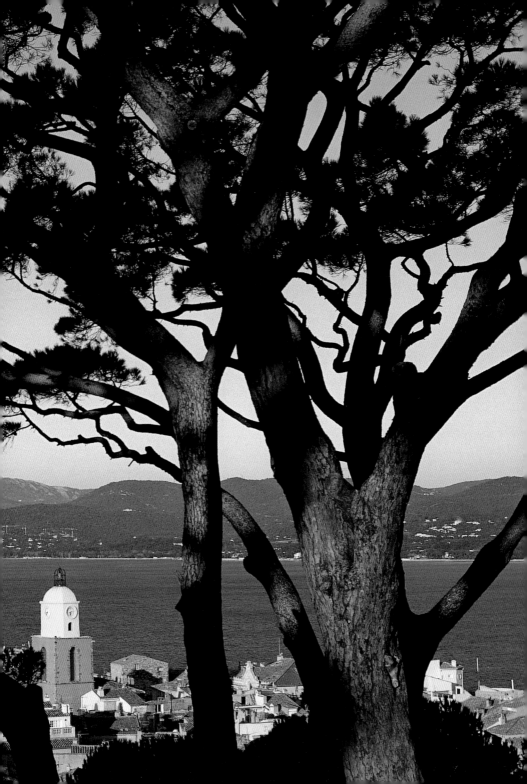

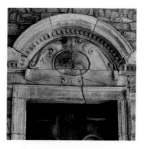
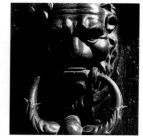

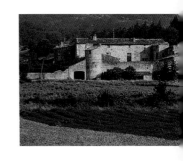

Houses

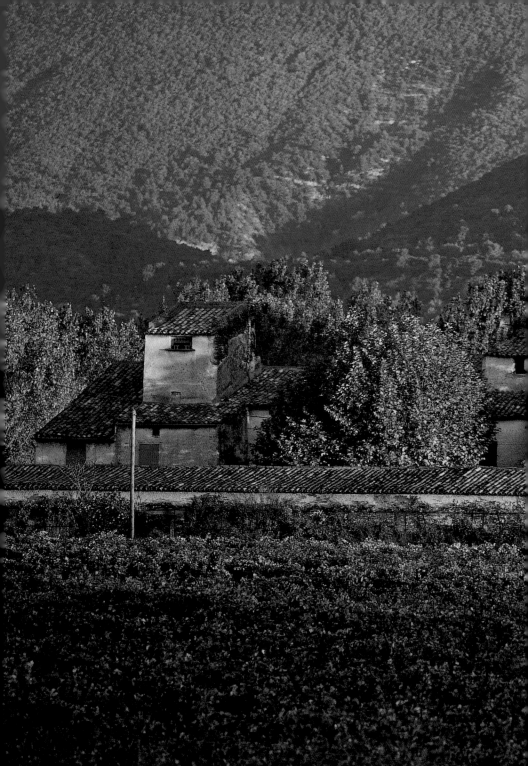

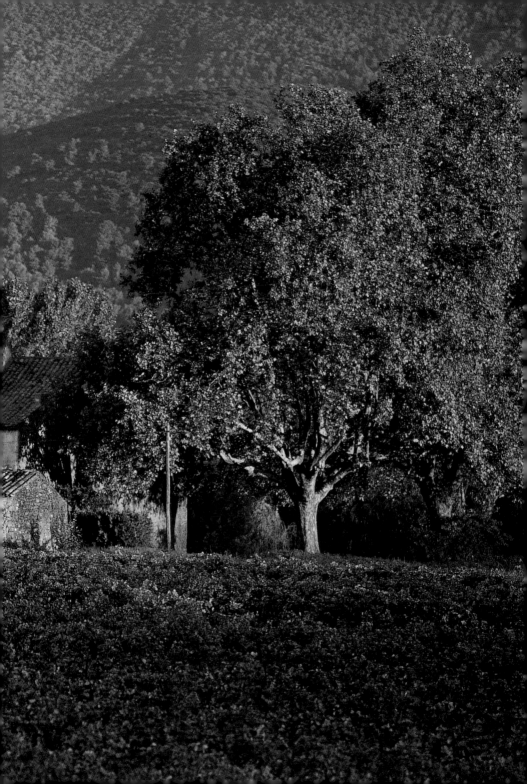

Houses

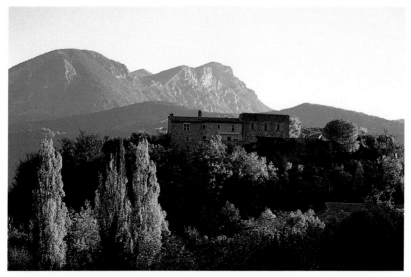

Houses with a view at Poët-Célard, in Provençal Drôme.

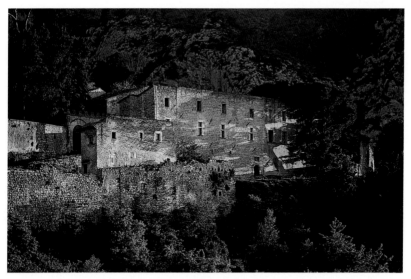

A few years ago, the houses of Oppède-le-Vieux were carefully restored.

preceding double page
A traditional southeastern French house,
a *mas*, surrounded by vines near
La Tour-d'Aigues in the south of the Lubéron.

The beautiful Renaissance
residences of Oppède-le-Vieux are
built into the slopes of the peak.

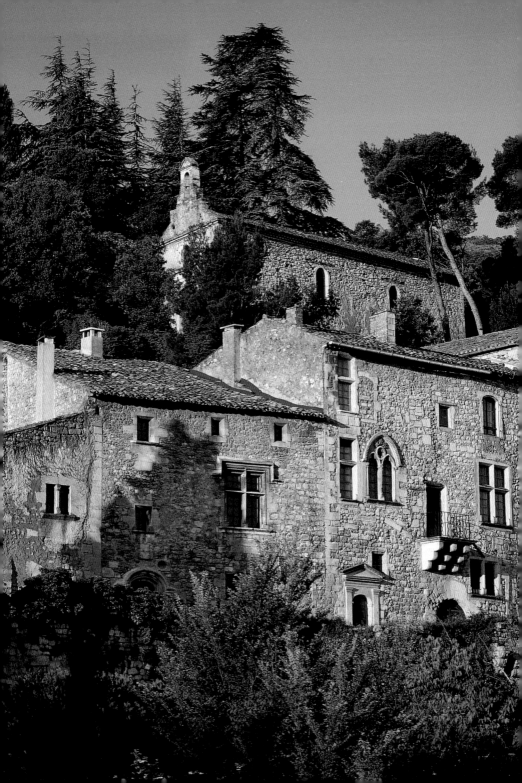

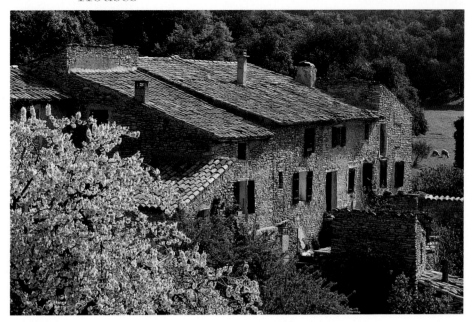

A traditional *mas* in the village of La Crémade not far from Gordes.

In Uzès, the houses nestle
around the duke's château.

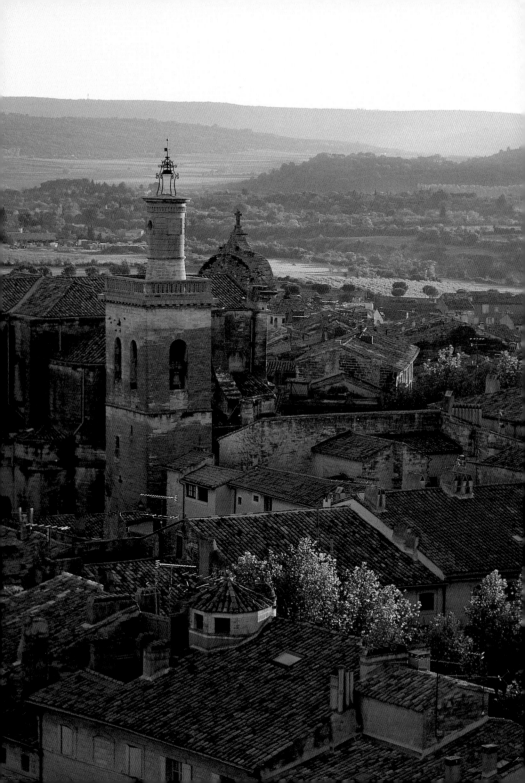

Houses

The village of Goult in the Lubéron.

The traditional sixteenth-century
Mas de la Brune, basking in
the shade of an old lime tree
in Eygalières, is a jewel of
Renaissance architecture.

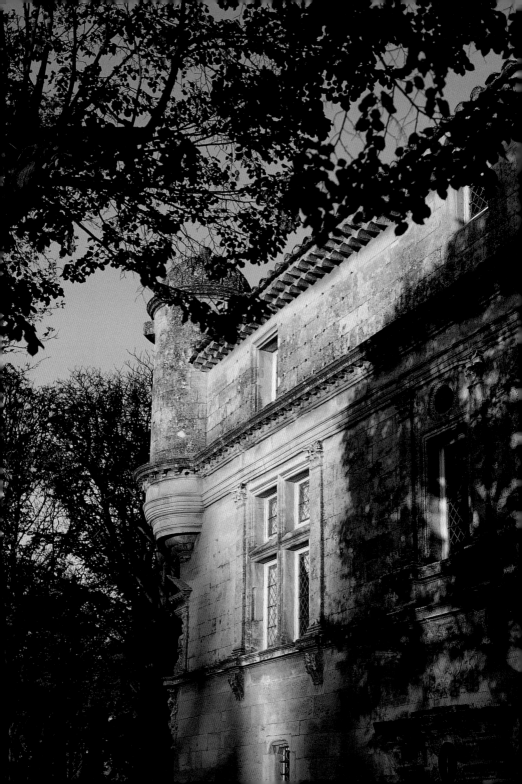

Houses

Former sheepfolds, here in Paradou in Les Alpilles, are often transformed into residences.

Traditional Provençal farmhouse—
a *bastide*—near Uzès.

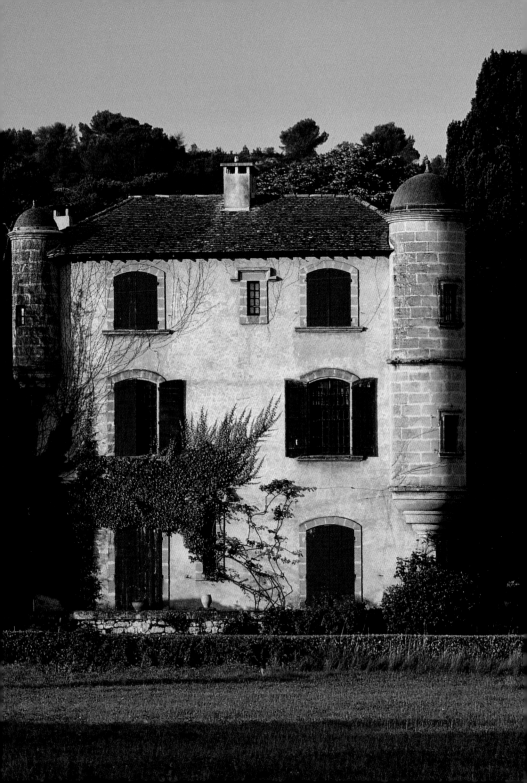

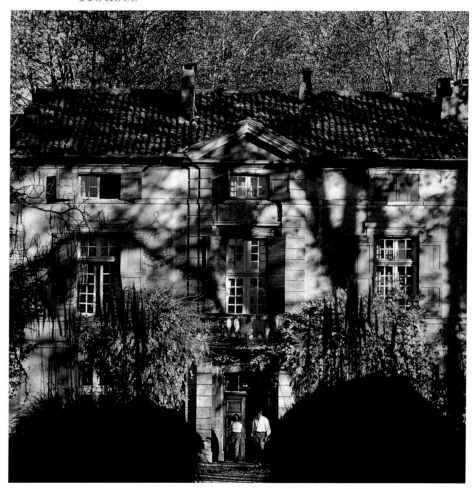

The Château de Roussan in Saint-Rémy-de-Provence, is a classic example of an eighteenth-century *bastide*.

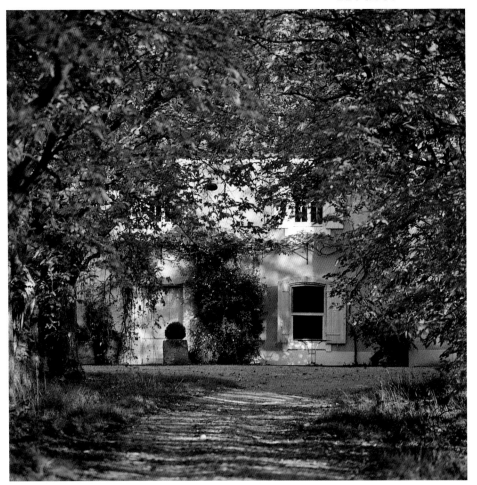

In Les Alpilles, a *mas* hidden at the end of a lane of chestnut trees.

following double page
In Fontvieille, in Les Alpilles, the Château d'Estoublon dates from
the eighteenth century. It produces high-quality wine and olive oil.

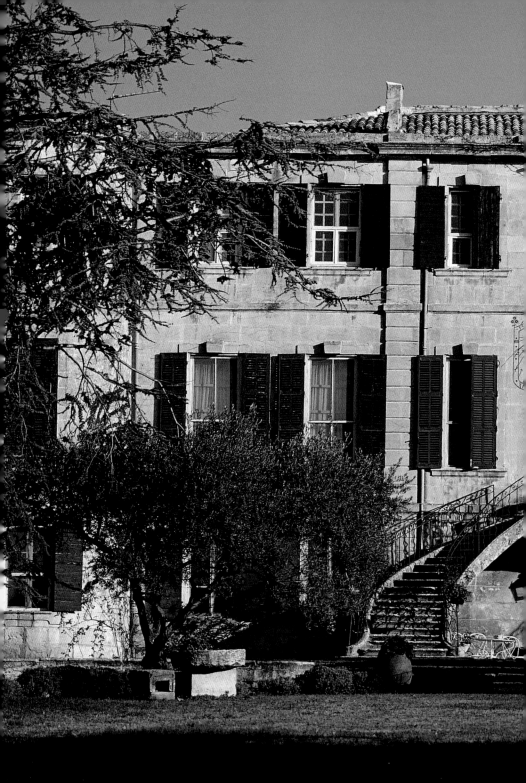

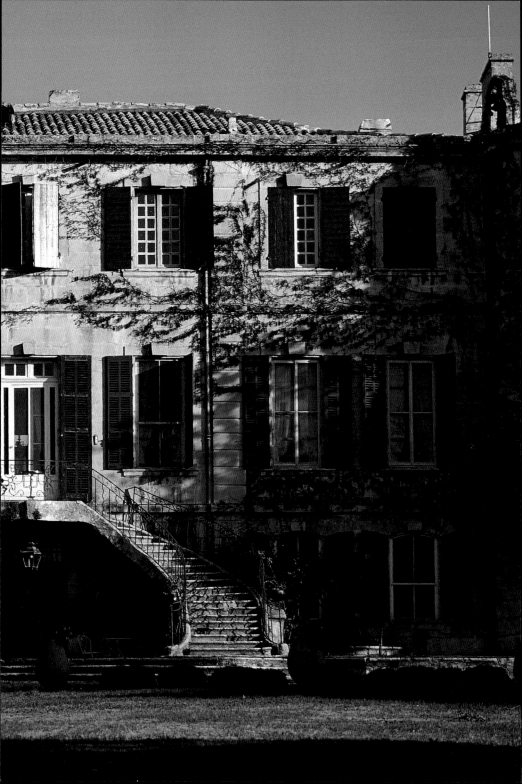

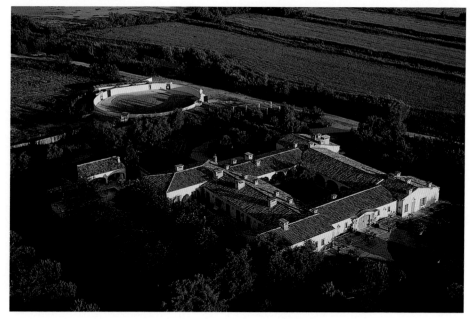

The Carrelet *mas* in the Camargue, where Spanish bulls are raised.

In the Petite Camargue, the Château
de Tellan, near Aigues-Mortes, was
restored in the seventeenth century.

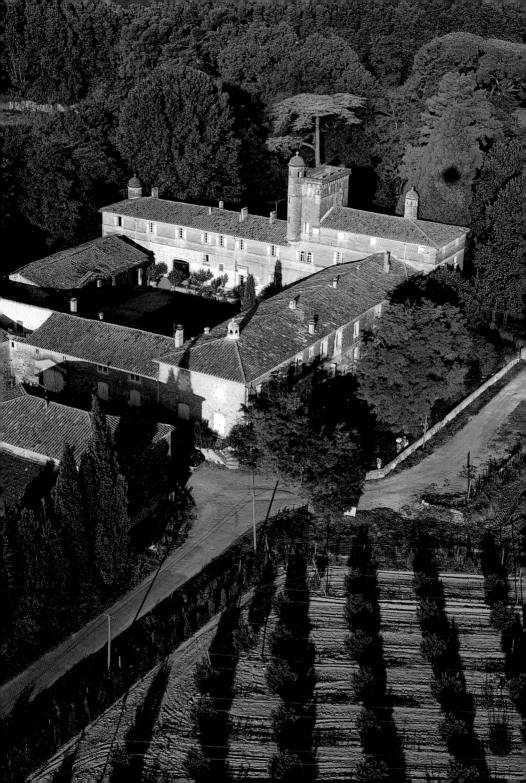

A dwelling place in the village of Ménerbes in the Lubéron.

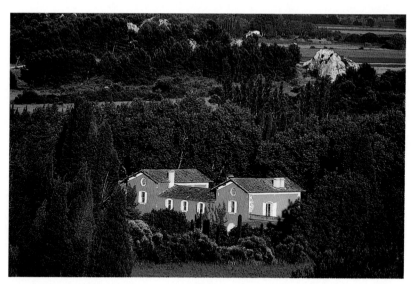

The ocher roughcast of a *mas* near Paradou in Les Alpilles.

A *mas* surrounded by crops
in the upper Lubéron.

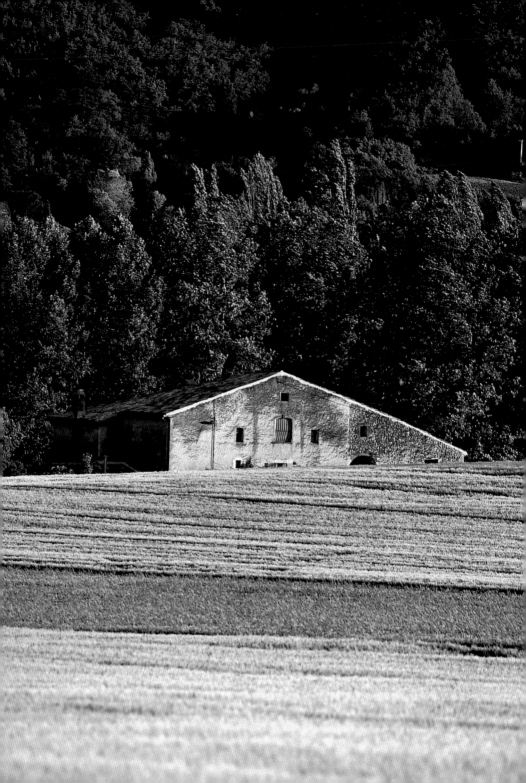

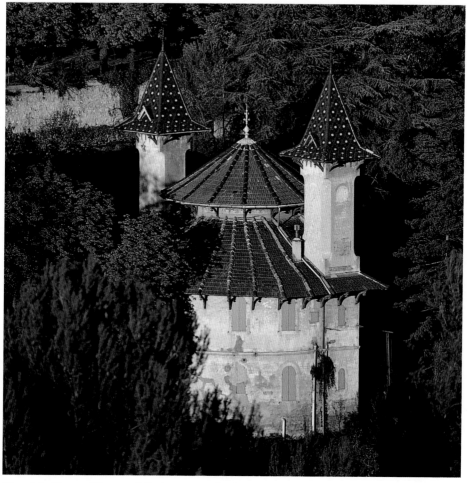

The old village of Pennes-Mirabeau, not far from Marseille, conceals architectural surprises.

following double page
A *mas* near Apt, amid the vineyards.
The region produces very interesting wines.

Between Carpentras and Mount Ventoux, the Modène bell tower, like a 1900-style bandstand, seems to rest on a house.

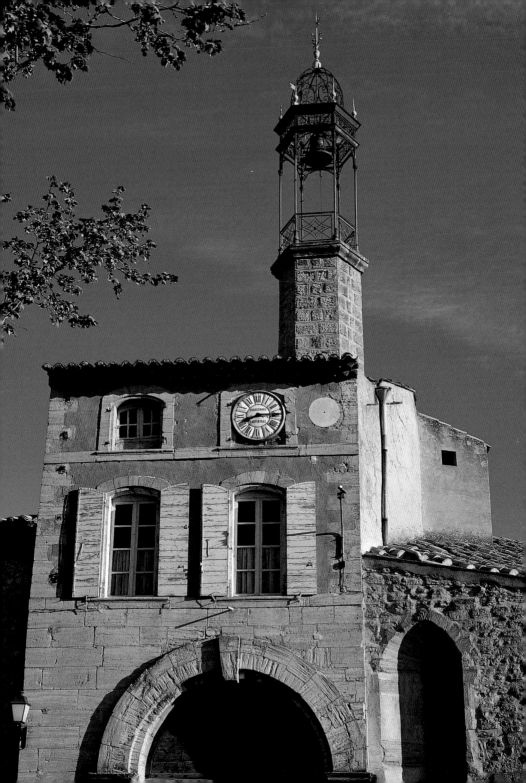

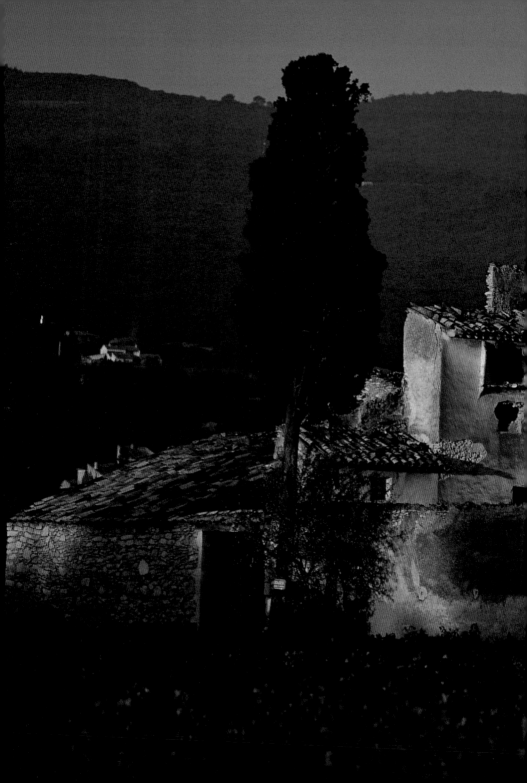

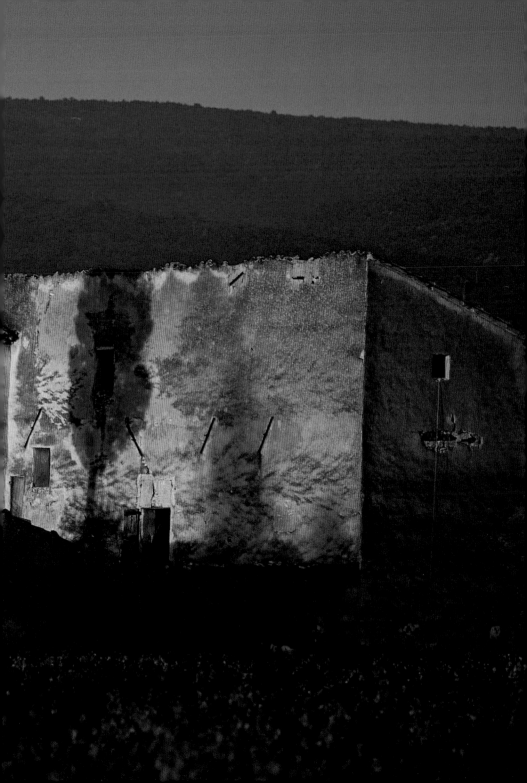

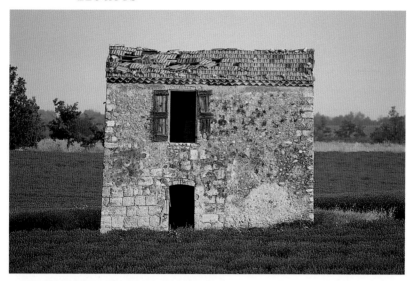

A two-story hut on the Valensole plateau.

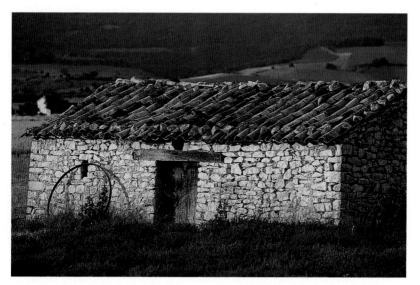

This hut, used to store field tools, also provides shelter from the sun.

Amid a sea of lavender, this stone hut
in Ferrassières breaks up
the pattern of the landscape.

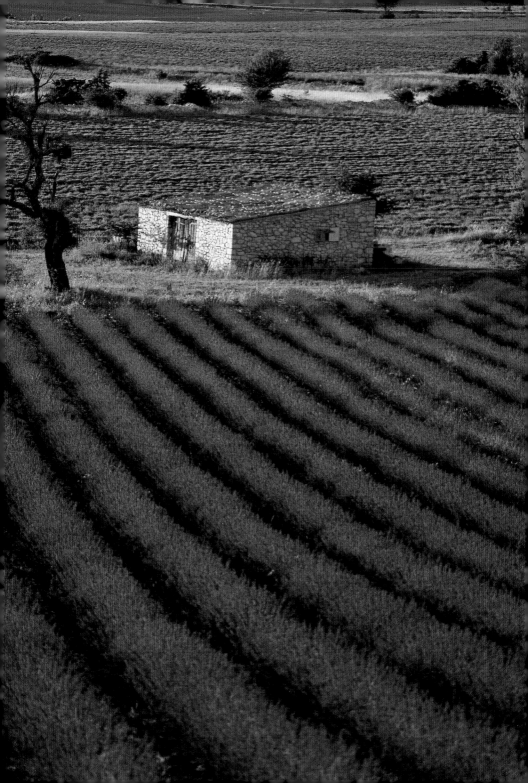

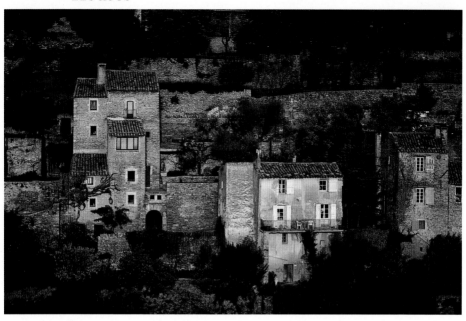

In Gordes, in the Lubéron, houses have to be constructed in dry stone.

following double page
Many traditional, abandoned *mas*,
such as this one near Bonnieux,
subsequently become delightful holiday homes.

In the mountains above Apt,
the houses of the small hamlet
of Sivergues are very isolated.

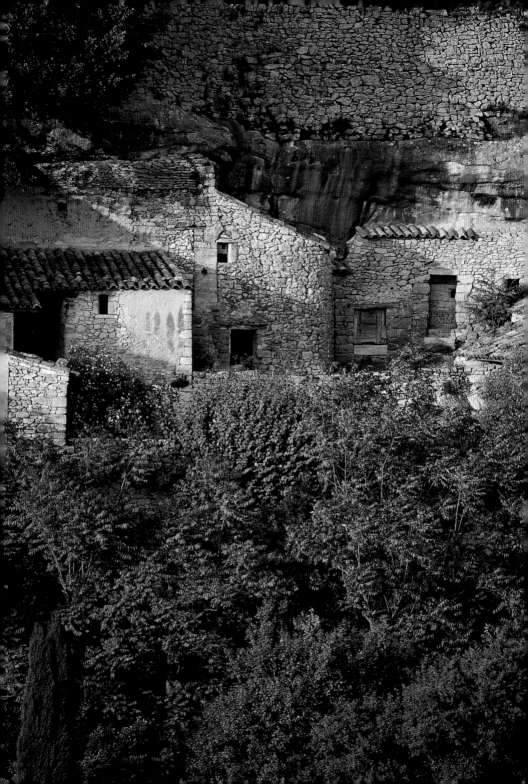

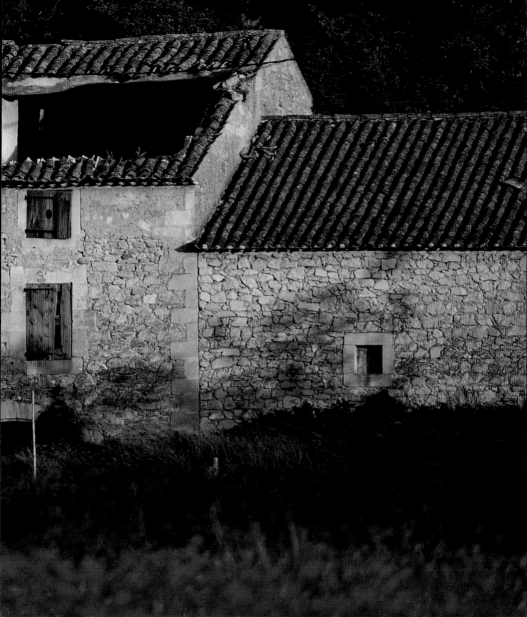

Houses

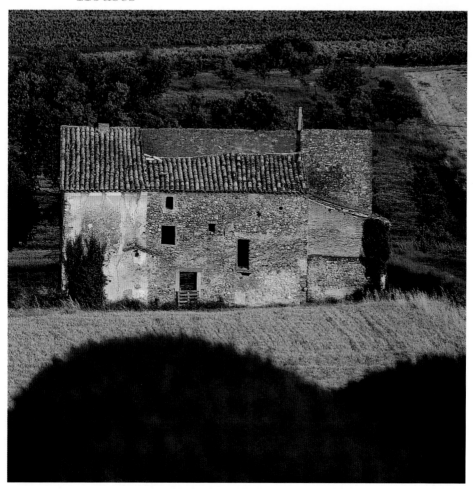

A farm and lavender crops in Provençal Drôme.

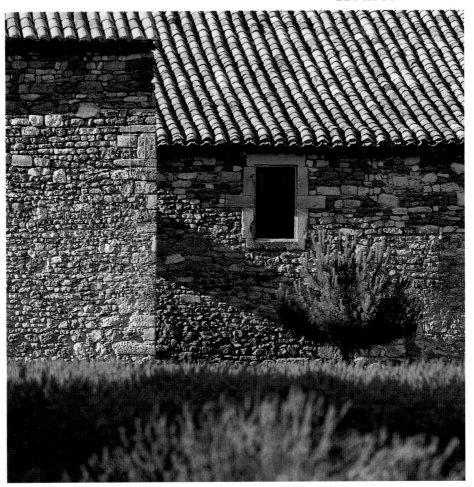

A traditional Provençal house. Lavender, ubiquitous in the region, surrounds the buildings.

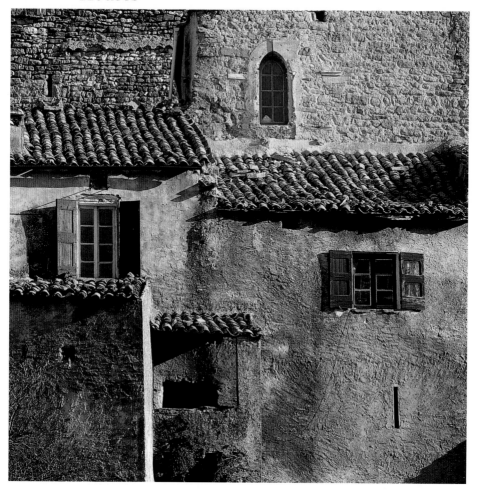

The ocher-painted façades of the hamlet of the Rocher-d'Ongles, north of Forcalquier.

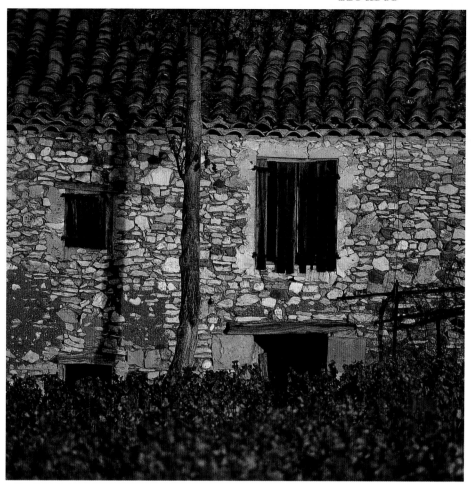

An outbuilding in the Lubéron. Such a refuge in the middle of the fields is very welcome during the hottest times of the day.

Provençal tiles in Entrevaux. Beneath the round-tiled roofs are drying rooms for fruit.

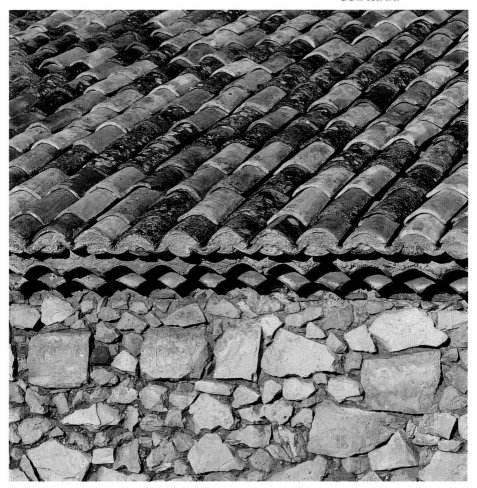

The rooftop of a *mas* in Les Alpilles. The frieze, composed of overlapping tiles, creates a wavy line between the roof and the rubblework of the walls.

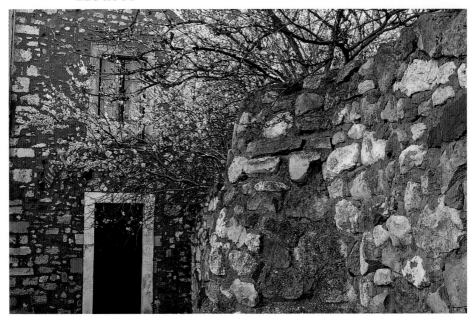

The light-colored stone frame of the door is illuminated by the flowers of a wild almond tree.

The abundant wisteria brings cool freshness to the heavy stone walls of this Saint-Rémy-de-Provence house.

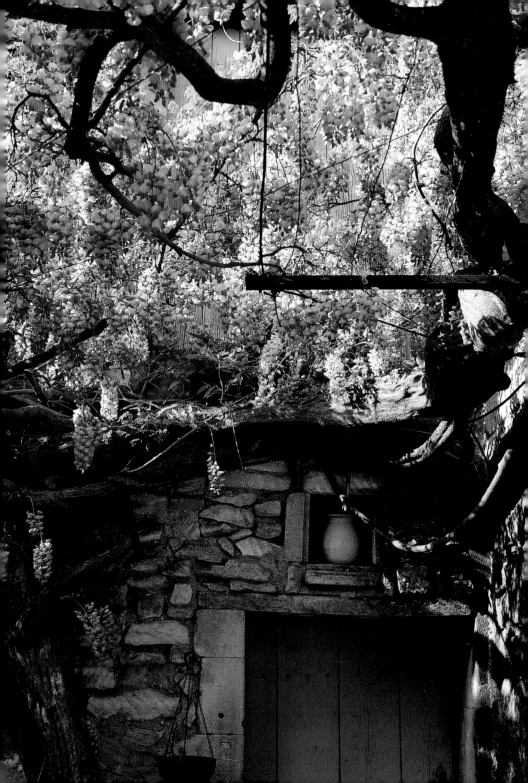

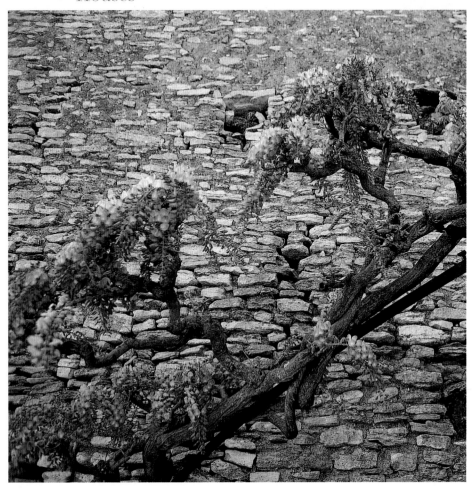

Knotted wisteria against a dry-stone *mas* at La Crémade.

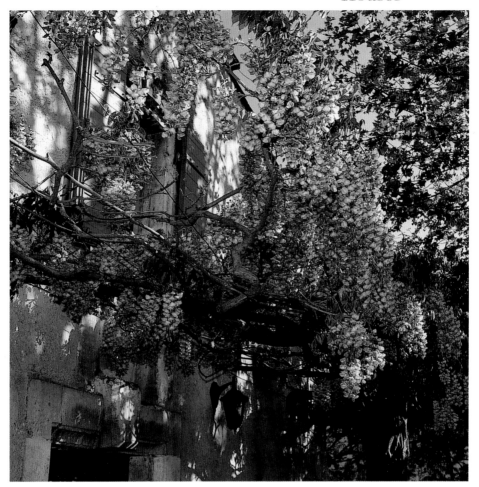

Walls, windows, and shutters are hidden beneath the exuberant flowering wisteria.

Houses

A *mas* built of dry stone in the Vaucluse. The window is small so as not to let in heat.

An attractive door with an ornate stone lintel, in La Bégude-de-Mazenc, Drôme.

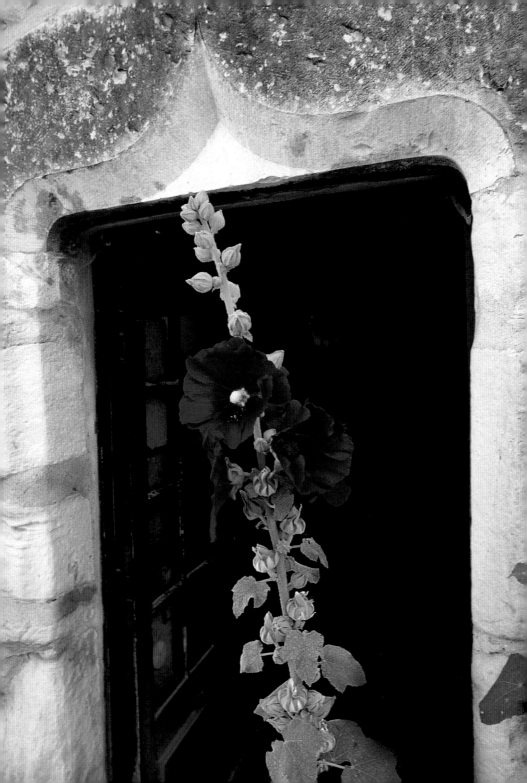

And old rose roughcast façade in Oppède-le-Vieux in the
Lubéron.

The majority of the Oppède-le-Vieux
mansions, on the north side of the
Lubéron, date from the fifteenth
and sixteenth centuries.

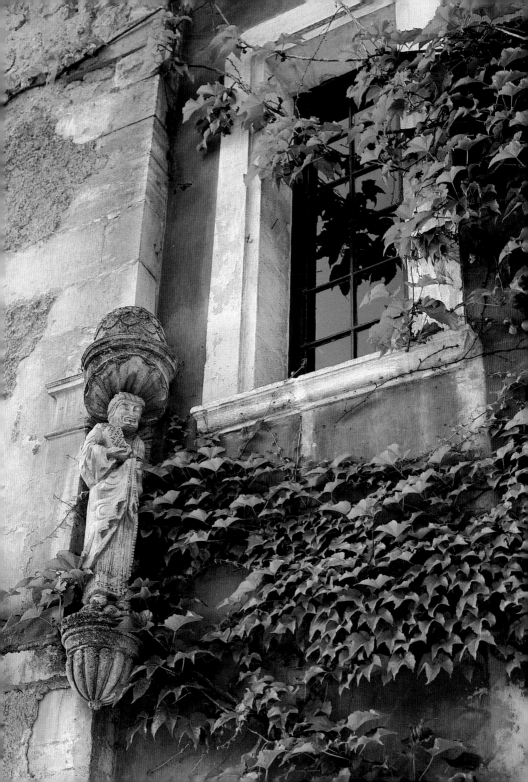

Houses

A round window provides light to the top floor of the house hidden behind the blossoming almond tree.

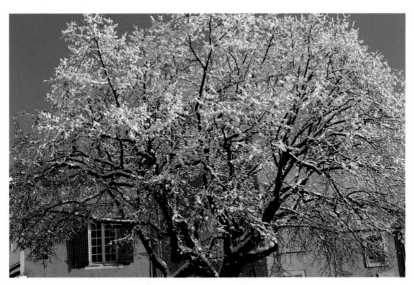

A Roussillon village in winter.

Round, so-called "canal" tiles, typical of Provence, produced with local clay from Roussillon.

Fishermen's houses in Martigues. The shades of the façades are enhanced
by the white frame of the windows and balconies.

An ocher façade in Roussillon.
The ocher-dye pigments of
the facing do not fade in the sun.

Houses

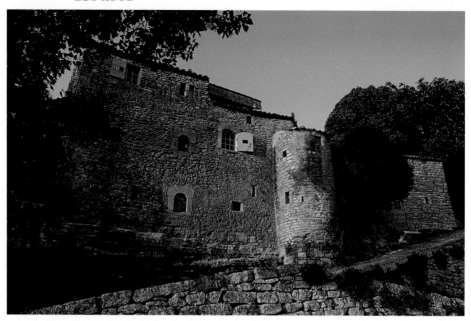

A fortress house, in Sivergues, in the foothills of the Lubéron,
with heavy stone walls and narrow doors and windows.

An elegant Roussillon
village square house.

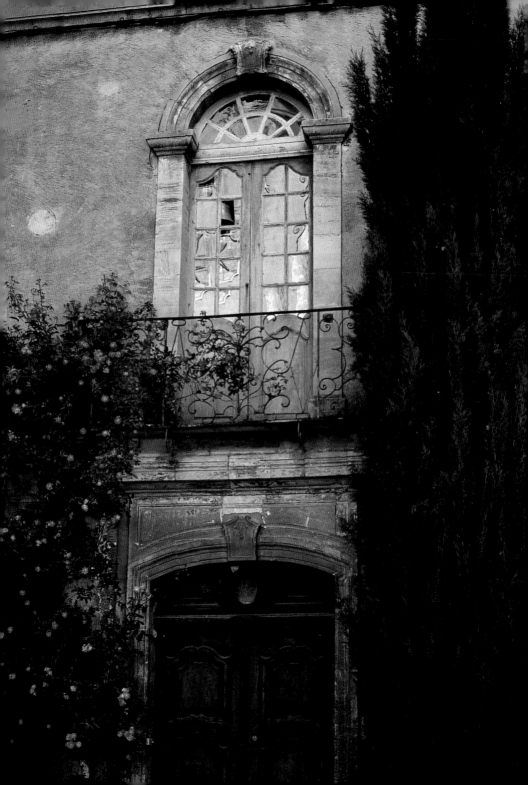

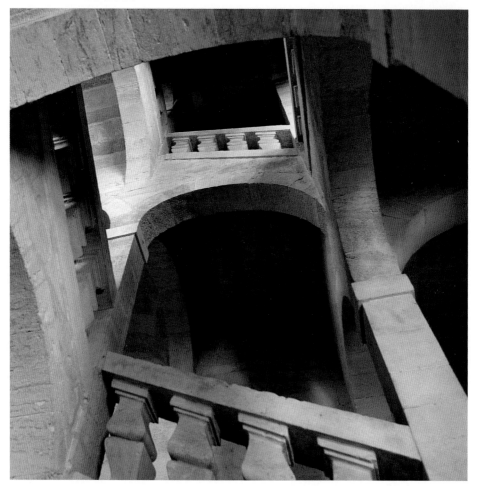

Baluster staircase with central opening in the Hôtel de Joubert et d'Avéjan, Uzès.

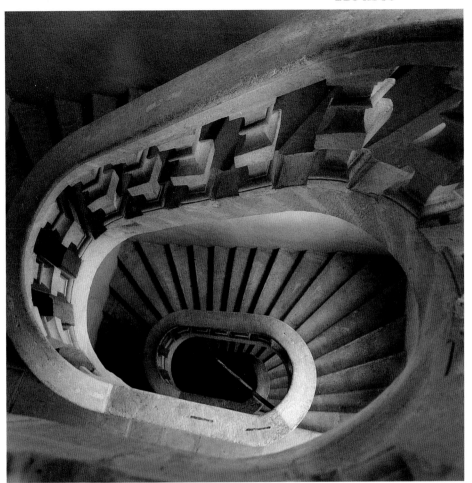

Eighteenth-century baluster staircase in a mansion of the Place aux Herbes in Uzès.

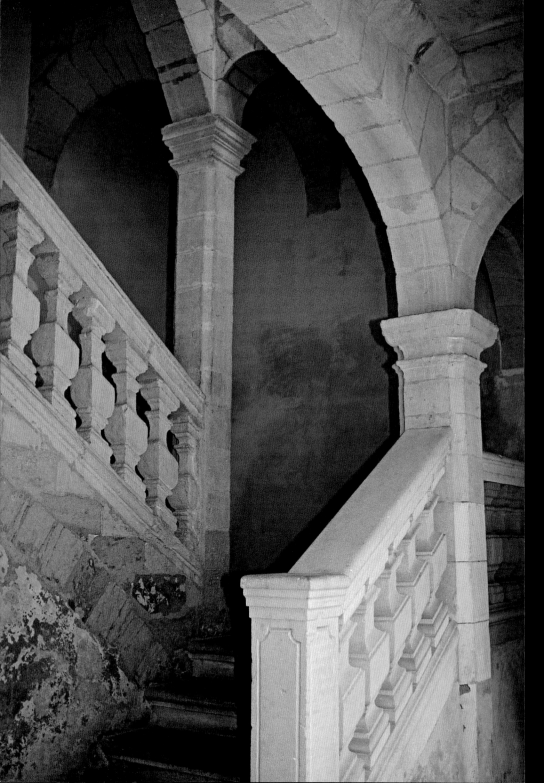

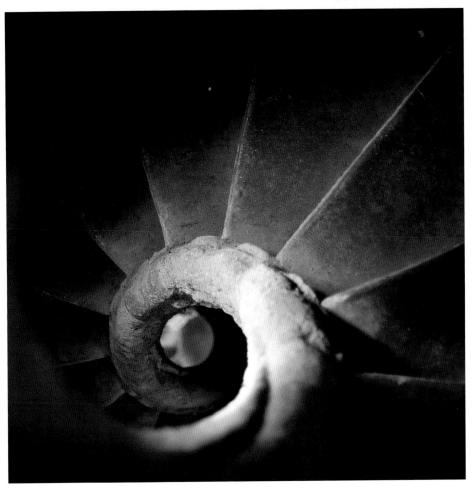

Spiral stone staircase in Uzès.

Internal staircase of the Hôtel
Dampmartin in Uzès.

following pages
Elegant wrought-iron railings
in two hotels in Uzès.

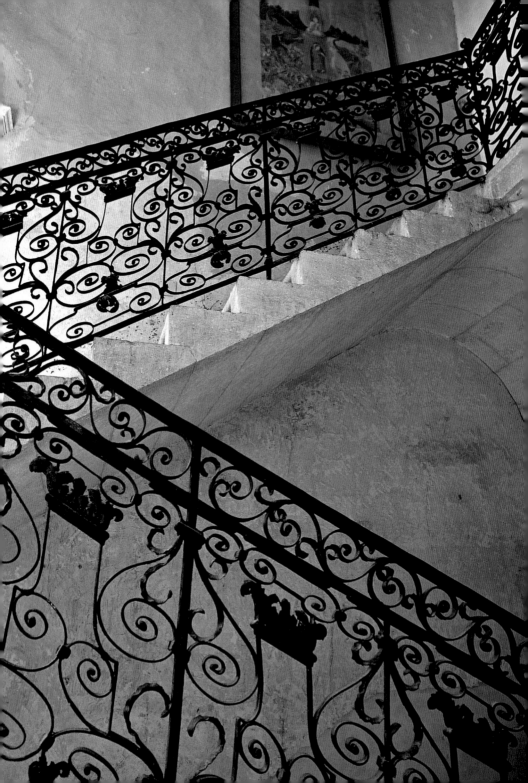

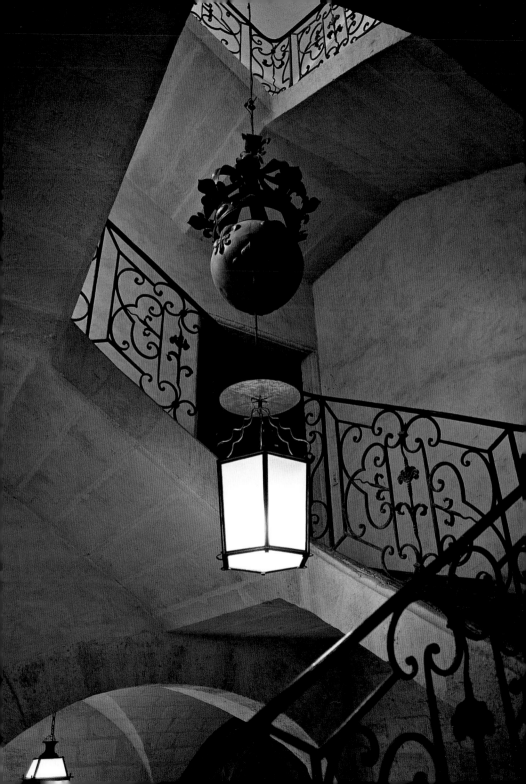

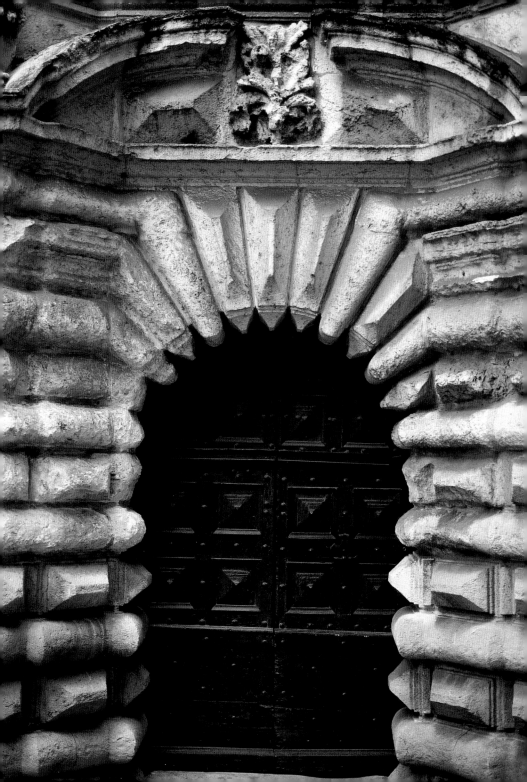

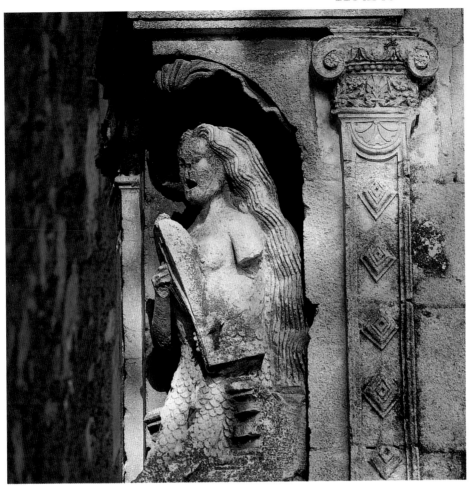

Close-up of the façade of the Mas de la Brune in Eygalières, Les Alpilles.

Louis XIII door, with huge round
bosses, rue Saint-Étienne in Uzès.

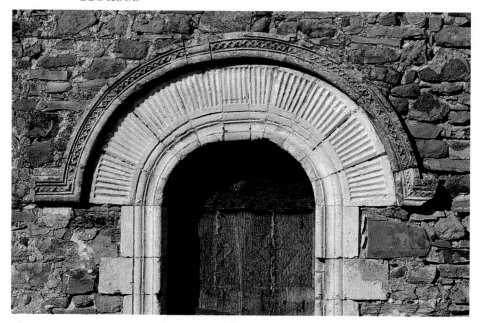

The elegant semicircular lintel and its ornate stonework contrast
with the rustic doorway in Simiane-la-Rotonde.

page 358
A door knocker from the town hall
in Aix-en-Provence.

page 359
An example from an antique door in Uzès.

Doorway of a large elegant
house in Simiane-la-Rotonde.

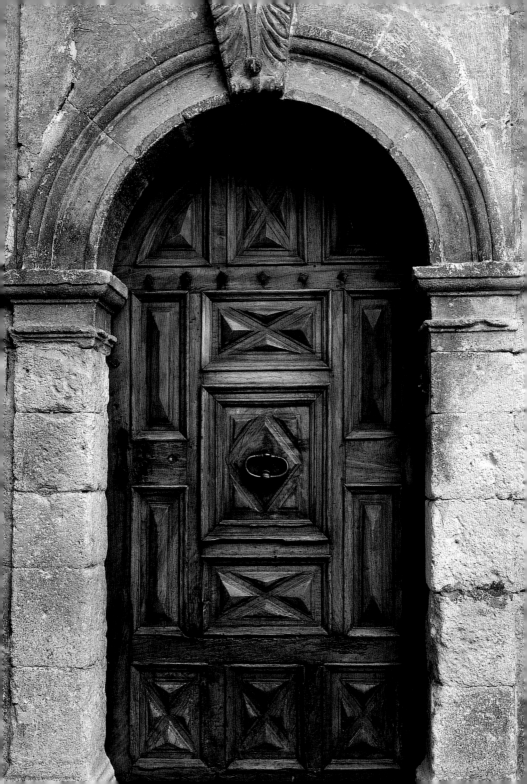

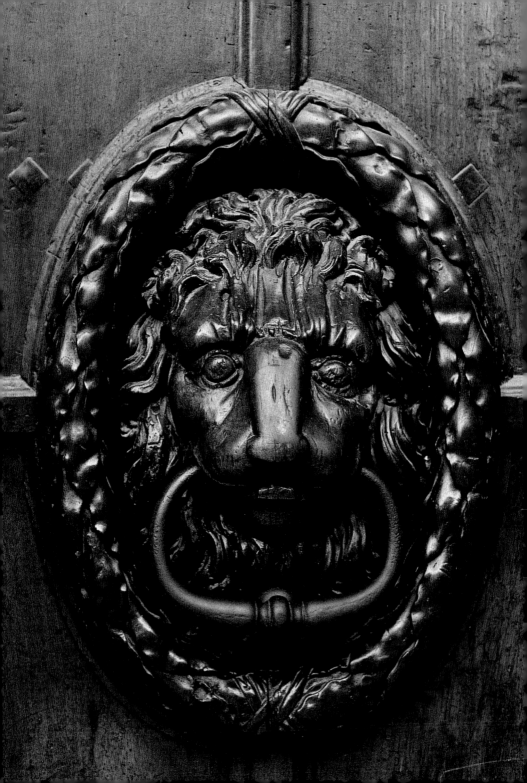

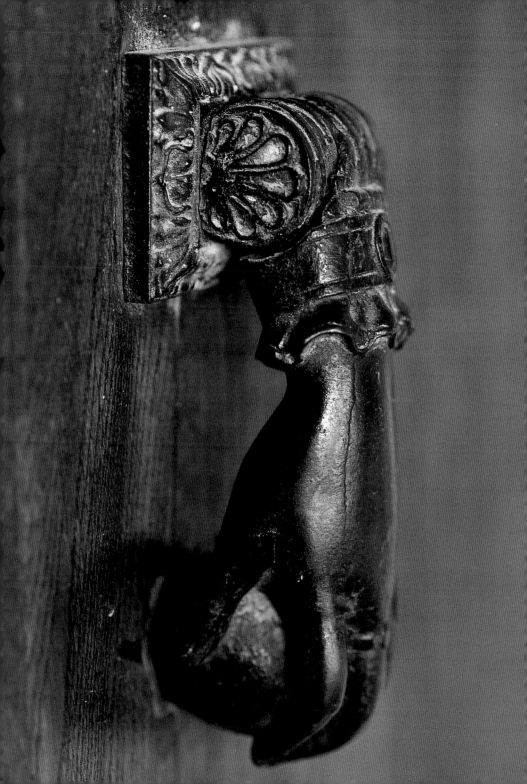

Houses

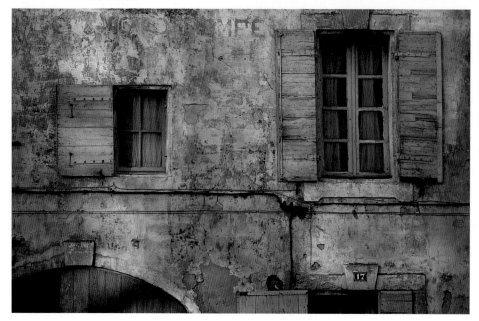

Façade of an old house in Tarascon that has faded with time.

preceding double page
The high windows of the mansions
in the Place aux Herbes in Uzès look
onto the fountain.

An exterior staircase leads
to the entrance of a house constructed
over the vault of an alleyway in
Lacoste, in the Lubéron.

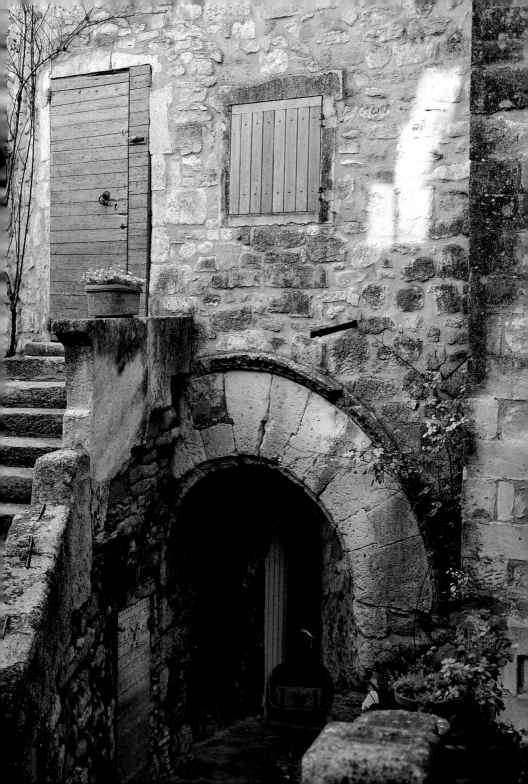

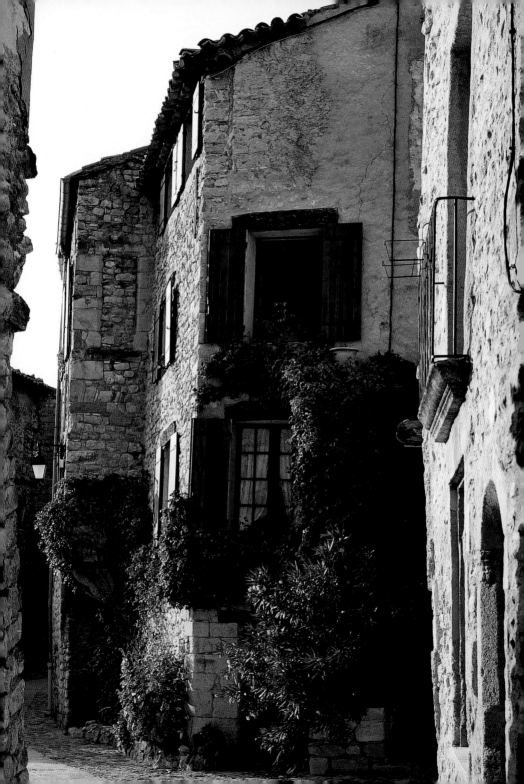

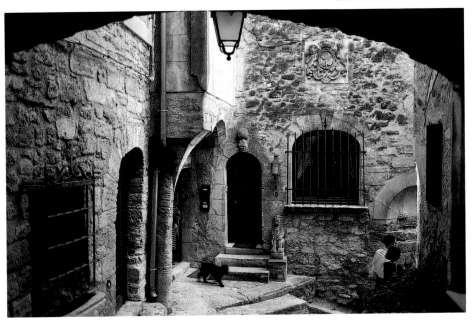

In Bonnieux, in the Lubéron, many houses were built between the sixteenth and eighteenth centuries.

The village houses are often high
and narrow like this one in the village
of Lurs, near Forcalquier.

Elegant stone ledges on a mansion house in the village of Oppède-le-Vieux, in the Lubéron.

The Mas de Brau in Mouriès, Les Alpilles. The façade is decorated with Corinthian columns and a Renaissance frieze.

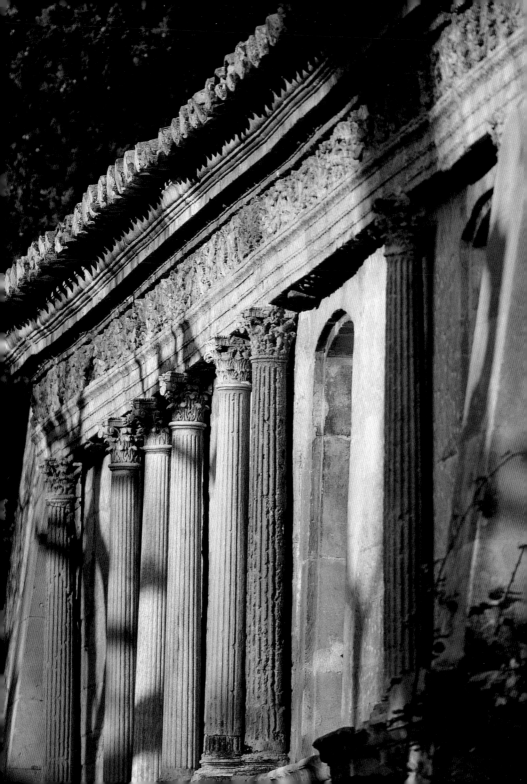

Houses

Village house in Vallabrègues in the Gard.

In Moustiers-Sainte-Marie,
the houses seem to cling to the
mountainside, like the whole village.

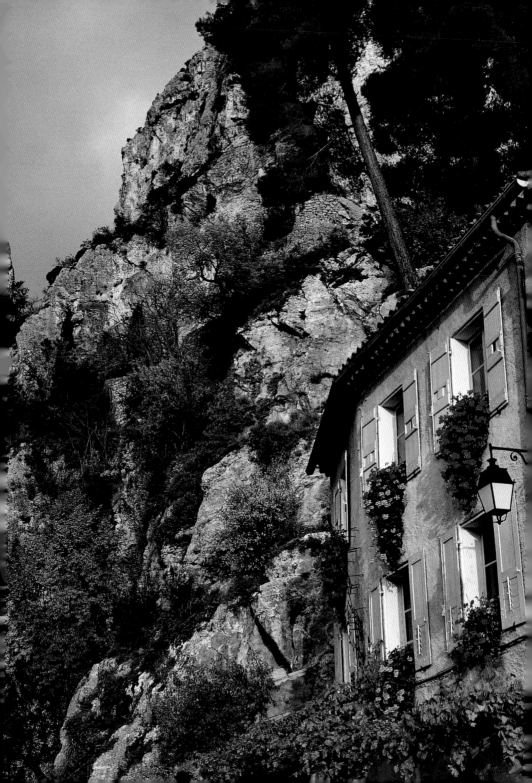

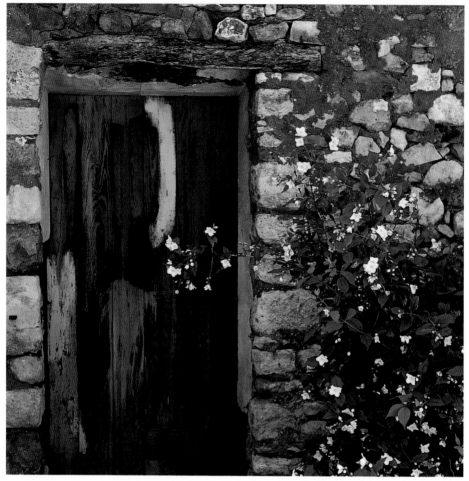

A wall with rubblework daubed with ocher in the village of Roussillon.

page 372
An ancient door in the village of Lurs.
page 373
Stone houses in the steep streets of the village of
Goult in the Lubéron.

A carved stone lintel frames
the solid door of this house
in Lacoste, a hillside town
in the Lubéron.

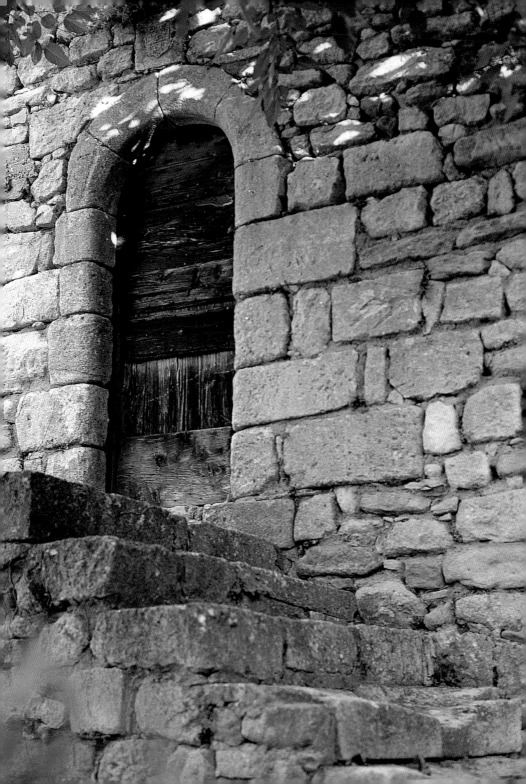

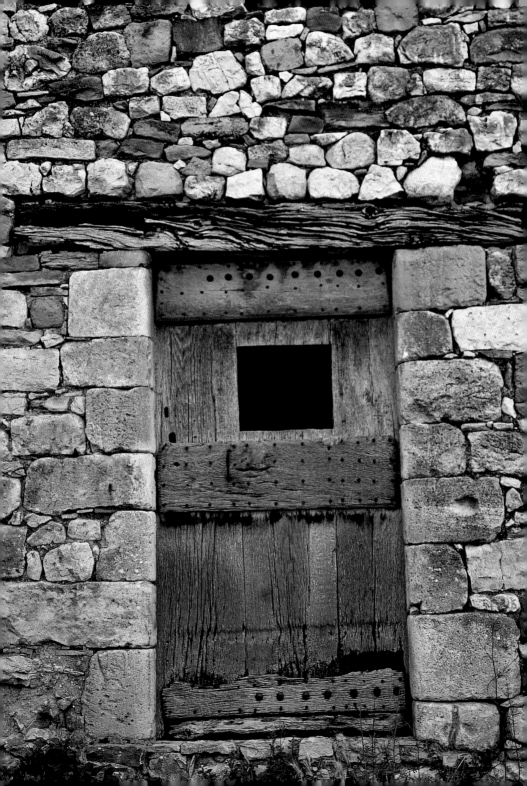

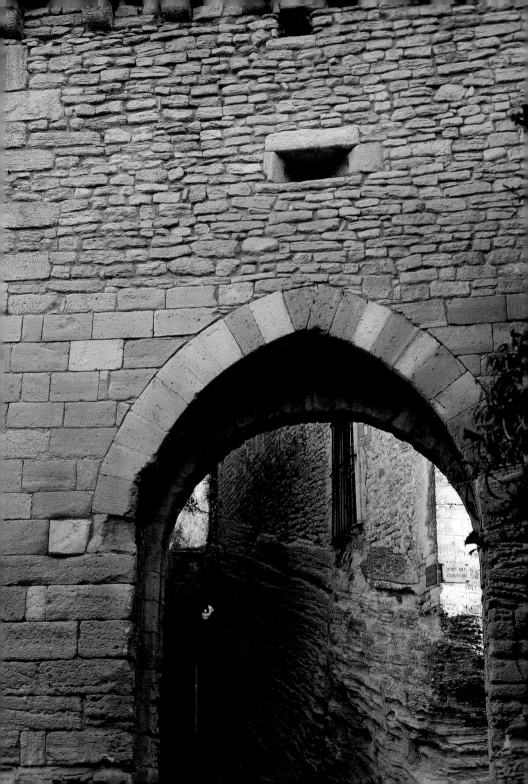

Houses

An old door in the village of Lacoste.

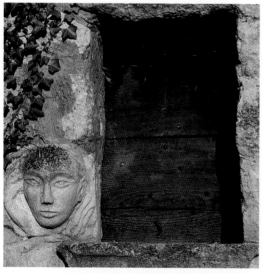

Window and sculpture in Oppède-le-Vieux.

Interior courtyard and well
in the Hôtel de la Rochette,
Place aux Herbes, Uzès.

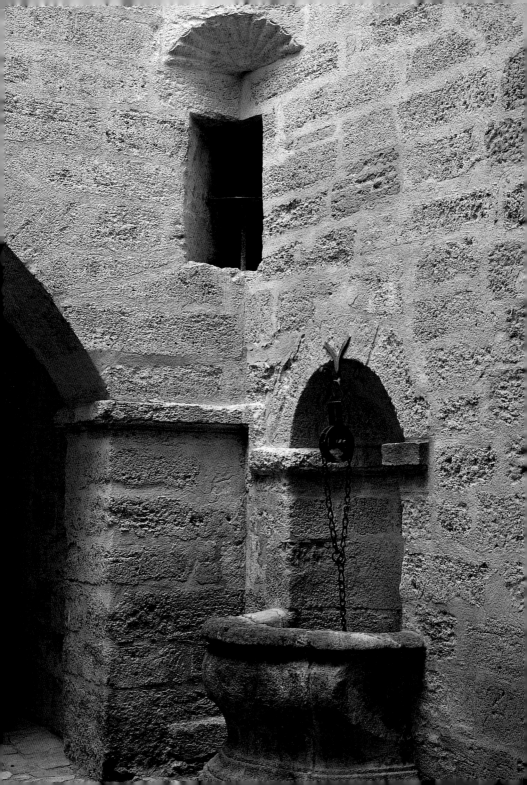

Houses

Small window protected by a decorative
wrought-iron bar in the village of Barroux.

In Lacoste, stone walls and a door made
of large studded horizontal planks.

Heavy studded wooden shutters
in the Les Alpilles massif.

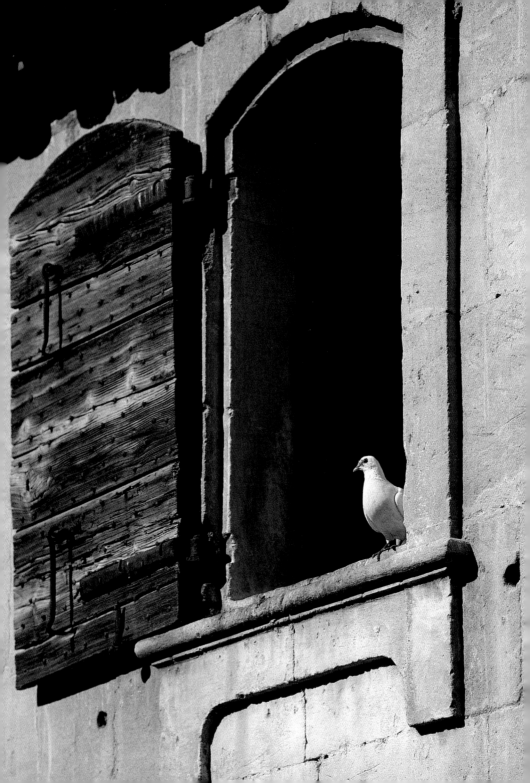

A dovecote in Simiane-la-Rotonde.

following double page
The house in Ménerbes in the Lubéron,
where Nicolas de Staël lived.

The dovecote of the
Mas de la Bélugue
in the Camargue.

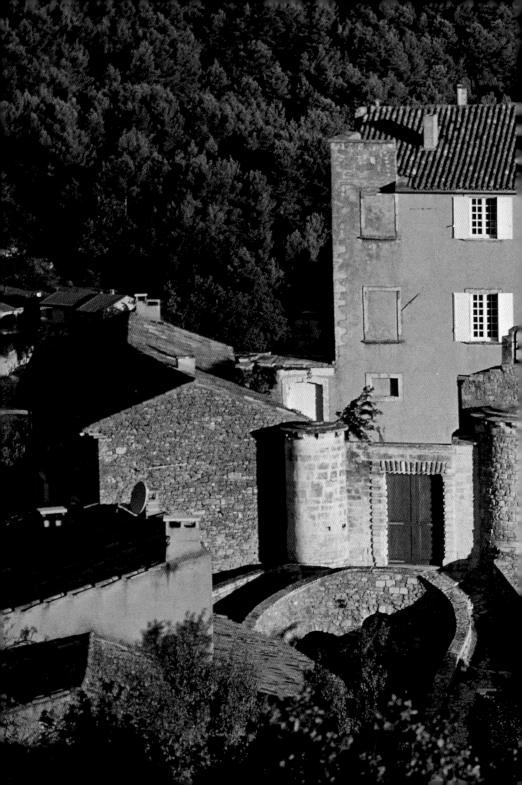

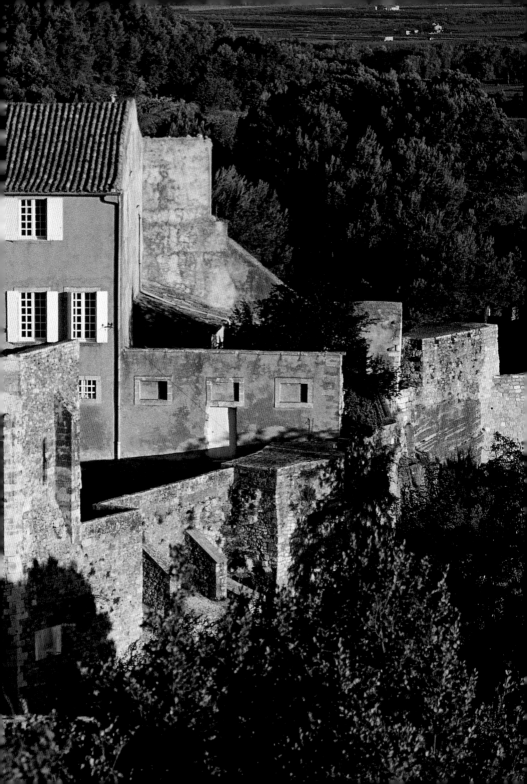

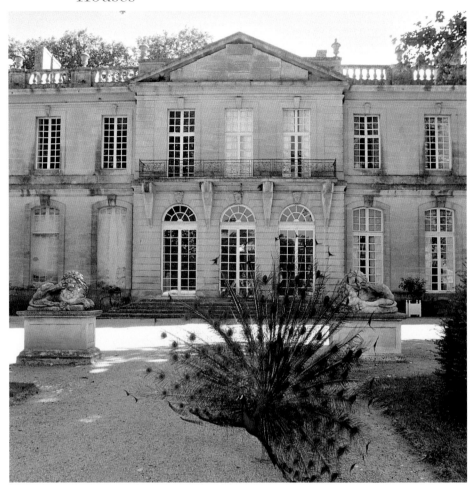

One of the most attractive classic residential properties of Provence,
the Château de Sauvan, near Forcalquier, which dates from the eighteenth century.

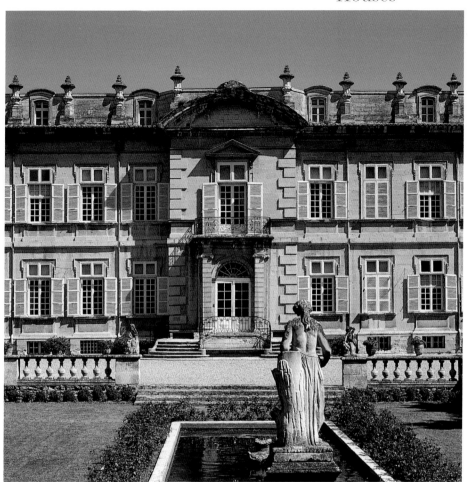

The Château de Barbentane, in the Bouches-du-Rhône region,
a perfect example of classicism in Provence.

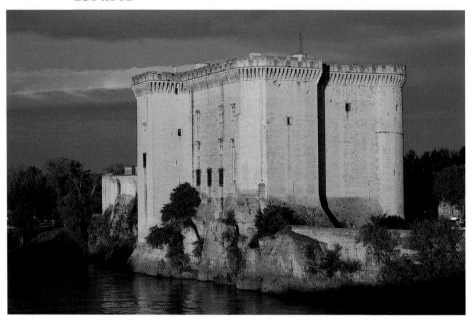

The Chateau de Tarascon, a powerful fortress of the fifteenth century,
on the edge of the Rhône.

Not far from Montagne Sainte-
Victoire that was dear to Cézanne,
the Château de Vauvenargues is a
straightforward sixteenth-century
building. Picasso once lived
and is now buried here.

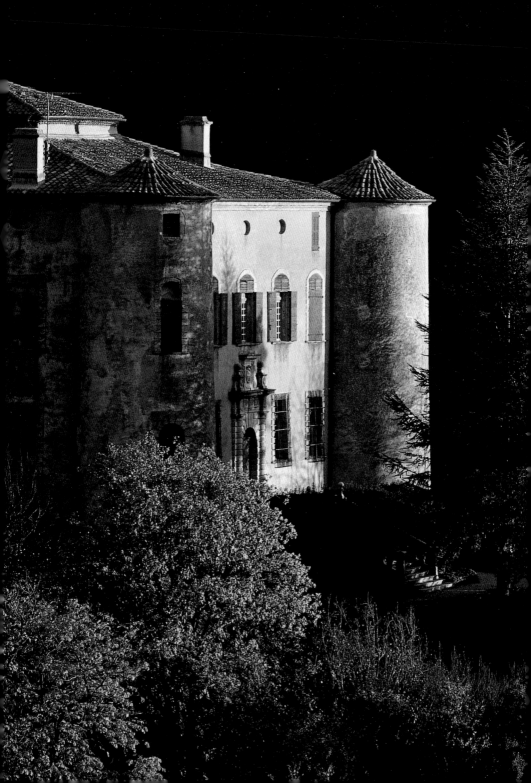

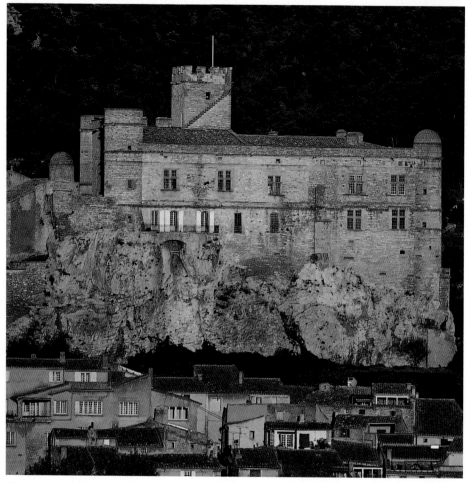

The Château du Barroux, which overlooks the Carpentras plain.

following double page
Built on an exceptional site, the Château
de La Barben near Salon-de-Provence
is open to visitors year-round.

The Château d'Ansouis,
perched on a rocky peak on the
southern slopes of the Lubéron.

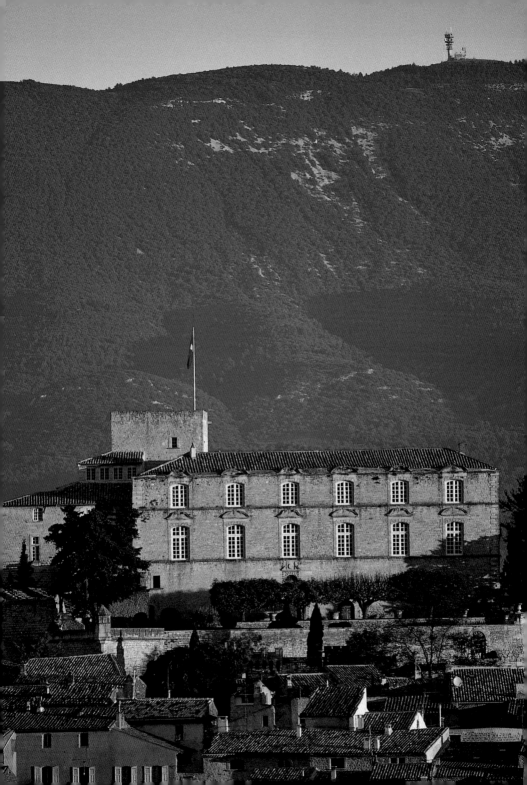

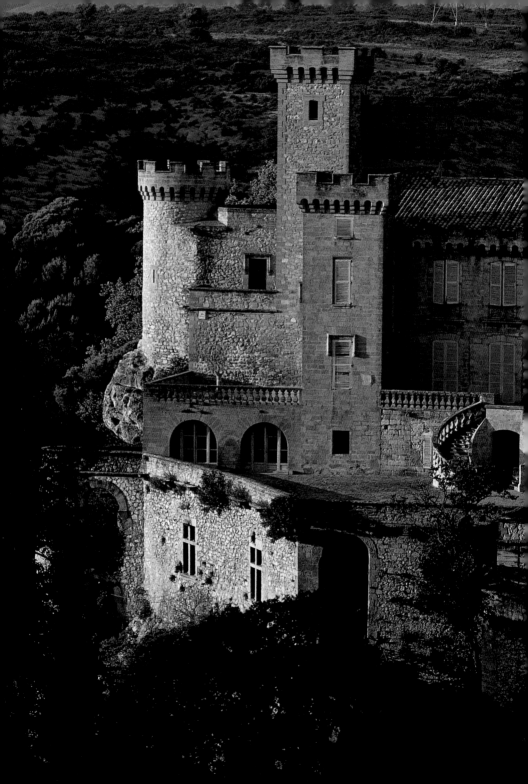

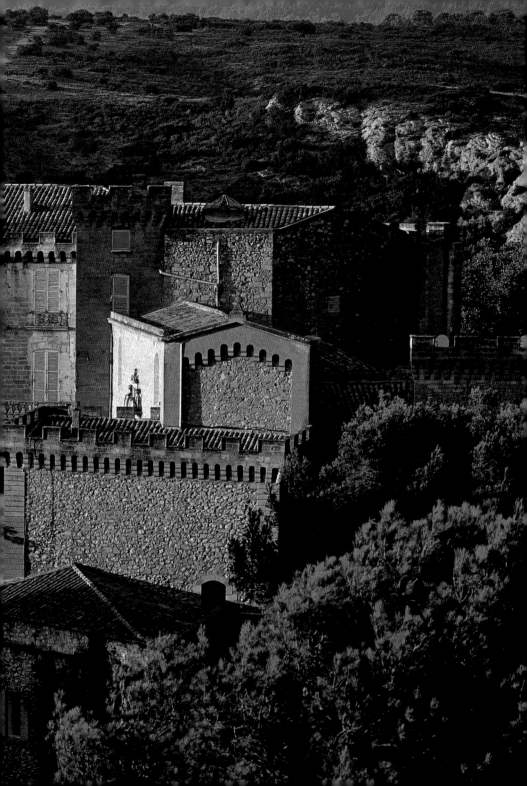

The citadel of Ménerbes with its hanging garden commands a superb view
of the Lubéron's villages.

following double page
The Château d'Aiguines (seventeenth
to eighteenth century) looms over
the Sainte-Croix-du-Verdon lake in the Var.

A turret in Oppède-le-Vieux
in the Lubéron.

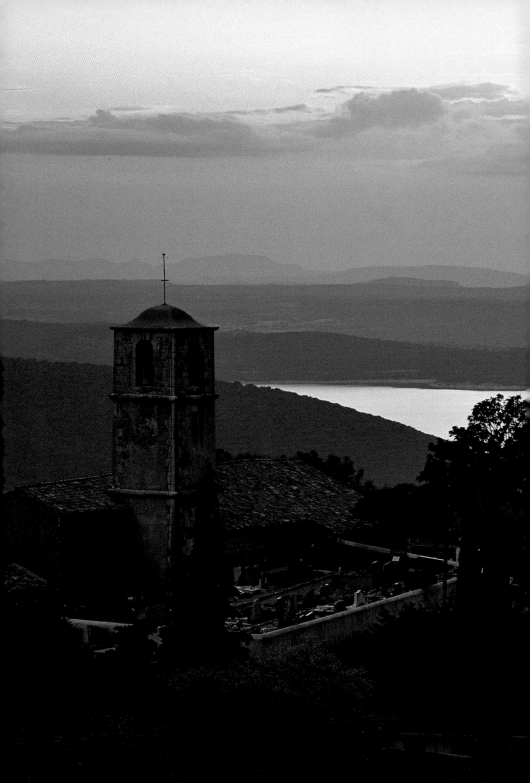

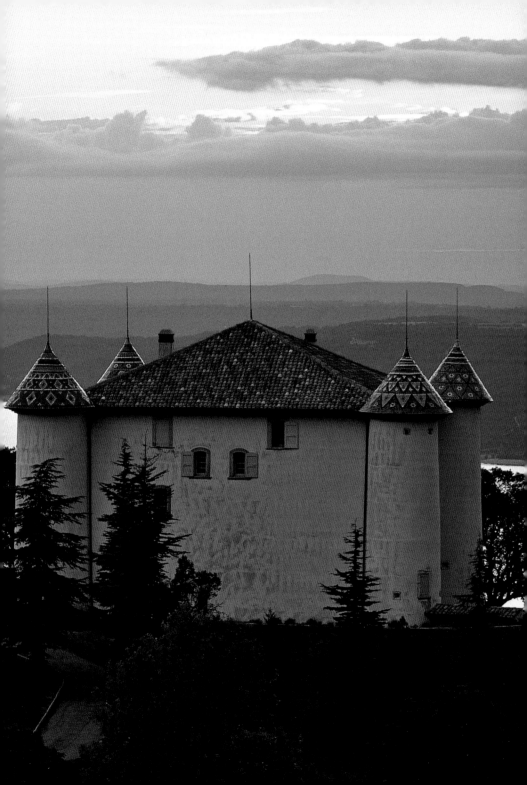

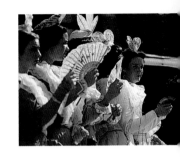

Flavors and Traditions

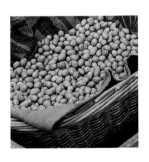

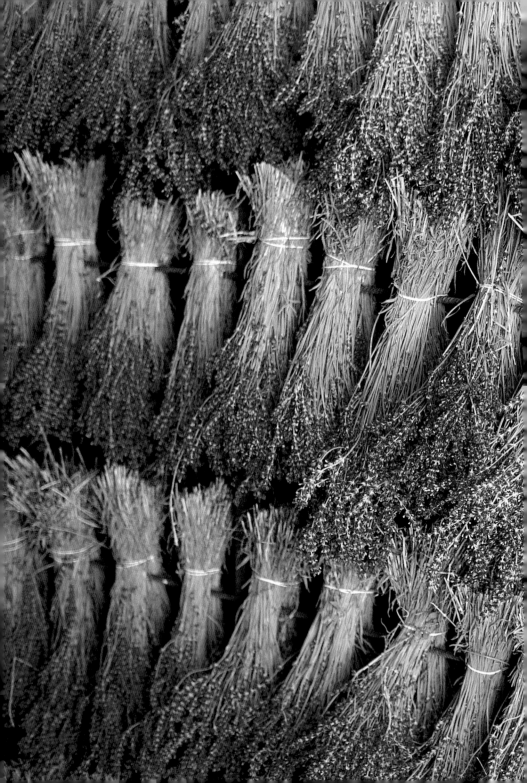

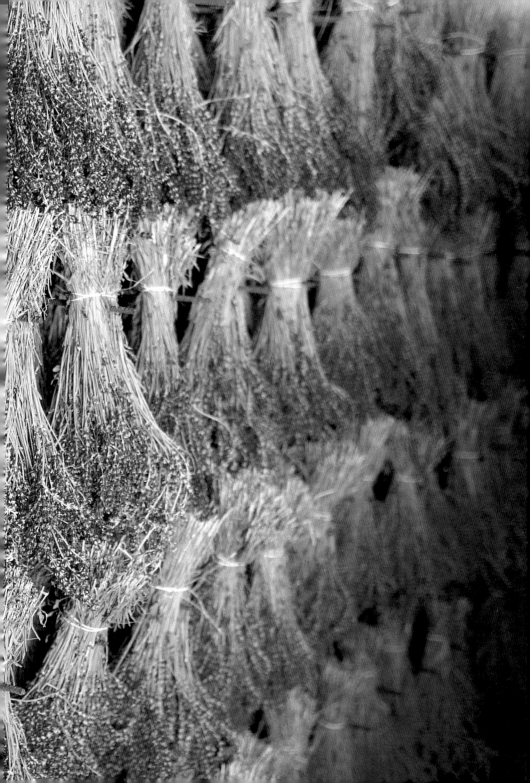

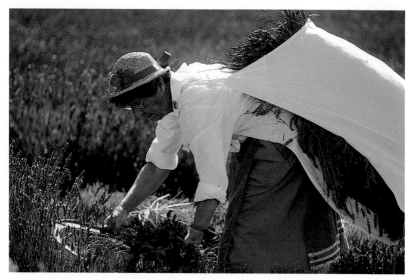

Cutting competition during the lavender festival in Sault.

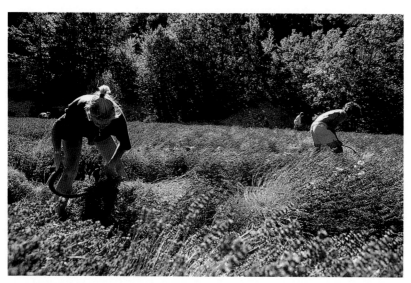

The lavender is cut at the height of summer when the flowers are most fragrant.

preceding double page
Bouquets of lavender in Ferrassières
in the Provençal Drôme.

Lavender drying
in Buis-les-Baronnies.

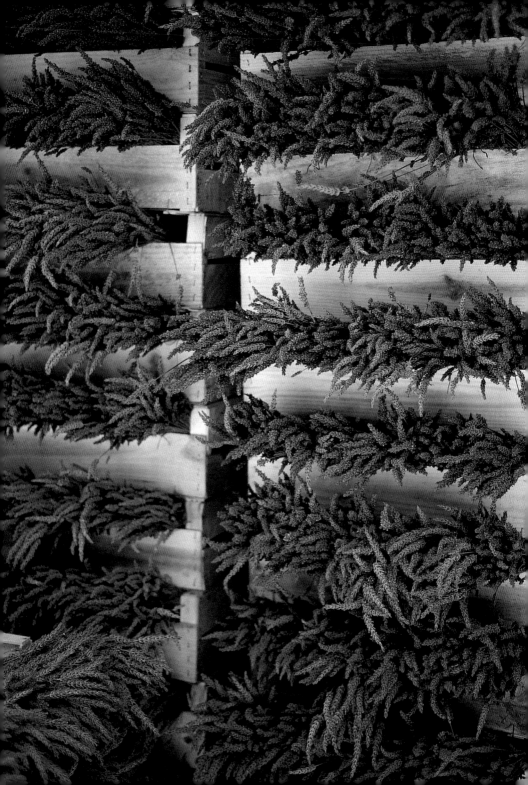

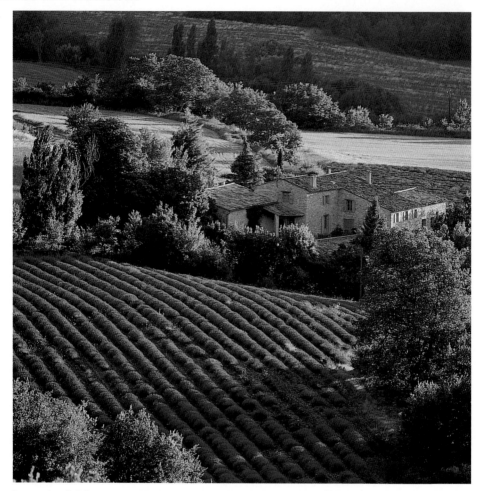

Lavender fields near Vachères, between Manosque and Forcalquier.

following double page
The lavender is cut, bundled,
and ready for distillation.

Lavender distillation in the north
of the Valensole plateau,
with its beautiful lavender
and almond tree landscape.

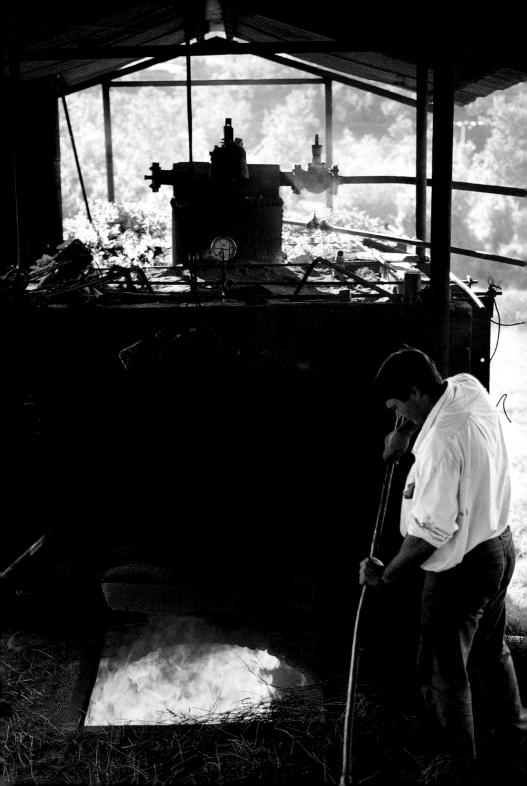

Sachets of lavender to perfume linen at the Cours Mirabeau market in Aix-en-Provence.

Every August 15, a festival featuring a horse-drawn procession is held
to celebrate the flower.

Artichokes in flower at a traditional market in Châteaurenard, at the heart of an important fruit- and vegetable-producing region in the lower valley of the Durance.

Lavender at the
August 15 Sault festival.

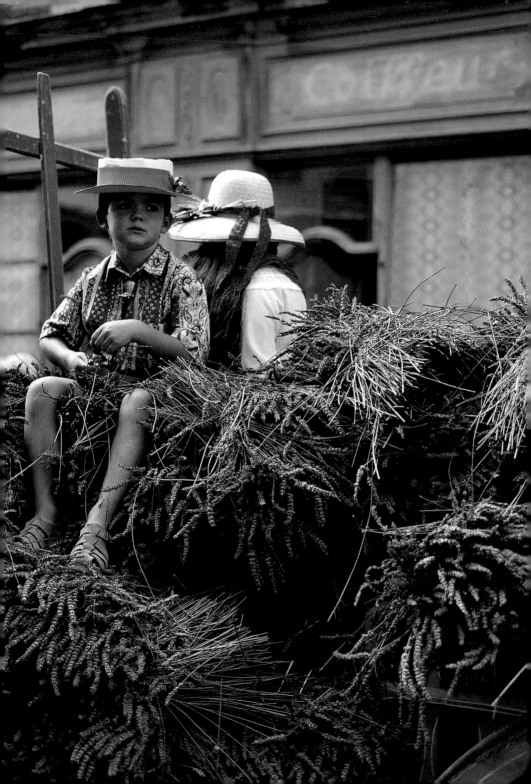

The art of basketry is very much alive in Provence. Wicker baskets come in all shapes and sizes for the harvesting of fruit and vegetables.

The basketwork festival
in Vallabrègues.

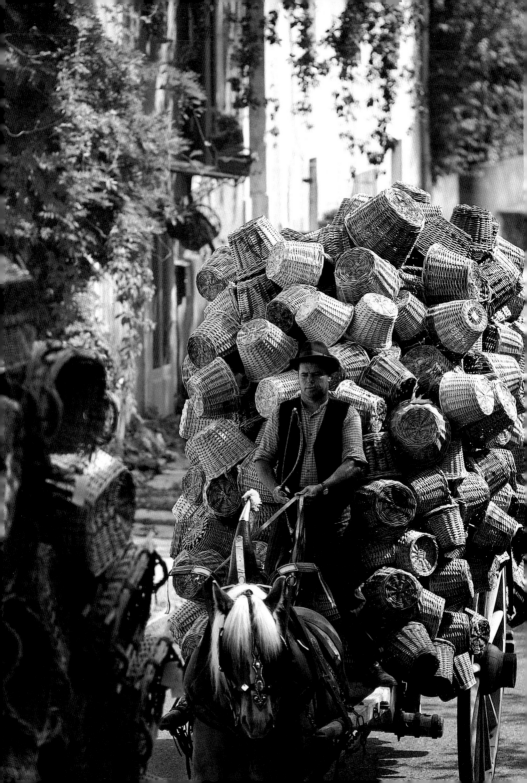

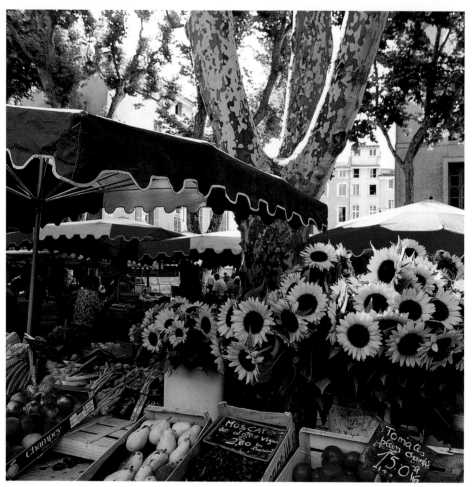

The Place des Prêcheurs fruit and vegetable market in Aix-en-Provence.

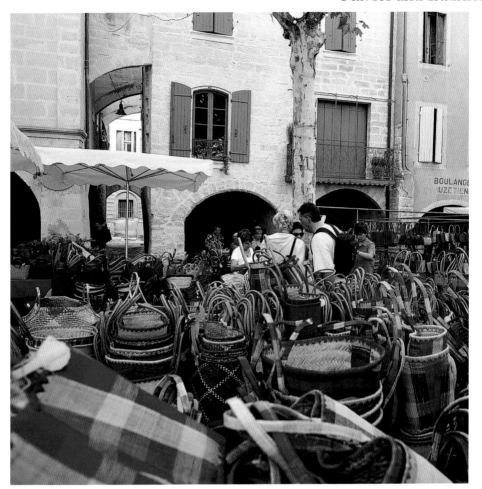

Market day in the Place aux Herbes in Uzès.

following double page
The flower market in
the town hall square
in Aix-en-Provence.

411

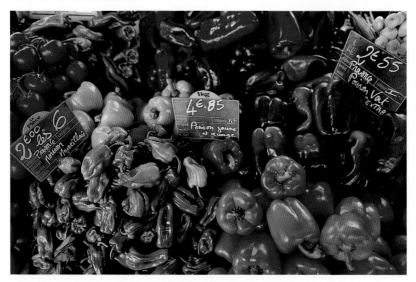

The Apt market in the Lubéron—peppers of every hue.

In Hyères in the Var, tomatoes and artichokes in an old-town store.

Tomatoes and eggplants, at the
Apt Saturday market, essential
ingredients of a good ratatouille.

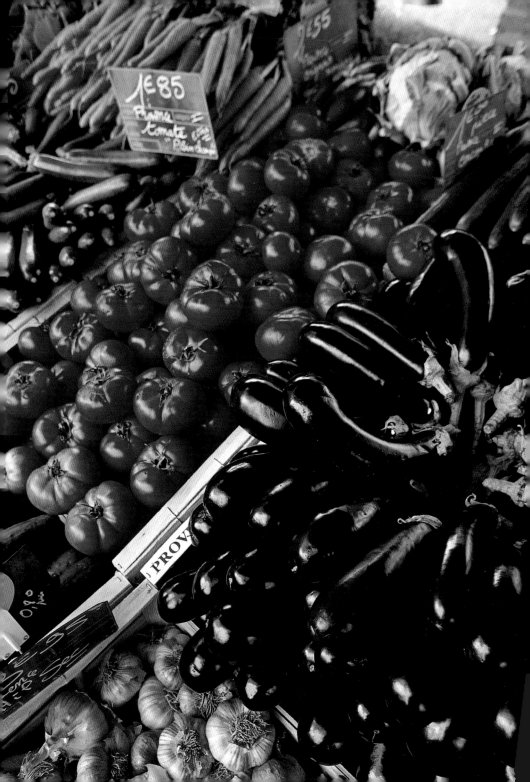

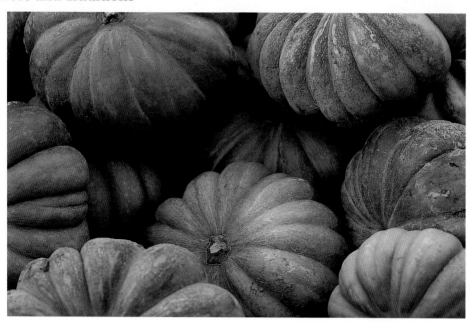

The pumpkins and squash that grow in Provençal gardens are harvested in the fall and kept for the winter. Squash is a staple in the Provençal diet.

Braids of garlic during
the Uzès garlic fair, held
on Saint John's Day, June 24.

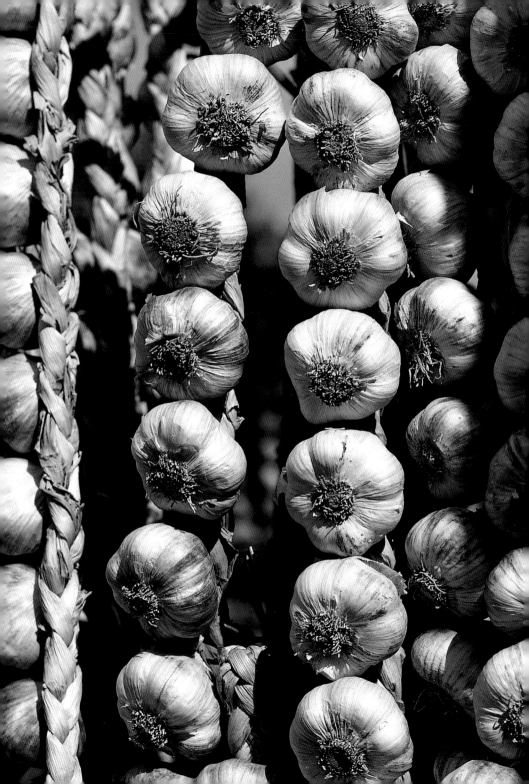

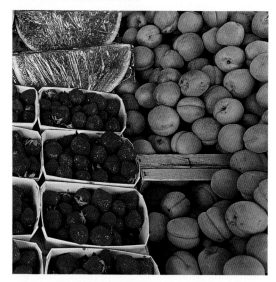

Watermelons, strawberries,
and apricots at the Apt market.

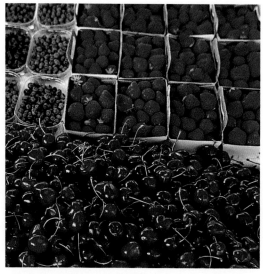

Strawberries and cherries
at the Apt Saturday market.

Apt is the European capital of
crystallized fruit. Bigarreau cherries,
melons, watermelons, pineapples,
oranges, and citrons are crystallized
and exported around the world.

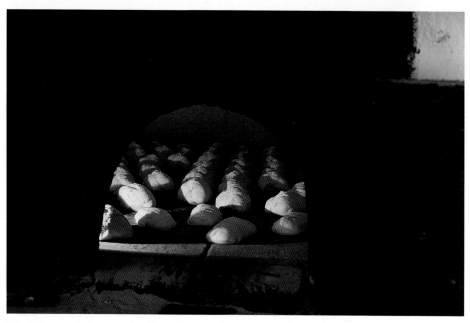

The Trigance bakers in the Haut Var. The bread is always cooked in an antique wood-burning stove.

page 422
Appellation d'origine contrôlé (AOC) olive oils from the Baux. The AOC certification guarantees the quality of the oil, and Baux oils are renowned for their excellence.

page 423
Olives on sale at the market of Saint-Rémy-de-Provence.

The traditional Apt *fougasse*. The *fougasse* is a sweet or savory bread or pastry—a Provençal specialty that can be cooked in an oven or in the hearth.

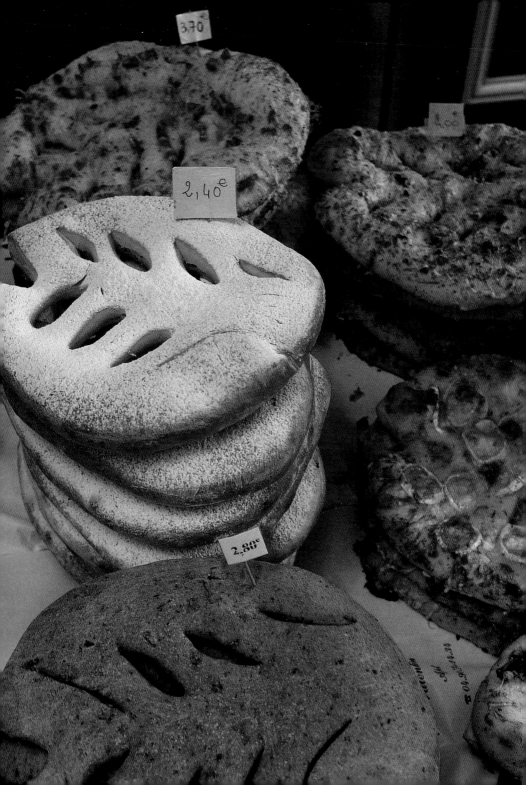

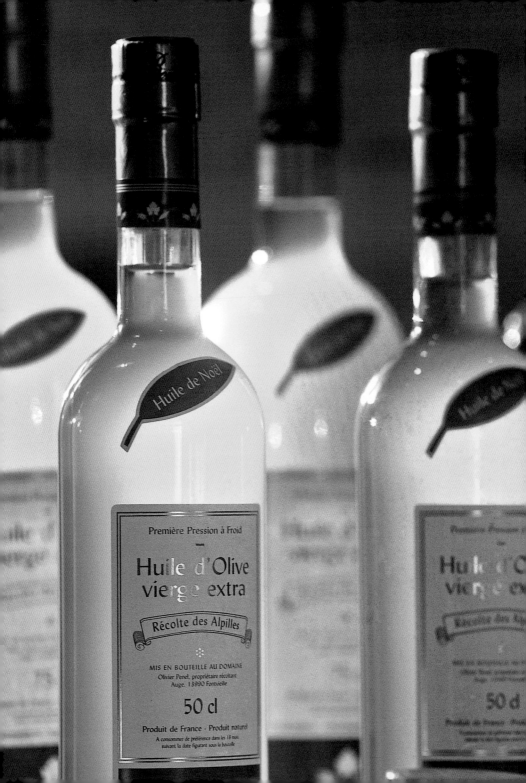

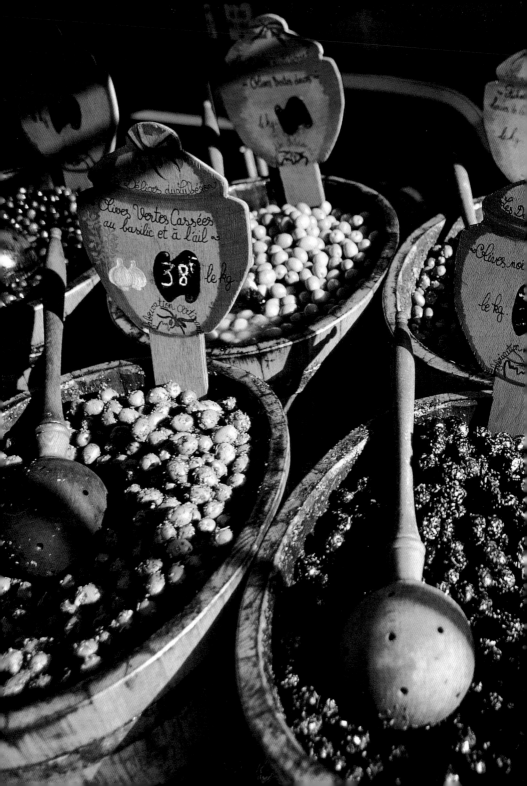

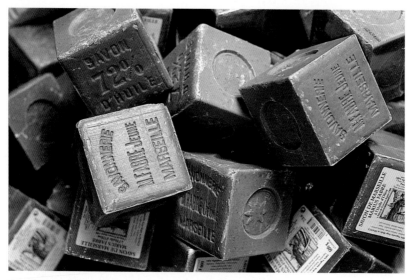

Traditional Marseille soap at the Marius Fabre soap factory
in Salon-de-Provence.

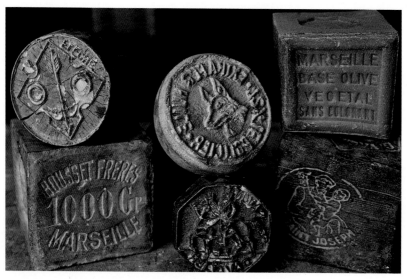

Antique soap and soap stamps at the Rampal soap factory
in Salon-de-Provence.

An assortment of traditional soaps
in an old-town store in Hyères.

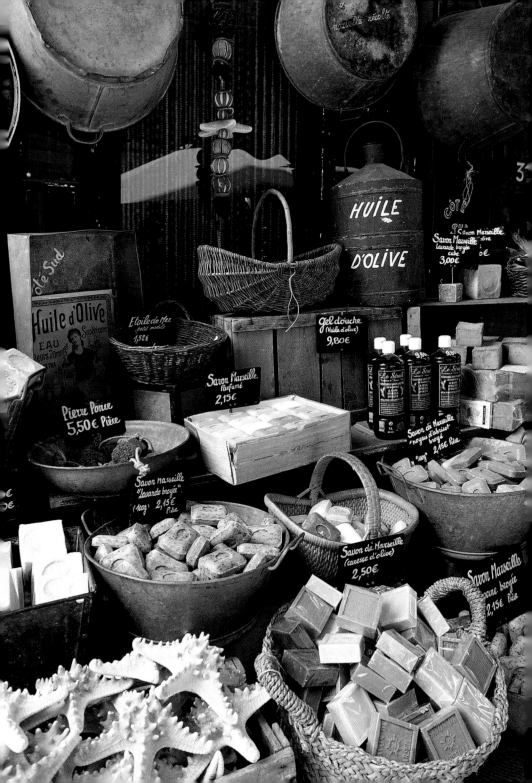

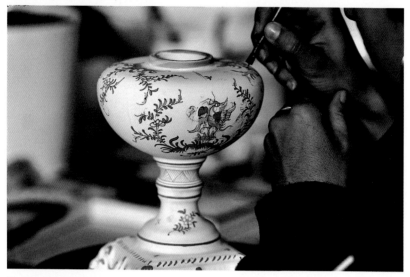

Decorative patterns painted freehand at the Lallier porcelain works
in Moustiers-Sainte-Marie.

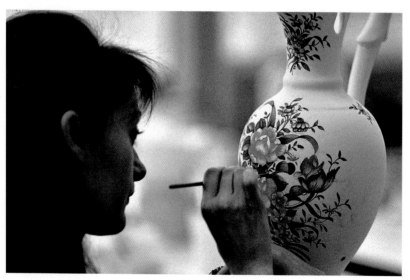

Moustiers-Sainte-Marie is renowned for its porcelain.

Monochrome blue design
at the Lallier porcelain works
in Moustiers-Sainte-Marie.

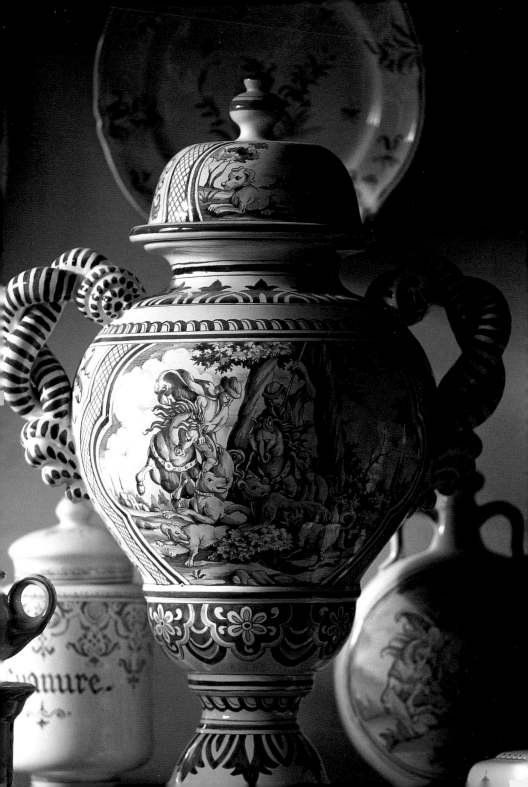

Tableware made of different colored clays that have been combined and glazed. Such creations are remarkable for their elegance and rustic simplicity.

Potters' market on the Place aux Herbes in Uzès.

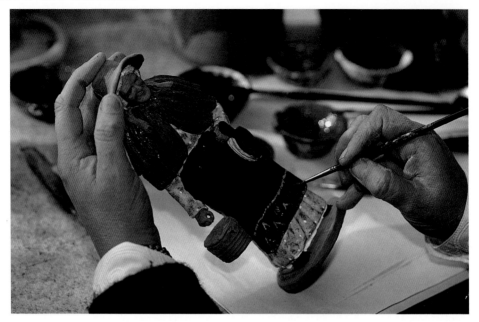

Christmas nativity scenes are decorated with handcrafted figurines, an art that is perpetuated in Provence, like here at the Fouque workshop in Aix-en-Provence.

"The Mistral blows" from
the Fouque workshop
in Aix-en-Provence.

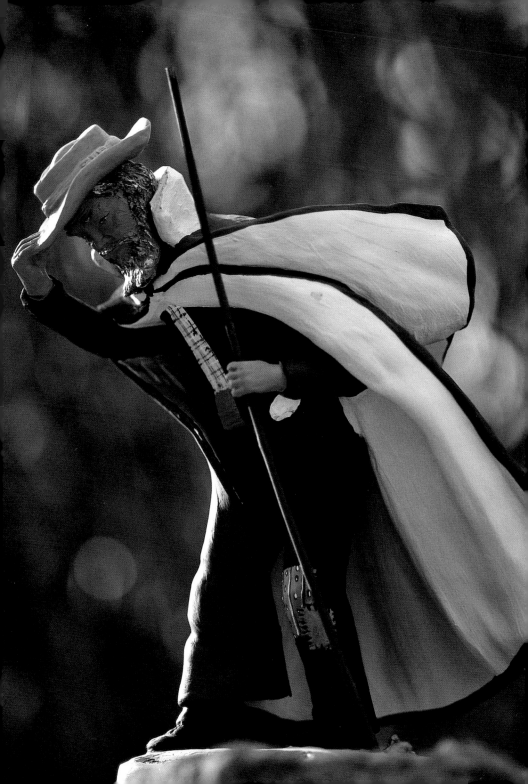

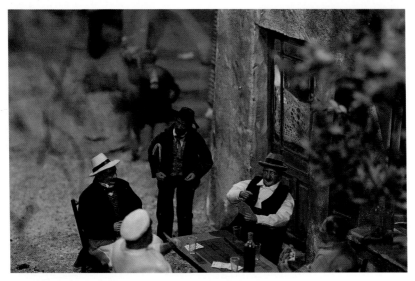

"The card players" from the Paradou "Petite Provence" museum
of figurines.

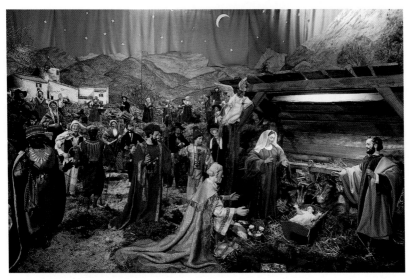

The nativity scene in the church of Gémenos, near Marseille.

Aubagne is said to be the capital of
manger figurines and is proud
to have a nativity scene produced
from antique collectors' pieces.

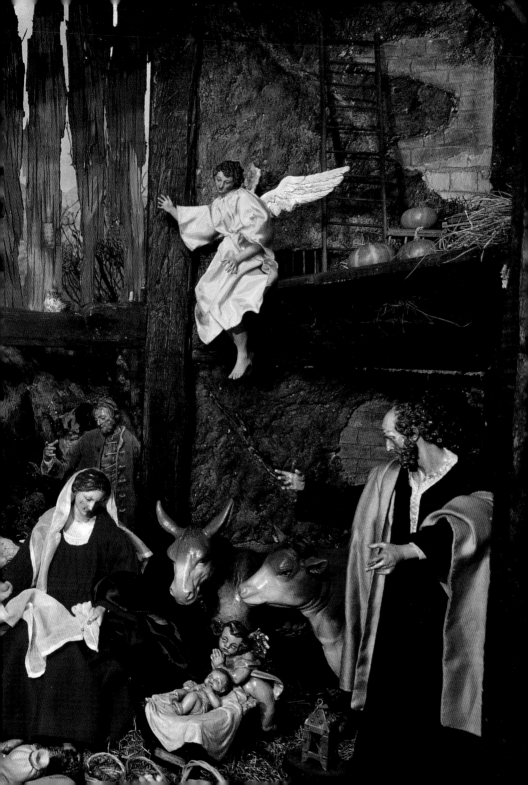

Close-up of a nineteenth-century Provençal costume worn during the Santo Estello festival in Aix-en-Provence, celebrating poetry written in the regional *langue d'oc* dialect.

Brightly colored Provençal fabrics.
Creators, like Soleiado in
Saint-Rémy-de-Provence, rework
traditional time-honored patterns.

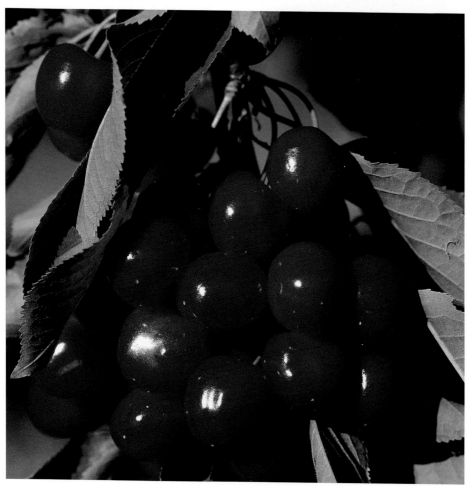

Cherries in the Lubéron.

Apricots in the Provençal Drôme.

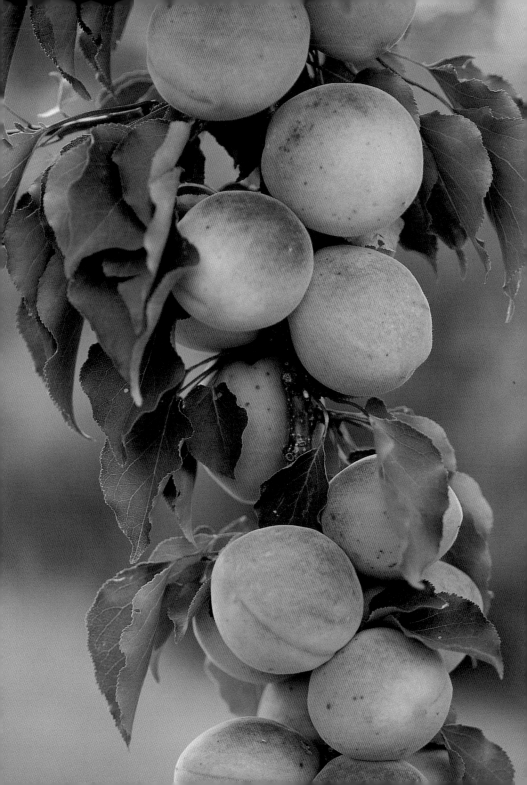

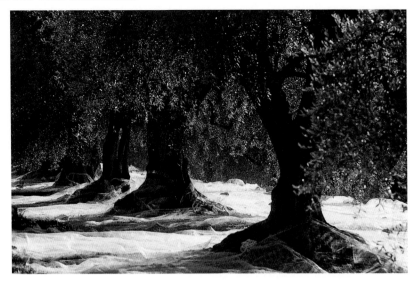

Olive tree in the hills above Vence.

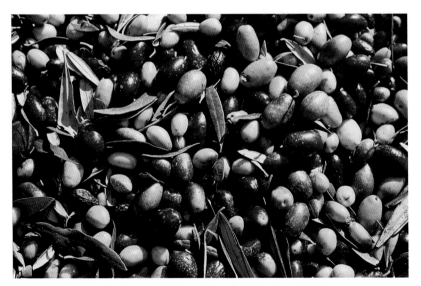

Harvesting olives in the Mas d'Auge, Fontvieille in Les Alpilles.

Olive trees around Fontvieille.

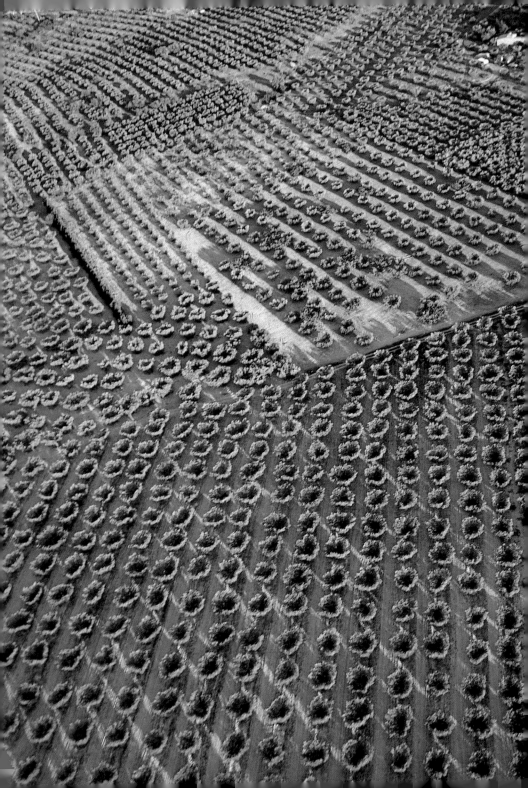

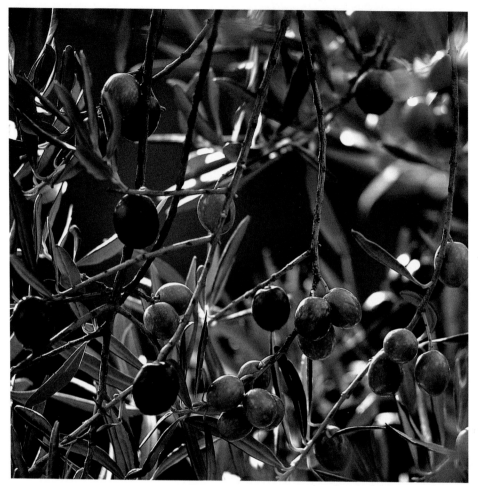

Depending on the variety, olives may be plump and fleshy or miniscule.

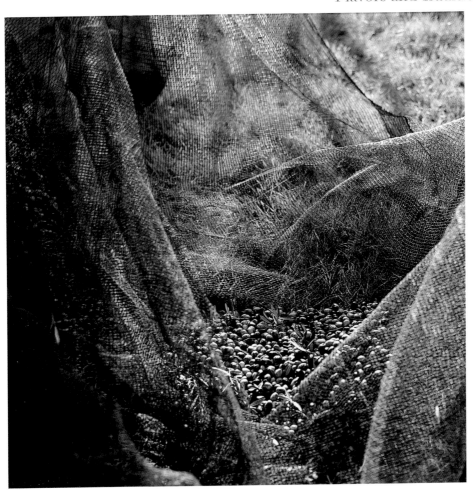

Every September, the harvest is followed by a green olive festival
in Mouriès in the Alps. Olives are harvested using huge nets.

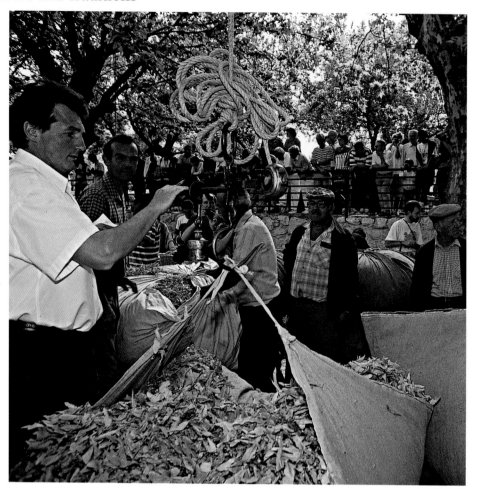

Weighing produce at the lime market in Buis-les-Baronnies in the Drôme.

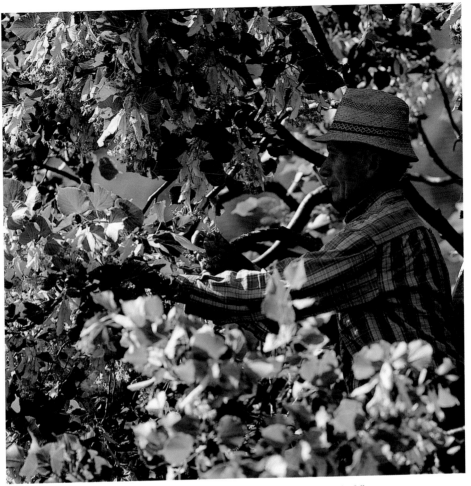

The small town of Buis-les-Baronnies is known as the "lime capital."

page 444
In a vineyard near
La Tour-d'Aigues in the Lubéron.
page 445
Flooded vines in the Rhône valley
around Châteauneuf-du-Pape.

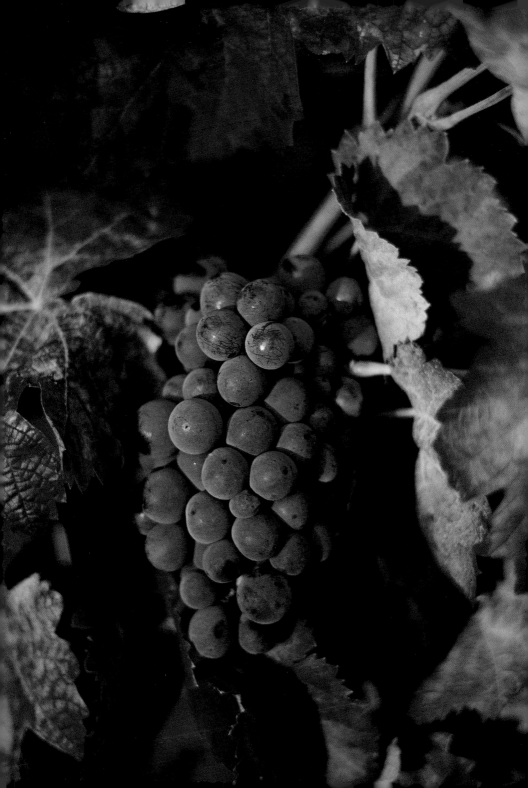

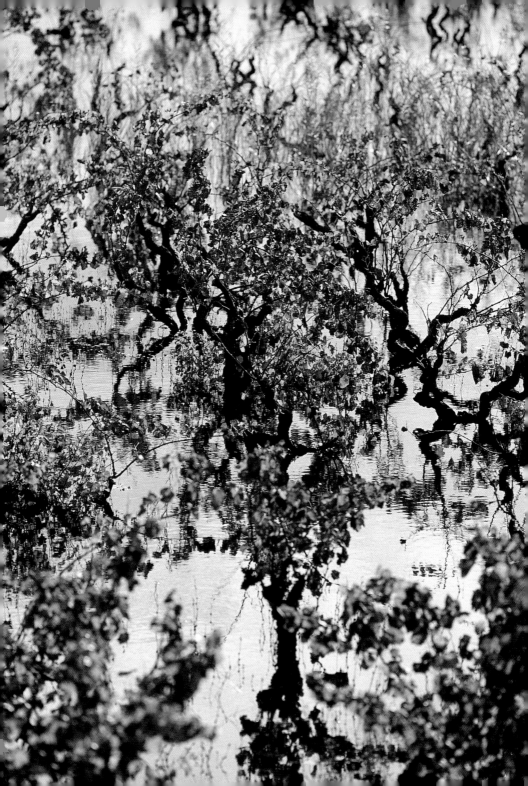

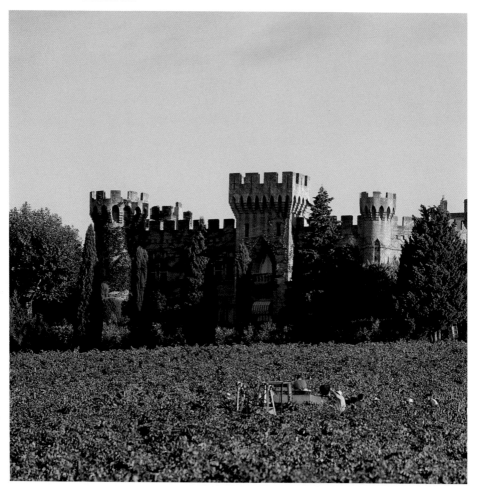

Grape harvesting at the Château des Fines Roches in Châteauneuf-du-Pape.

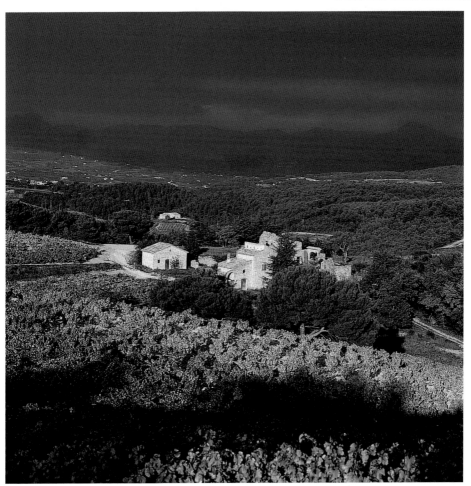

Traditional *mas* farmhouse in Dentelles de Montmirail,
an area with distinguished wine producers of several varieties.

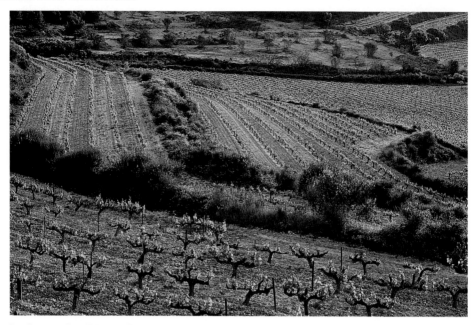

In the south of Vaison-la-Romaine, the Dentelles de Montmirail massif
is surrounded by vineyards.

Wine country in the heart
of Provence. The Dentelles
de Montmirail area is home
to the dessert white
Beaumes-de-Venise and
rich full-bodied Gigondas wines.

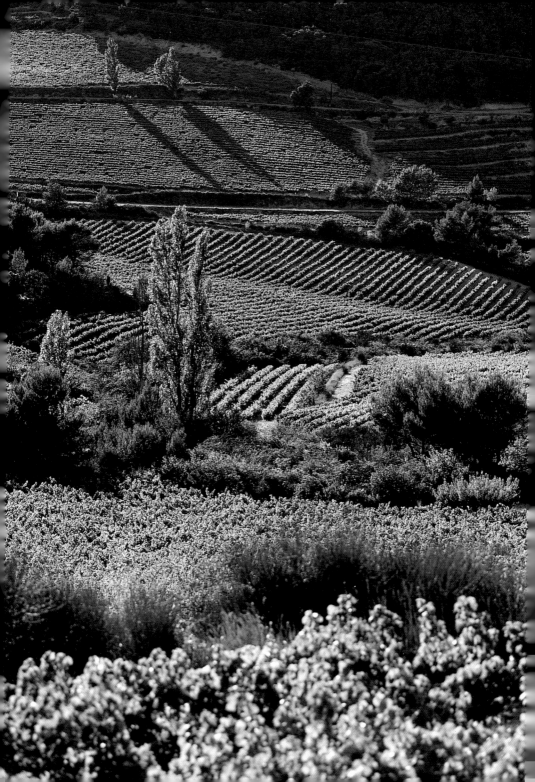

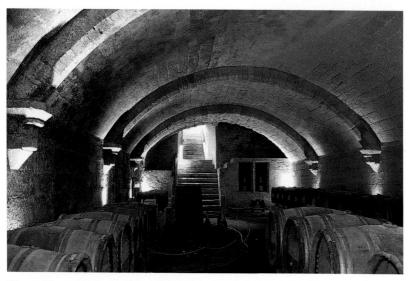

The red or rosé wines of the Château du Duché d'Uzès are local country wines.

The cellar of the Domaine de Beaucastel in Courthézon, south of Orange.
The estate has stayed in the same family for three generations.

Wine tasting in the cellar
of the Domaine de Beaucastel estate,
which produces a distinguished
Châteauneuf-du-Pape.

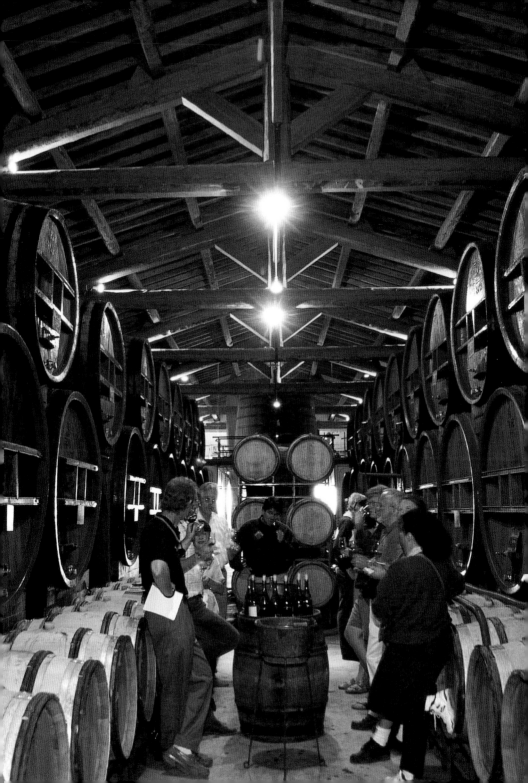

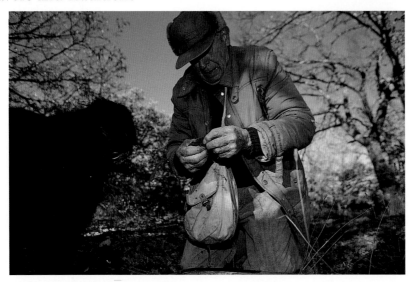

Gathering truffles with a truffle hound in the Haut Var.

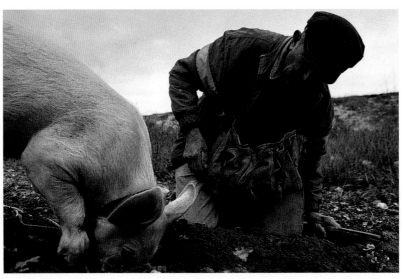

Truffle sows are just as effective at unearthing the precious tuber.

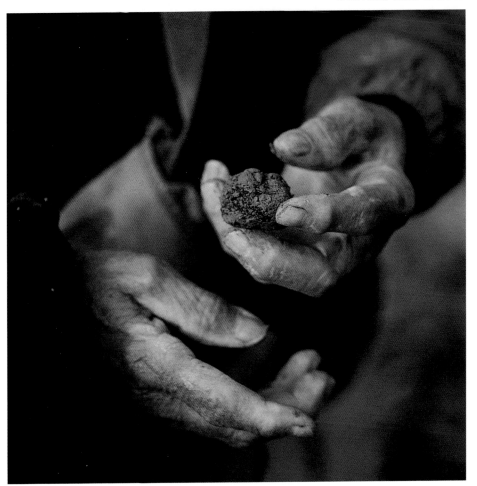

The truffle is one of the jewels of Provençal cuisine. The winter traveler should visit the region's truffle markets. The Richerenches market, which is held from November to March, is one of the most popular.

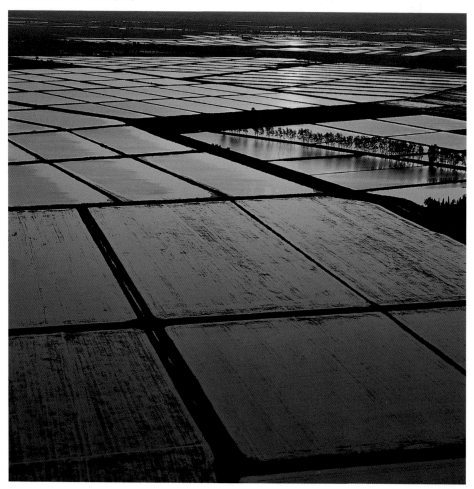

A shimmering water patchwork formed by the paddy fields of the Camargue between the branches of the Rhône.

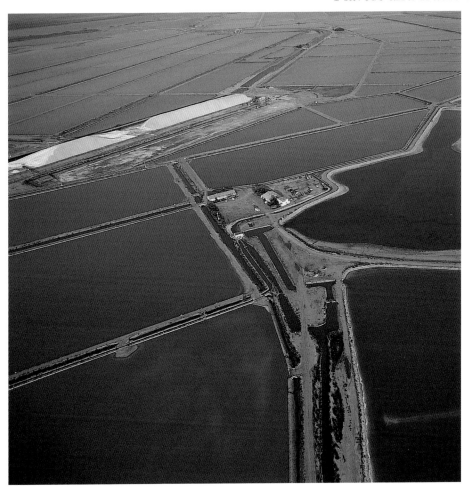

Salt marshes in Aigues-Mortes. The Camargue is known for its quality
rice and salt production.

following double page
Salt harvest in Salin-de-Giraud
in the Camargue.

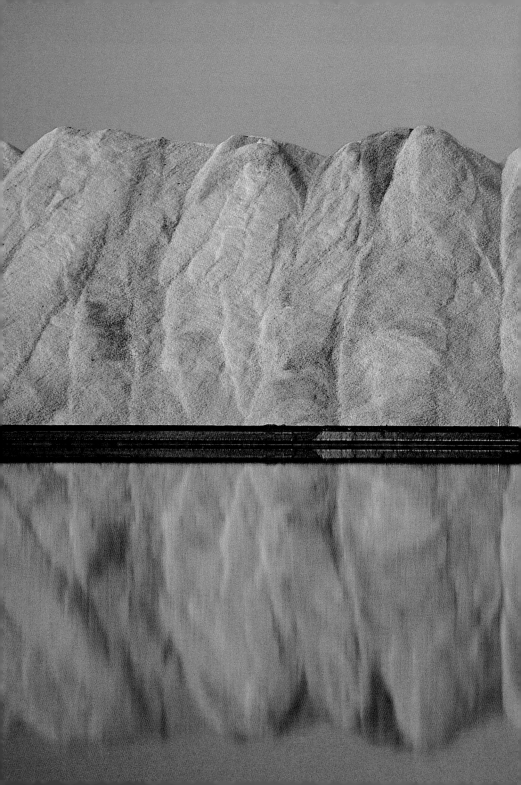

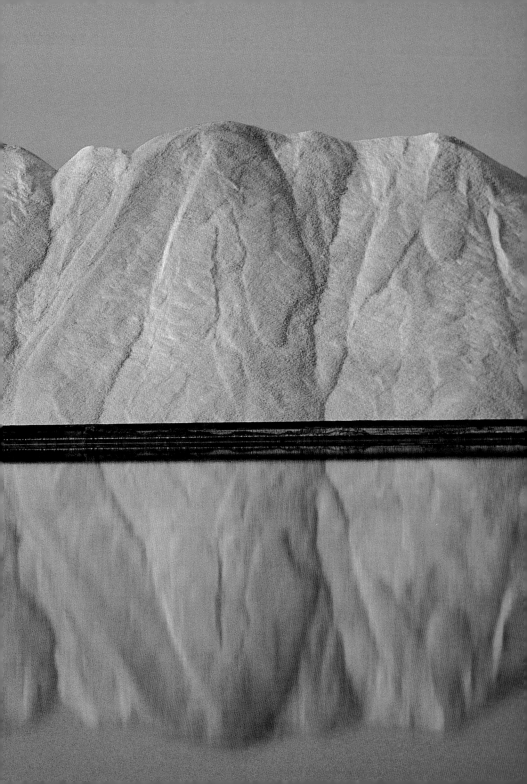

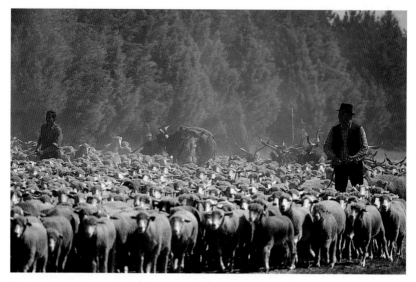

The Transhumance festival in Saint-Rémy-de-Provence takes place
at Pentecost.

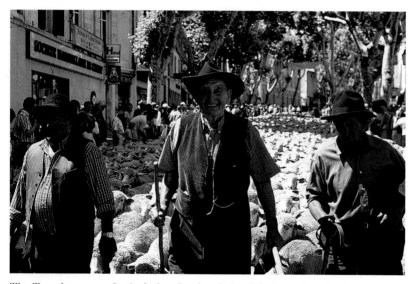

The Transhumance festival; the shepherds lead their trailing flocks
through the town several times. The distinctive odor of the passing sheep
lingers in the town.

Thousands of merino
sheep, gathered for the long
Transhumance journey.

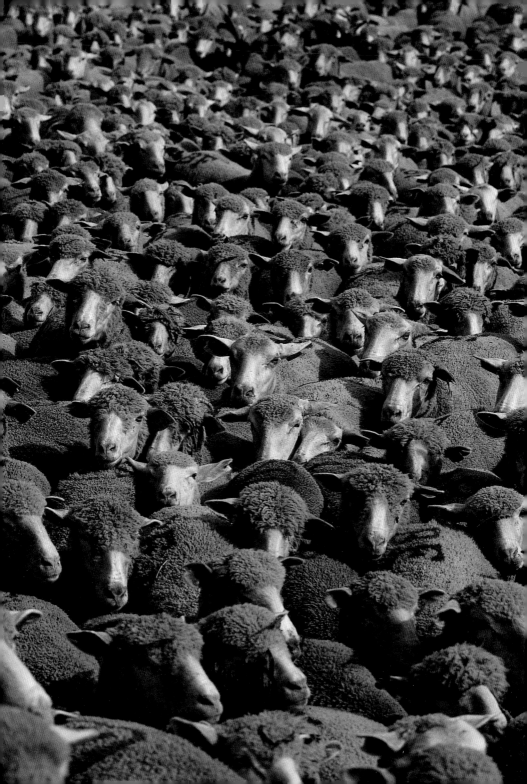

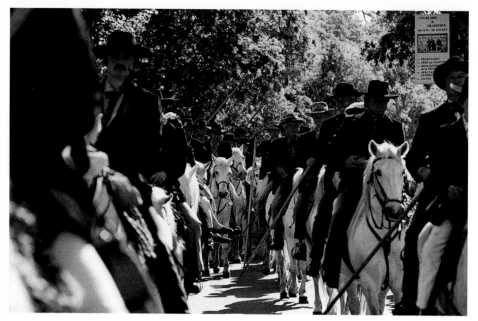

Every May 1 in Arles, the Fête des Gardians celebrates the herdsmen of the Camargue.

At the Fête des Gardians festival
the intricate craftsmanship
of the Camargue's traditional
harnesses is on display.

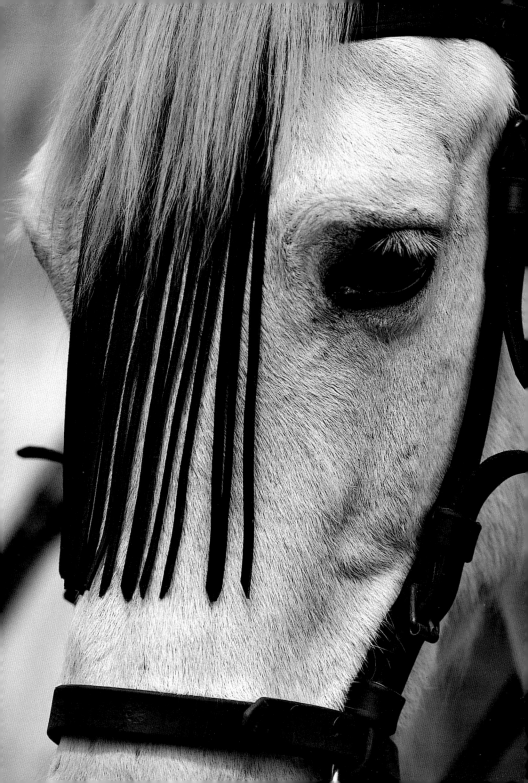

The *Jeu du bouquet* in the Arles Arena during the Fête des Gardians. The rider has to protect a bouquet of flowers from other riders.

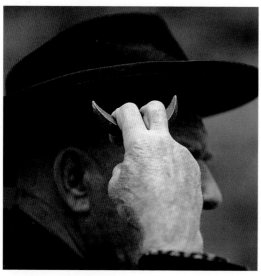

Herdsman with his trident, the tool of his trade and symbol of his profession.

A herdsman in traditional costume, Arles.

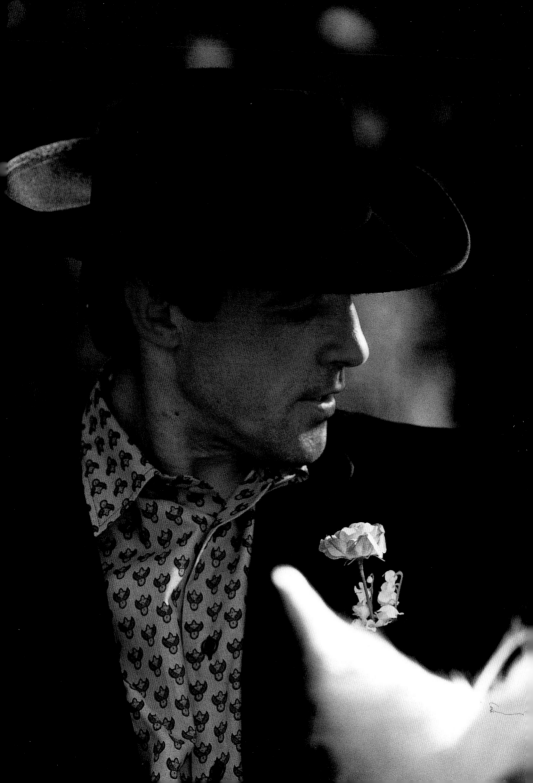

The Camargue saddle is unique in design and shape. It is the work of skilled artisans who perpetuate local traditions.

Close-up of a traditional costume from Arles. The scarf is held in place with a pin.

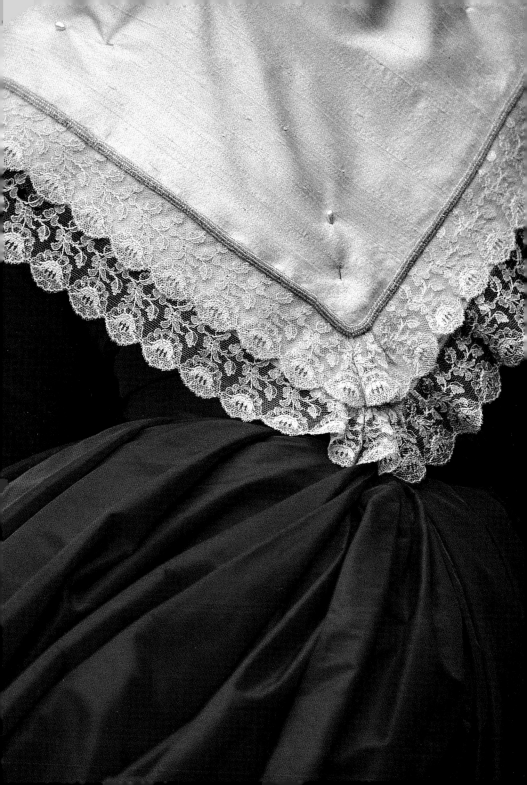

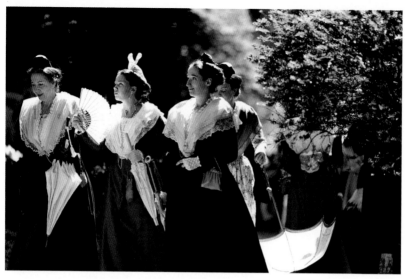

The people of Arles during their costume festival, on the first Sunday in July.

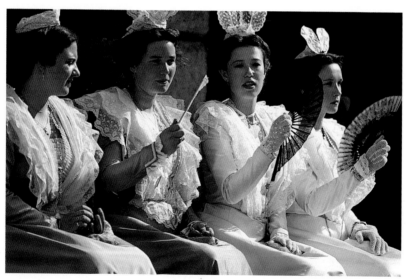

The queen and her ladies in waiting are elected every three years.

Close-up of a traditional
Arles costume — a fitted camisole
and skirt with tight folds.

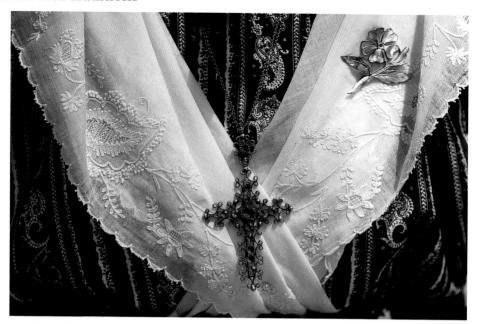

Close-up of a traditional Provençal costume. The scarf and chemisette
are often decorated with an intricately crafted cross.

Pentecost in Aix-en Provence—
the Fête de Santo Estello where
langue d'oc poets gather to assess the
year's work. Traditional Provençal
costumes from the nineteenth
century are worn for the event.

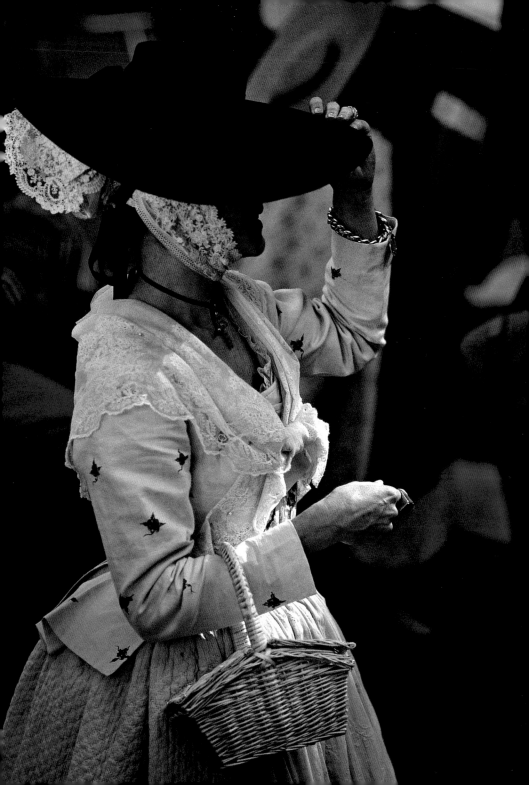

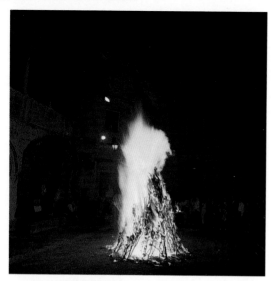

Bonfire celebrating Saint John
in the village of Barbentane.

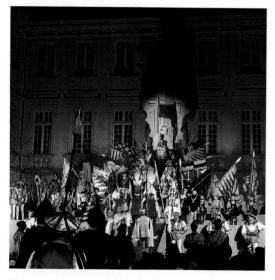

The night before Saint John's Day is the Fête
du Petit Saint-Jean in Valréas. The town elects
its own "Petit Saint-Jean," a child to protect
the town over the coming year.

The Carmentran festival in Murs.
The "Carmentran" is a form
of scapegoat that symbolizes
misfortune. The character is burnt
after a mock funeral procession.

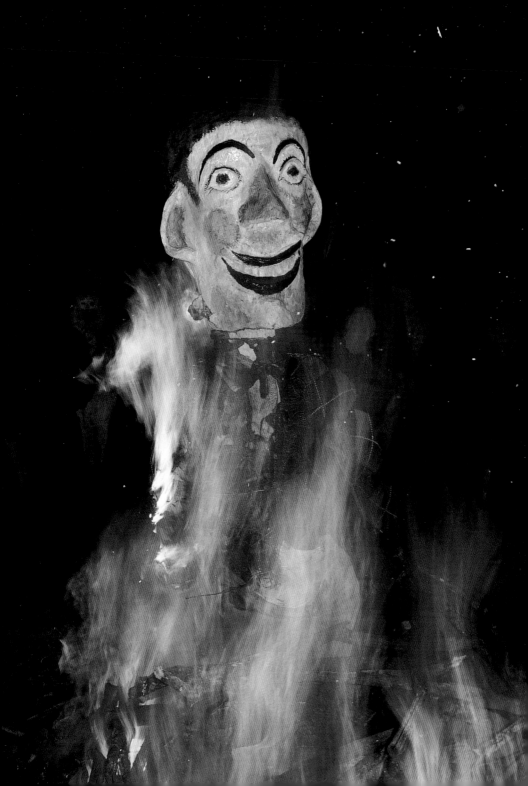

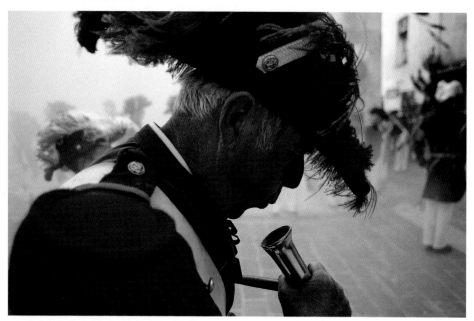

Blunderbusses are fired during the Fête de la Bravade (the Defiance Festival) in Saint-Tropez, which lasts three days.

The Fête de la Bravade
commemorates the victory
of the people of Saint-Tropez
over the Spanish galleys.

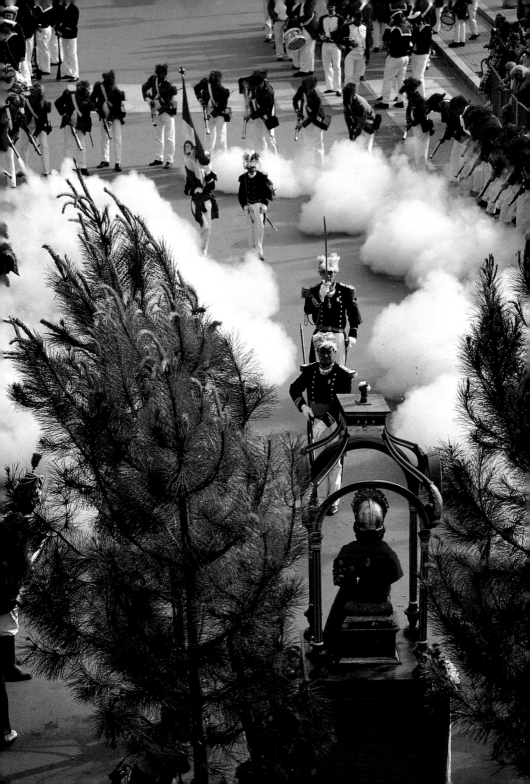

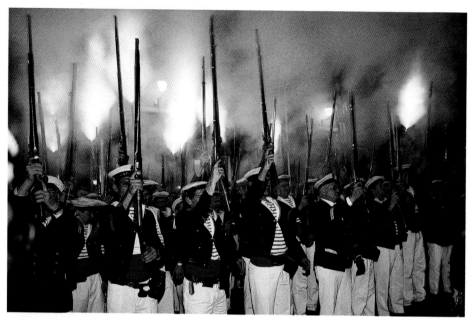

A night tribute during the Fête de la Bravade in Saint-Tropez. Sailors parade, firing musket salvos, through the town, bedecked in red and white bunting.

Mass in honor of the
Fête de la Bravade in
a Saint-Tropez church.

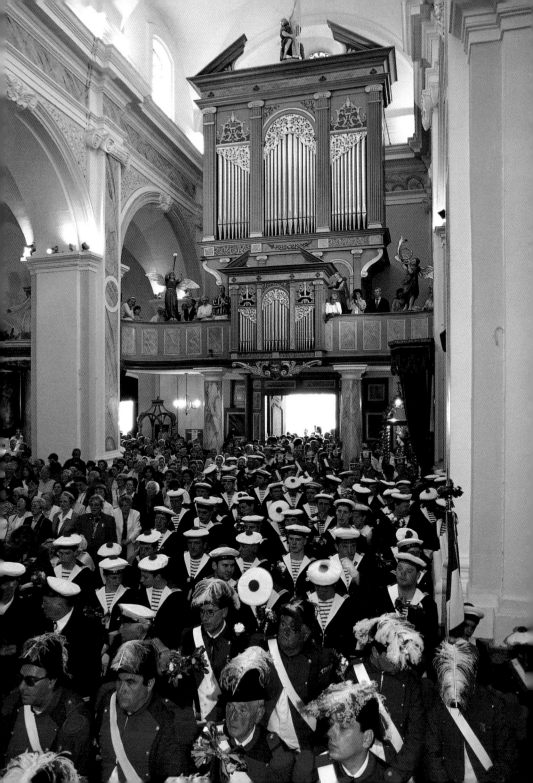

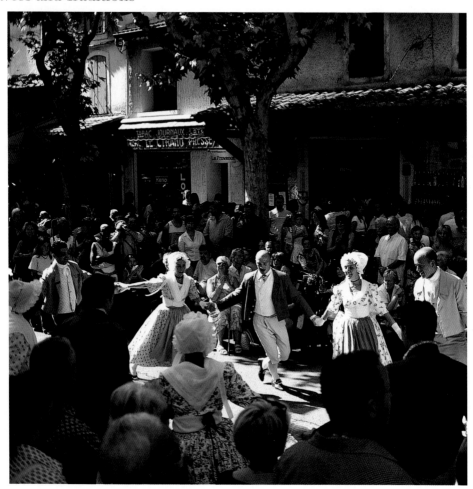

In September, during the green olive festival in Mouriès, Les Alpilles,
the farandole is danced in the streets.

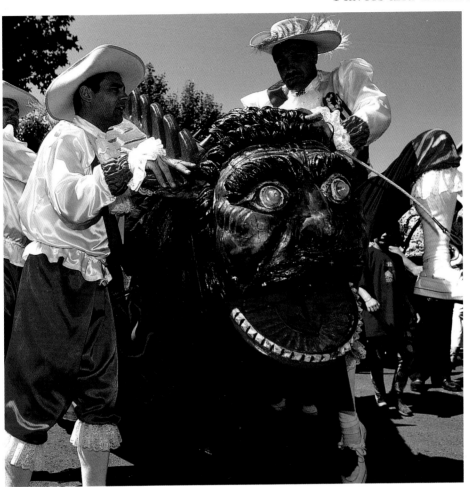

The "Tarasque" monster in Tarascon. Legend has it that the creature once terrorized inhabitants of the banks of the Rhône downriver from Avignon. The town was freed of the beast by Saint Martha and adopted its name from the dragon. The town's liberation is still celebrated today.

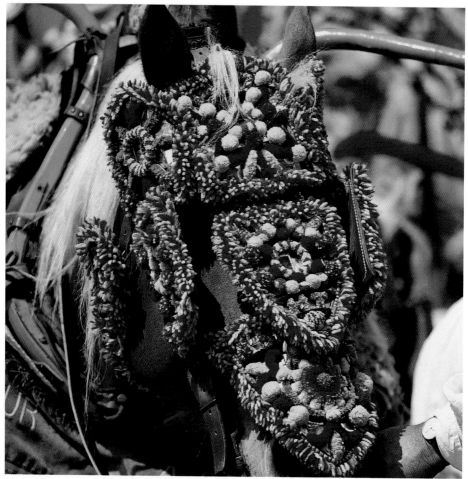

The Fête de Saint-Éloi in Mollèges is, above all, a horse festival, which features
a procession of a carriage bedecked with greenery.

The red float of the Fête de
la Madeleine in the republican
town of Châteaurenard.
The singing of the republican
hymns "La Marseillaise"
and the "Internationale"
replaces religious blessings.

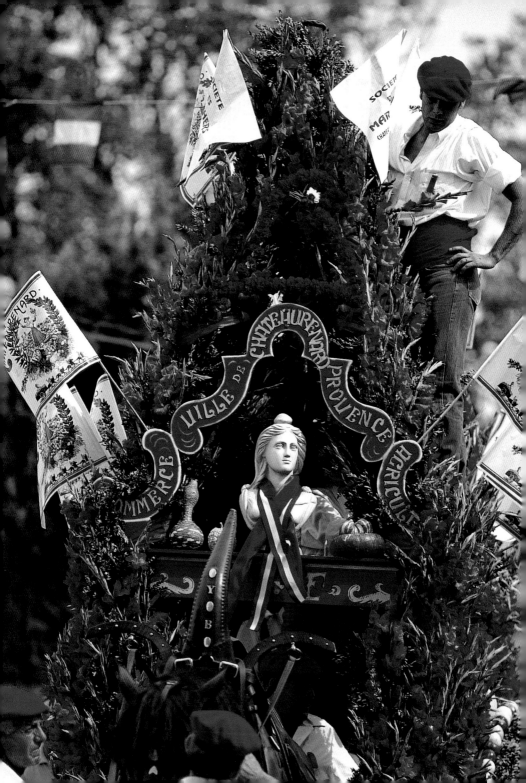

In May, thousands of Gypsies congregate in Saintes-Maries-de-la-Mer.

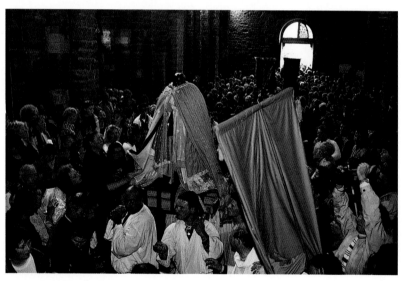

The procession of Saint Sarah during the Fête des Gitans
(gypsy festival) in the fortified church of Saintes-Maries-de-la-Mer.

following double page
Fête de Saint-Éloi in Mollèges. The cart is
harnessed to a procession of fifteen horses.

The "Carmentran" in Murs
in the Lubéron. The festival is an
occasion for music and singing.

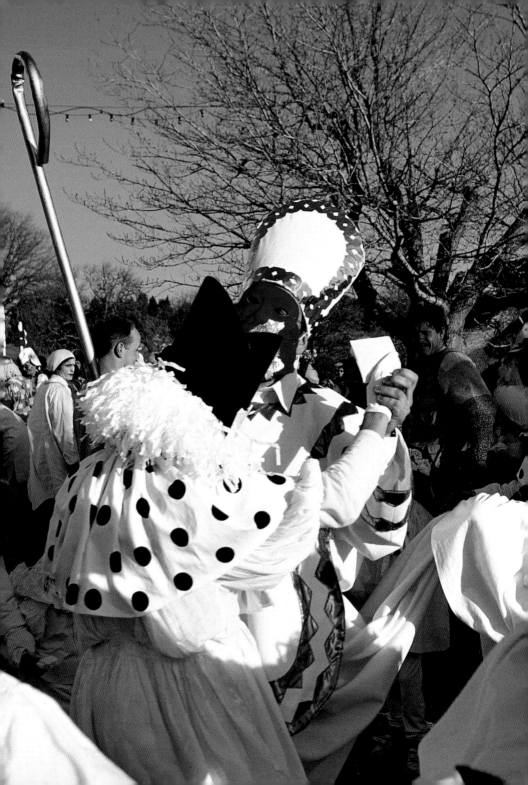

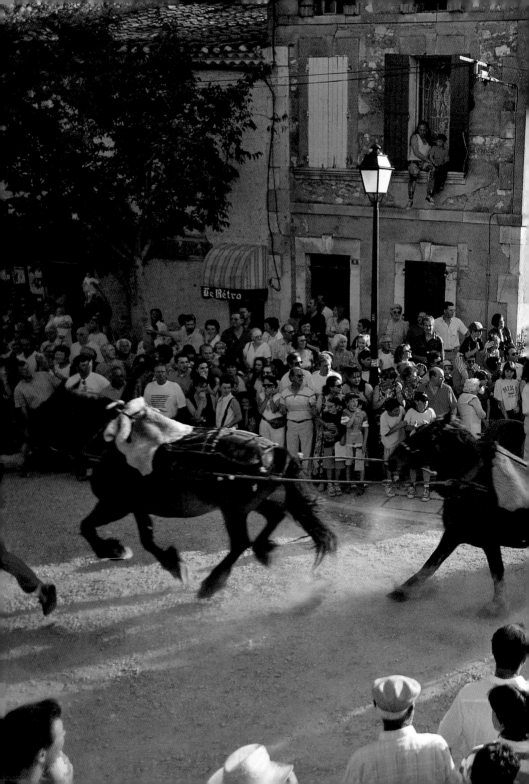

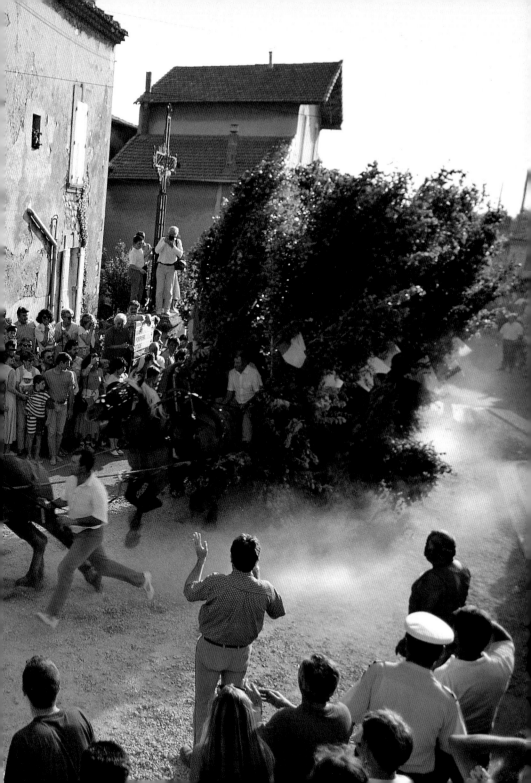

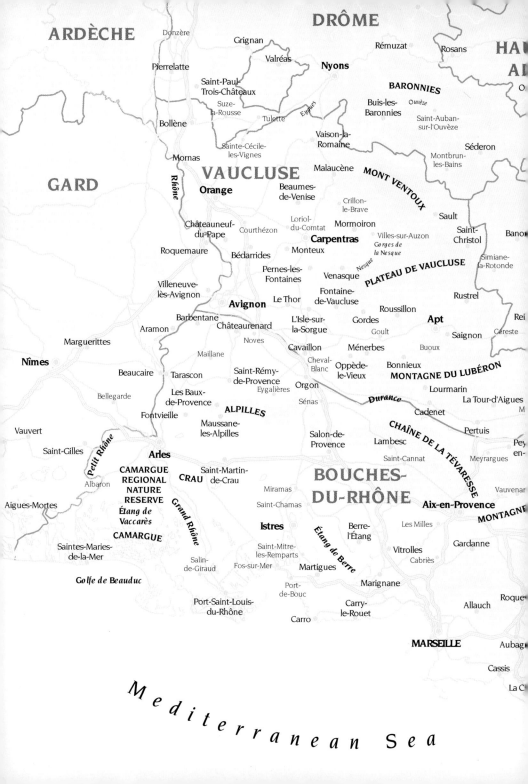

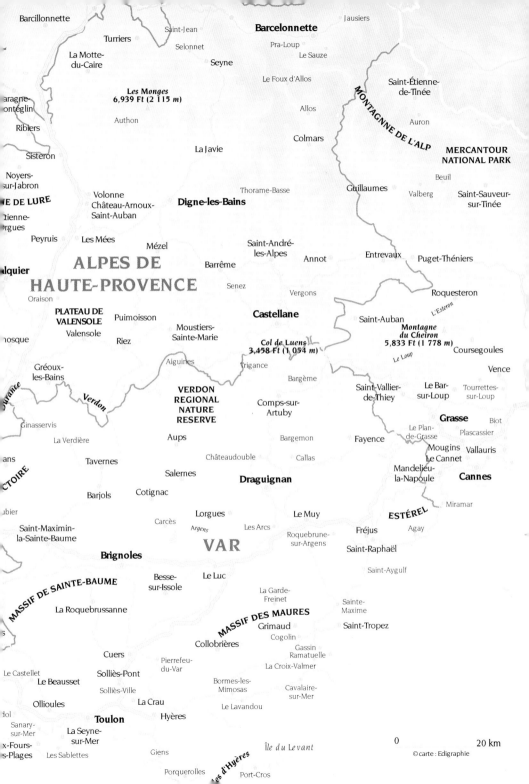

Additional photo captions

Front cover: A tree surrounded by lavender on the Sault plateau.
Back cover, clockwise:
> Fishing boats in Martigues.
> Bouquets of lavender.
> Marseille soap.
> The hill town of Vaison-la-Romaine.

Page 4
> *top:* Stone pines in Aigues-Mortes.
> *center:* Lavender fields in the Contadour.
> *bottom:* The village of Moustiers-Sainte-Marie.

Page 5
> *top:* A regatta in Saint-Tropez bay.
> *center:* A house in the Rocher d'Ongles near Forcalquier.
> *bottom:* Olives in Saint-Rémy-de-Provence market.

Pages 12–13
> A one-hundred-year-old olive tree near Nyons.

Page 14
> *left:* A poppy field near Lacoste in the Lubéron.
> *center:* A sunflower near Montagne Sainte-Victoire.
> *right:* Olive tree and roses in Valsaintes.

Page 15
> *top:* Lavender on the Valensole plateau.
> *left:* The "Ocher Trail," Roussillon, in the Lubéron.
> *center:* The Col d'Allos near the Verdon river.
> *right:* The Calanques de Cassis.

Page 116
> *left:* The village of Bories near Gordes in the Lubéron.
> *center:* The village of Callian in the Haut Var.
> *right:* Château de Grignan in the middle of lavender fields.